STARRY NIGHT

STARRY NIGHT

VAN GOGH AT THE ASYLUM

MARTIN BAILEY

FRANCES LINCOLN

**The author would like to acknowledge with grateful thanks
the research and translation assistance of Onelia Cardettini.**

Brimming with creative inspiration, how-to
projects, and useful information to enrich your
everyday life, quarto.com is a favourite destination
for those pursuing their interests and passions.

First published in hardback in 2018.

This paperback edition first published in 2022 by Frances Lincoln Publishing,
an imprint of The Quarto Group.
The Old Brewery, 6 Blundell Street
London, N7 9BH,
United Kingdom
T (0)20 7700 6700
www.Quarto.com

A catalogue record for this book is available from the British Library.

ISBN 978-0-7112-7731-1

10 9 8 7 6 5 4 3 2 1

Printed in China

CONTENTS

A NOTE TO THE READER

Vincent van Gogh lived at the asylum of Saint-Paul-de-Mausole, just outside the town of Saint-Rémy-de-Provence, from 8 May 1889 to 16 May 1890. The place-names are normally shortened in this book to Saint-Paul and Saint-Rémy. Endnotes give the sources of quotations, along with additional information. Frequently cited sources in the notes have abbreviated references, with the full references in the Select Bibliography. Van Gogh's letters are numbered from the definitive 2009 edition, *Vincent van Gogh – The Letters: The Complete Illustrated and Annotated Edition*, edited by Leo Jansen, Hans Luijten and Nienke Bakker (www.vangoghletters.org), with the Saint-Rémy letters in vol. v. Van Gogh's paintings are identified by the 'F' numbers from the 1970 catalogue raisonné by Jacob-Baart de la Faille, *The Works of Vincent van Gogh: His Paintings and Drawings*. Unless otherwise specified, illustrated works are by Van Gogh. In captions, height is given before width, in centimetres. Artworks and the archive at the Van Gogh Museum in Amsterdam are mainly owned by the Vincent van Gogh Foundation, set up by the family. Some of the museum's archival documents are available on the website with the artist's letters. Years of birth and death of residents of Saint-Rémy are mainly from census returns, voters' lists and birth, marriage and death records at the Archives Municipales (spellings of names can vary, but the most likely variant has been used). Ages given for asylum staff and patients are normally those for May 1889, when Van Gogh arrived.

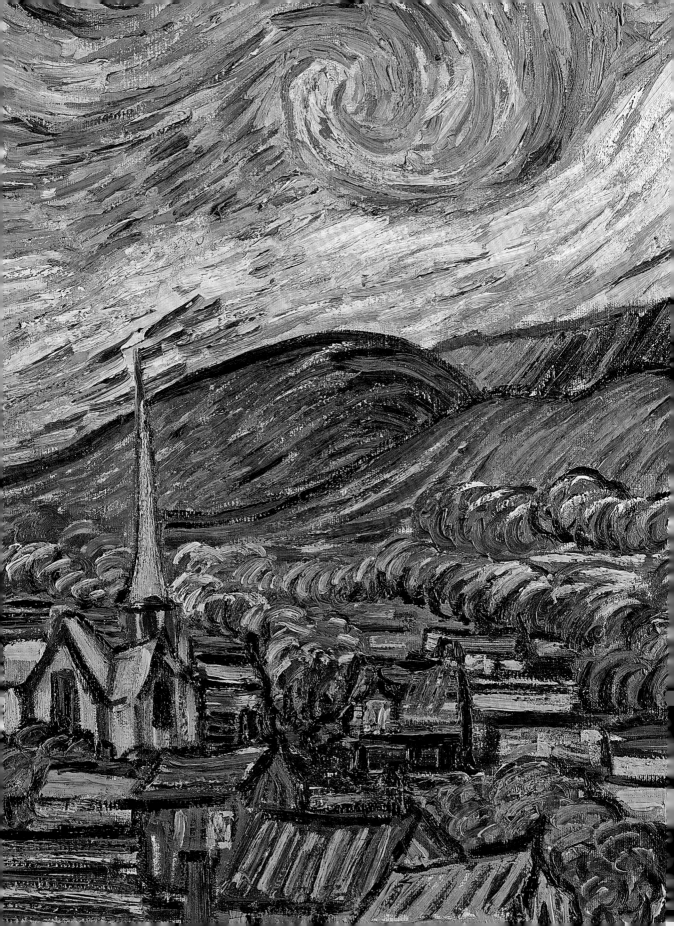

PREFACE

Set against a backdrop of craggy limestone hills, the market town of Saint-Rémy-de-Provence is an enchanting cluster of buildings nestled together amidst cobbled alleyways. Beyond its historic centre, ringed by a tree-lined, circular boulevard, lies the quintessential landscape of Southern France – a tapestry of olive groves, vineyards and cypresses. Aromas of wild thyme and rosemary fill the air, together with the cicadas' summer song. On the southern outskirts of the town lies the former monastery of Saint-Paul-de-Mausole, a place of sanctuary for over a thousand years.

Today visitors flock to Saint-Paul partly to linger in its Romanesque cloister, but primarily to experience what was once the asylum home of Vincent van Gogh. The artist withdrew to this sheltered retreat after mutilating his ear, the terrible episode which ended his collaboration with Paul Gauguin in their studio of the south in nearby Arles. Van Gogh would stay at the asylum for 374 days, from 8 May 1889 to 16 May 1890.

An advertising poster dating from the late nineteenth century describes Saint-Paul as a *maison de santé*, a house of health (fig. 1)[1]. The image depicts a rural idyll of picturesque buildings clustered around its chapel, set beneath Les Alpilles (the Little Alps) and surrounded by groves of trees. The poster's text compares its climate to that of Nice and Cannes, as if it were a resort. In fact it was an asylum for patients who were then known as *les aliénés*, the insane.[2] The reality of life inside the institution, as Van Gogh would soon discover, was rather different from that portrayed in its poster.

This former monastery has now become a modern psychiatric hospital, secure behind its high walls. Visitors are welcomed to gardens, the chapel, the twelfth-century cloister and several upper rooms. These include a small cell presented as 'Van Gogh's Bedroom', furnished as it might have been in 1889. Many tourists leave believing they have seen the actual room where the artist slept, but he is unlikely to have ever set foot inside it. Van Gogh was confined to what was then the men's block, beyond the cloister, a building that has now been modernised to

Detail of fig. 49 *Starry Night*, Museum of Modern Art, New York

9

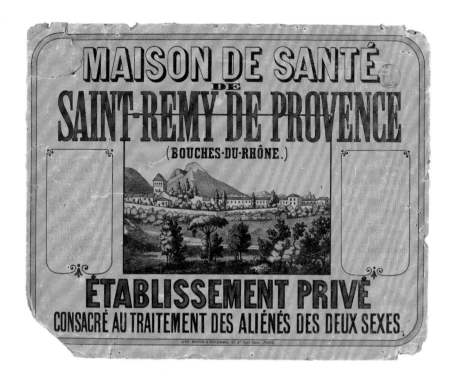

fig. 1 Poster for Maison de Santé de Saint-Rémy-de-Provence, c.1880s, lithograph, 37 x 49 cm, by Baster & Viellemard, Paris

serve the hospital. Even though this area is strictly out of bounds, the evocative former monastic complex offers a marvellous opportunity for visitors to experience the atmosphere and surroundings of one of the key places where Van Gogh lived and worked.

In 1987, when I first began taking a serious interest in Van Gogh, I asked to see inside the hospital, particularly the former men's block. Understandably, the arrangements proved complicated, but eventually my request was granted. Henri Mison, the director, kindly escorted me around at a time when the patients were in their rooms. I began to imagine what life might have been like for the artist during the year of his confinement within these walls.

I was immediately struck by how the view from the vestibule of the former men's block into the garden (fig. 2) remained almost unchanged from that in Van Gogh's day (fig. 30). The large door opened into a walled garden, where the artist spent many of his happiest hours. Water was still cascading from the fountain into its circular basin, a scene which the artist depicted in several works (fig. 21). The chairs in the vestibule, for patients to take onto the terrace outside, caught my eye. This rather poignant cluster reminded me of the 'empty chairs' which Van Gogh had depicted in Arles a few months before his arrival at the asylum – separate paintings of his own chair and that of his colleague Gauguin.[3]

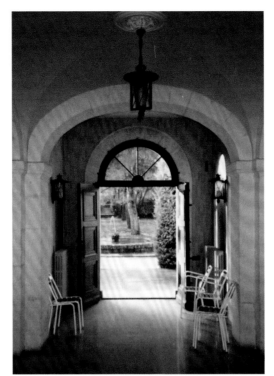

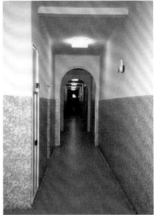

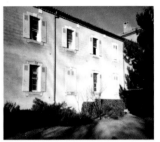

fig. 2 Vestibule of former men's block (north wing), Saint-Paul-de-Mausole, 1987, photograph by author

fig. 3 Corridor of former men's block (north wing), Saint-Paul, 1987, photograph by author

fig. 4 Exterior of former men's block (east wing), Saint-Paul, 1987, photograph by author

Most of the hospital had been modernised in the 1960s and 70s, when many of the original features were lost. The long corridor had been narrowed, to release space to enlarge the patients' rooms, and the lower walls had been tiled, creating a rather institutional feel (fig. 3). In Van Gogh's time the corridors did at least have a certain architectural elegance (fig. 31).

Mison then took me outside into another garden which faced Les Alpilles. Stepping into what was formerly a wheatfield, I immediately recognised the walled area that became one of Van Gogh's favourite motifs. From the garden I looked up at the wing where the artist's bedroom had been, on the upper floor (fig. 4). I asked Mison whether the patients realised that the famous artist had once stayed there. Not usually, he explained, adding that they might have found that disturbing.[4]

With the approaching centenary of Van Gogh's stay in 1989–90 the hospital faced an increasing number of requests for visits, which were nearly always refused. Today access inside is virtually ruled out, which means that I am one of very few present-day Van Gogh specialists who has been inside. I was also permitted to photograph parts of the interior, and the images in this book are the first to be published in colour in the Van Gogh literature.[5]

* * *

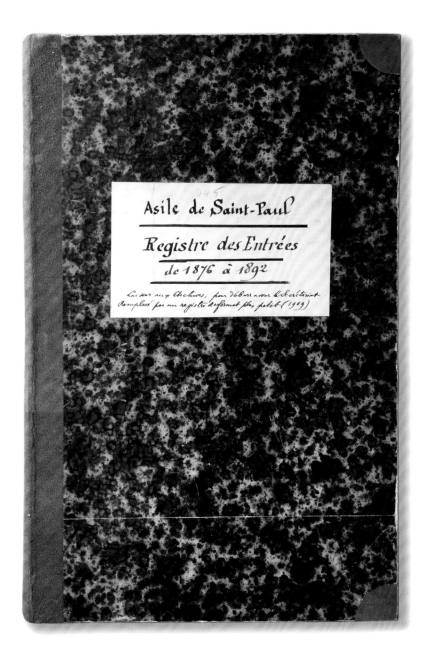

fig. 5 Register of admissions at Saint-Paul (1876–92), Archives Municipales, Saint-Rémy

fig. 6 Entries in the register of admissions for 1889 at Saint-Paul, with Van Gogh's name half way down, Archives Municipales, Saint-Rémy

Following my first visit to Saint-Rémy, I subsequently returned numerous times, but it was not until nearly thirty years later that I heard of possible new documentary evidence about Van Gogh's stay. Rémi Venture, then the town's archivist, confirmed that the municipal archive held a late nineteenth-century admission register of patients who entered Saint-Paul. Astonishingly, this ledger has never been used by Van Gogh scholars – and it is now very rare

for fresh documents on the artist to surface. I rushed to Saint-Rémy in early 2017, accompanied by my friend and researcher in Provence, Onelia Cardettini.

In the archive room, on the upper floor of a mansion which now serves as the town's library, Venture settled us by a long table and brought out a heavy box filled with folders. We quickly sifted through them and found the document we were seeking, with the inventory number 3Q5. In great anticipation, we untied the white ribbon securing it. Inside was a large register bound in mottled paper, recording the arrival of hundreds of patients (fig. 5).[6]

Turning to the page for 1889, we immediately spotted the entry for the asylum's most illustrious patient (fig. 6). This records that Vincent van Gogh had been born in Holland, was aged 36 and had come from Arles. Three dates are given: for his admission (8 May 1889), for the medical report by the certifying doctor (9 May) and for the report's dispatch to the authorities (11 May). The day of Van Gogh's arrival was already known, so only minor details were new, but we quickly realised that the register might make it possible to identify the artist's fellow patients.[7]

There were only 18 male patients in the asylum on the day of Van Gogh's arrival. The artist lived with this small community for a full year, sharing their sufferings. Gradually he came to know the men well, calling them 'my companions in misfortune'.[8] The admission register contains no medical data, but with the names of his fellow patients I was then able to use other sources to research their varied backgrounds and conditions. I was shocked to discover quite how ill most of them

were – and what a challenging environment this must have created for Van Gogh. The artist, I now realised, was not exaggerating when he wrote that 'one continually hears shouts and terrible howls as though of the animals in a menagerie'.[9]

Jean Revello, for instance, was 20 when he arrived in May 1887, two years before Van Gogh.[10] He never learned to speak and was prone to acts of violence – not surprisingly, since he was unable to communicate verbally. Revello ended up being the last male patient in the asylum, which accepted only females after the First World War. In later life, he would usually sit by the entrance lodge, occasionally uttering incomprehensible sounds. Revello died at Saint-Paul on 22 April 1932, aged 65 – after being held nearly 45 years in the asylum.

Henri Enrico was admitted two weeks after Van Gogh. Although not naming him, the artist wrote that this new arrival 'breaks everything and shouts day and night'.[11] Henri's brother and sister had also previously been at Saint-Paul, so the siblings presumably suffered from a genetic disorder.

Another patient, like Van Gogh, suffered from 'auditory hallucinations'. These hallucinatory noises could explain why Van Gogh had earlier taken the terrible step of cutting off his left ear. He might well have done this in a desperate effort to silence the terrible noises or words that he believed he was hearing. Although the fact that Van Gogh had experienced auditory hallucinations is recorded in the asylum medical records, I feel that insufficient attention has been focused on this evidence.

* * *

Learning of the sufferings of the patients encouraged me to delve into the story of the asylum, which has been surprisingly little studied by Van Gogh specialists. I wanted to learn more about what life must have been like for Van Gogh, Revello and Enrico. Unpublished papers on an 1874 inspection at Saint-Paul revealed some very shocking details. Fortunately, this led to prompt reforms by a recently appointed director, Dr Théophile Peyron, who would later treat Van Gogh with kindness and sensitivity. But although Dr Peyron and his staff did their best, little was then known about the causes of mental illness and treatment was rudimentary.

Van Gogh must have found it difficult taking his meals in the refectory and relaxing in the common room with his fellow patients, many of whom were in a considerably worse condition than himself. Needless to say, he was far away from family, friends and fellow artists. Virtually the only artworks he saw were reproductions in publications. So much of what he valued most in life remained elusively distant, but what he did have was the opportunity to continue to paint.

Although 62 of Van Gogh's letters from Saint-Paul survive, he wrote relatively little about the everyday details of asylum life. Perhaps he wished to spare recipients the stark details or he may have wanted to switch off from reality, treating

fig. 7 Almond tree near Saint-Rémy, 2017, photograph by author

correspondence with outsiders as a welcome escape.[12] Biographers of Van Gogh understandably rely on his letters, but this has produced a rather sanitised account of his time at Saint-Paul.

I decided to look afresh at this next stage of his artistic journey.[13] On my visits to Saint-Rémy I followed in Van Gogh's footsteps to explore the places where he painted. I climbed up the ravine behind the asylum, ventured into the quarry where he had suffered a mental crisis, explored the olive groves and tramped through Les Alpilles. On numerous occasions I returned to Saint-Paul, to soak in the ambiance of this monastery-turned-hospital.

I even managed to track down what may well have been the actual almond tree whose blossoms Van Gogh captured in paint to celebrate the birth of his nephew (fig. 106). Two long-time residents of Saint-Rémy took me to the venerable tree. Almond trees can sometimes live for 150 years and although the evidence they gave me that this was the one depicted by Van Gogh was not conclusive, it was nevertheless persuasive.[14] I am reluctant to reveal details, since identifying the location could endanger its life – visitors might be tempted to follow the artist's example and break off blossom-covered twigs (fig. 7).

In Saint-Rémy I also set out to search for memories of locals who had known Van Gogh.[15] An unpublished diary compiled in the 1920s and 30s by a local artist, Jean Baltus, includes reminiscences from several neighbours.[16] This made it possible to locate the olive grove of Charles Trabuc, the chief orderly, where Van

Gogh would paint and chat with his wife Jeanne. I also found more memories of Jean-François Poulet, who as a young man had worked at the asylum and had accompanied Van Gogh on his painting excursions. This means that we can now identify the previously unnamed 'gardener' depicted in Van Gogh's finest portrait from Saint-Paul.

Biographers invariably divide Van Gogh's life into a series of periods, according to where he lived and worked. From his late teens he was continually on the move, always searching for a more appropriate setting to pursue his vocation. The 12 months from May 1889 to May 1890 is conventionally called Van Gogh's 'Saint-Rémy' period, but this is something of a misnomer, since he rarely set foot inside the town. It would be more accurate to call it the Saint-Paul period, because he spent virtually all his time inside the asylum or in its surrounding countryside.

The Saint-Paul year witnessed a remarkable development in Van Gogh's art, as the exuberant colours of his Arles period gave way to rather more muted tones that perhaps reflected his mood. As Jo Bonger, his sister-in-law, later put it: 'His palette had become more sober, the harmonies of his pictures had passed into a minor key'.[17] But if his colours softened, his brushwork became ever more energetic, with his distinctive swirling, sinuous lines.

It was doubtless Van Gogh's passion for art that meant he was able to cope with asylum life. The intensity of his work helped him fend off the indignities of daily existence, giving him a purpose and making his troubles bearable. It is often assumed that Van Gogh's art must have suffered from his mental deterioration and there were certainly periods of a few weeks at a time when he was unable to paint or draw at all. But there are only a handful of surviving paintings where one can detect evidence of his mental instability, and for most of his time at Saint-Paul he remained lucid and self-possessed. He was certainly highly productive and there are just over 150 surviving paintings, as well as perhaps one or two dozen which have been lost. This extraordinary output represents a picture every two days.

<center>* * *</center>

Starry Night (fig. 49) is the most celebrated of Van Gogh's paintings from Saint-Paul. I was curious to explore how much of the picture's imagery was based on reality and what burst out from his imagination. The church must represent that of Saint-Rémy and the hills in the background are certainly Les Alpilles, but it is the heavens which dominate the painting.

Van Gogh was a keen observer of the night sky, and as he had written before his arrival: 'The sight of the stars always makes me dream.'[18] With very little artificial light at Saint-Paul, the night skies would have been truly aglow. Peering

through the iron bars of his window, just before climbing into bed, must have represented blissful moments of escape for the artist.

To discover more about Van Gogh's painted sky I turned to the Royal Observatory in Greenwich. Brendan Owens of the Peter Harrison Planetarium very kindly put on a presentation for me – showing the Provençal sky facing east on the night of 14–15 June 1889, when Van Gogh conceived his painting.[19] As I sat alone in the auditorium, he dimmed the lights and step-by-step projected the heavenly elements that the artist would have witnessed onto the large domed ceiling.

First came the rising moon – almost full, and far from being the crescent in the painting. Next, he added the planets and stars, showing that Jupiter was the only really bright evening object near the moon. Owens then fast forwarded the sky, hour by hour, until Venus, the brightest planet, appeared just before dawn. By that time the moon would no longer have been visible from Van Gogh's room. Owens then presented the Milky Way, filtering out some of the moonlight to make it stand out more prominently. I wondered whether it could have inspired the white band in Van Gogh's painting that hovers just above the crest of the hills.

As my visit to the planetarium drew to a close, I left with the conviction that when Van Gogh stood at his easel and began working on his blank canvas he paid little heed to the details of what he had witnessed the previous night. Instead, he retained memories of having seen countless night skies, allowing his imagination free rein to create a stunning, highly personal vision.

Starry Night is emblematic of Van Gogh's time at the asylum. Although for three quarters of the time he was mentally alert and worked prodigiously, he also suffered a series of crises which thrust him into a darkness that made it impossible to paint. Yet each time he recovered and reemerged from the depths of despair. He would return into the light, once again taking up his brush. *Starry Night* represents a vibrant testament to the artist's struggle to overcome the challenges of living and working in an insane asylum.

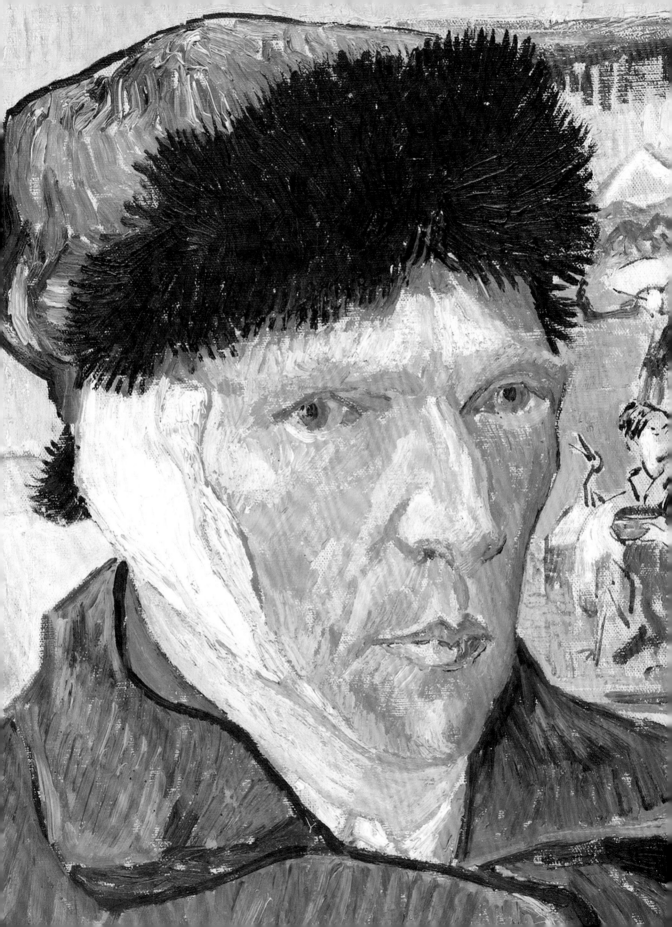

TWO BROTHERS, TWO LIVES

*'The love between brothers is a great support in life,
that is an age-old truth'*[1]

It was a whirlwind romance for Theo, Vincent's 31-year-old younger brother: just over a week after meeting his future wife, Johanna (Jo) Bonger, the couple decided to marry. In December 1888 the young Dutch woman was visiting Paris, where Theo was working as an art dealer. Although they had met very briefly, in 1885 and again in 1887, on the latter occasion Jo had been involved with another man and had gently rebuffed Theo's attempt to develop a serious relationship. This time it was quite different, with Jo immediately reciprocating. Their first days together in Paris were bliss – a quite unexpected, dreamlike experience, when they spent many hours together, talking late into the evenings.[2]

Theo wrote with great emotion to his mother Anna just eleven days after meeting Jo: 'I loved her too much, & now that we have seen one another a great deal these last few days, she has told me she loves me too... And now dear Mother I ask you to take her into your loving mother's heart.'[3] Anna immediately wrote back to her son, giving her blessing. After just two weeks together, Jo left Paris the day after Christmas to return to her family in Amsterdam, where the engagement was formally announced and preparations for their wedding were begun.

A few days later Theo also returned to the Netherlands to celebrate the engagement with family and friends on 9 January 1889. To mark the occasion he and Jo posed for studio photographs (figs. 8 and 9). After just over a week together in the Netherlands, Theo had to return to Paris for his work at the Boussod & Valadon gallery, while Jo remained behind in Amsterdam. It would be nearly three

Detail of fig. 11 *Self-portrait with bandaged Ear and Japanese Print*, Courtauld Gallery, London

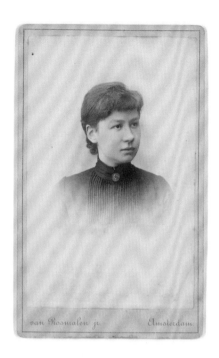
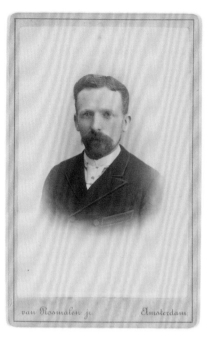

fig. 8 Johanna (Jo) Bonger, photograph by Frederik van Rosmalen Jr, Amsterdam, January 1889, Van Gogh Museum, Amsterdam (Vincent van Gogh Foundation)

fig. 9 Theo van Gogh, photograph by Frederik van Rosmalen Jr, Amsterdam, January 1889, Van Gogh Museum, Amsterdam (Vincent van Gogh Foundation)

months before they would see each other again, but in the meantime they wrote frequently, excitedly sharing their feelings and discussing how they would set up home together in Paris.

The first step in their new life together was finding more suitable accommodation, since Theo's apartment at the top of Montmartre was too far from his work to return at lunchtime. Theo set out to track down 'the place where we shall build our nest'.[4] He eventually discovered an apartment at the bottom of the hill, at 8 Cité Pigalle. Letters packed with details of domestic arrangements shuttled back and forth. Theo even posted a fabric swatch for their bedroom curtains (Jo lovingly saved this small sample with his letter and it is still preserved at the Van Gogh Museum). 'What a nice, cosy home we shall have', Jo wrote back to her fiancé.[5]

At the end of March Theo took the train back to Holland for a round of family visits, followed by the wedding in Amsterdam on 18 April 1889. After a 24-hour honeymoon in Brussels they arrived in Paris, where Theo escorted his sweetheart into their new apartment, its rooms decked with flowers. Jo reported back to her sister Mien: 'Theo is so kind and good to me – and we are getting on so well together, we were used to each other from the very first moment... And the housekeeping... everything is running well and I do my best to keep it clean and tidy.'[6] Theo and Jo delighted in the thought of life together in their new home.

* * *

fig. 10 *The Yellow House*, September 1888, oil on canvas, 72 x 92 cm, Van Gogh Museum, Amsterdam (Vincent van Gogh Foundation) (F464)

For Theo's brother, it was a very different story. In February 1888 Vincent had left Paris, where he had stayed with Theo for two years, to move to Arles. While in Paris he had come into contact with avant-garde colleagues and his palette brightened as he discovered the colouring of the Impressionists. Now he wanted to develop his art, believing that the south of France would open up fresh opportunities.

After arriving in Arles Van Gogh rented the Yellow House (fig. 10), his first ever spacious home of his own. 'My house here is painted outside in the yellow of fresh butter, with garish green shutters, and it's in the full sun on the square… inside, I can live and breathe, and think and paint,' he wrote to his sister Willemien (Wil). It would be what he called the studio in the south, a home and workshop to share with a fellow artist.[7] Van Gogh then invited Gauguin to join him, feeling that life would be cheaper for two and it would be more productive to work alongside a colleague.

Gauguin arrived in October, and initially everything went well. The two painters explored Arles and its surroundings for subjects, set up their easels together and

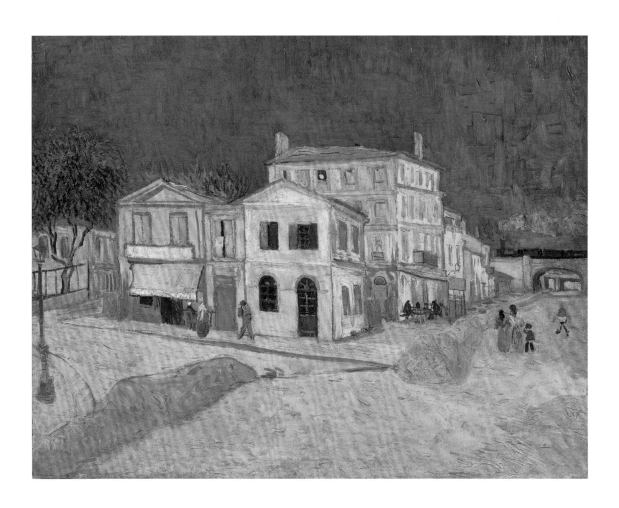

enjoyed long, stimulating discussions about art. But tensions soon developed, sparked off by their different personalities and their strong – and often opposing – views about work. By the middle of December relations were at breaking point, with tempers flaring and Gauguin making repeated threats to leave. This was the very moment when Theo and Jo met and were embarking on their relationship.

Disaster struck on the evening of Sunday 23 December 1888 when, following a bitter argument, Gauguin stormed out of the house. Van Gogh grabbed his razor and in a fit of utter desperation cut off much of his left ear. After wrapping the flesh in paper, he delivered the gruesome package to a woman in a local brothel. This drastic act would eventually become art history's most infamous episode (fig. 11).

What was the trigger for the self-mutilation? There is strong evidence that earlier that day Vincent had received a letter from Theo revealing that he had met Jo – and that they planned to marry.[8] Vincent was terrified of abandonment and was immediately struck with great anxiety. Theo was the one family member who he was close to and he feared that Jo's arrival would dilute his relationship with his beloved brother.

Money was arguably of even greater concern. For the past eight years Theo had generously supported Vincent, sending him a regular allowance from his salary. As part of the arrangement, Vincent would periodically send off his paintings to his brother. Vincent had not had any paid employment during this entire period, so without these remittances he would never have been able to survive as an artist. Jo's arrival on the scene meant that Theo's salary would have to support a wife – and probably children too.

Fear of Gauguin's departure and, more importantly, the loss of Theo's emotional and financial support was the spark, although not the fundamental cause of Vincent's destructive act. The cause of his medical condition would later be endlessly debated by countless specialists. One of the more recent suggestions is that he may have suffered from what is termed borderline personality disorder, which results in abrupt mood changes and is characterised by several factors, including a fear of abandonment.[9]

Gauguin telegraphed Theo on Christmas Eve with news of the terrible incident. Theo postponed his return to the Netherlands and immediately rushed to take the overnight train to Arles, where he visited his brother in hospital. With Vincent in an extremely weak condition, his doctors feared that he might well not survive. Fortunately the wound healed remarkably quickly, although the psychological scars remained. Vincent was discharged from hospital on 7 January 1889, two days before his brother's formal engagement announcement.

Vincent seemed to be making a good recovery, but in early February he was struck down by a second mental crisis and had to be rushed back into hospital. After returning to the Yellow House later that month, Van Gogh faced growing

Fig. 11 *Self-portrait with bandaged Ear and Japanese Print*, January 1889, oil on canvas, 60 x 49 cm, Courtauld Gallery, London (F527)

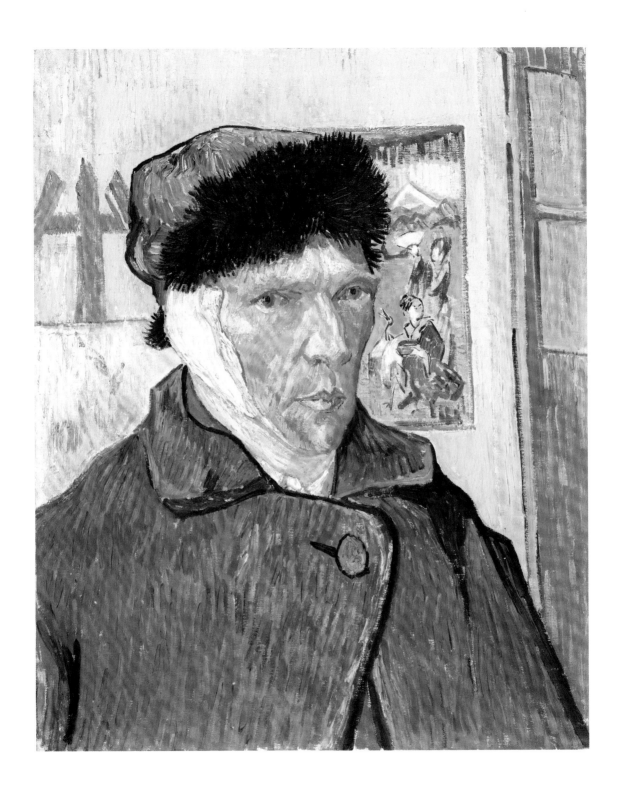

hostility from his neighbours, who drew up a petition demanding his departure. This pressure, along with his unstable mental condition, set off a third crisis. His doctors then advised that he should move to an asylum. This must have seemed a terrifying prospect, since conditions in nineteenth-century insane asylums were generally wretched and little was done to alleviate the suffering of patients, let alone cure them.[10]

For Vincent, the very idea of an asylum brought back extremely painful memories. Nine years earlier, at the age of 27, he had been living in the coal-mining area of the Borinage, in southern Belgium, where he was serving as a missionary. Totally unsuited to this work, his post was terminated and he then fell into abject poverty. At this point his father was concerned about his condition and tried to get him committed to Gheel, a mental institution in Belgium. Until 1990 very little was known about this episode, since references to it were expunged from the published edition of the Van Gogh correspondence, in an attempt to disguise the unfortunate family rift.[11] When Vincent's doctors in Arles suggested he move into an asylum, memories of his own father trying to get him institutionalised must have flooded back.

Theo was equally horrified at what lay ahead. As he wrote to Jo: 'It's harrowing to think of him being in an institution when the spring comes, with high walls all around and no one but lunatics for company.'[12] On the same day he expressed his sorrow to Vincent: 'It breaks my heart to know that now that I'll probably have days of happiness with my dear Jo, you will actually have very bad days.'[13]

The doctors suggested the asylums in Marseille or Aix-en-Provence, both of which were large public institutions.[14] Van Gogh was extremely fortunate in not ending up in either. The Saint-Pierre asylum in Marseille, housed in a former prison, held 1,085 patients and the Montperrin asylum in Aix had 696.[15] Had Van Gogh gone to either of these overcrowded establishments he would have been surrounded by a mass of troubled minds. Both institutions were also on the outskirts of major cities and Van Gogh would almost certainly have had no access to the countryside, which was essential for his painting.

In April Reverend Frédéric Salles, the Protestant pastor in Arles who had been helping Van Gogh since his hospitalisation, instead proposed Saint-Paul-de-Mausole, on the edge of the town of Saint-Rémy-de-Provence. Just 25 kilometres from Arles, this privately run asylum in a beautiful rural setting cared for only 41 male and female patients, ensuring far more personal attention. The pastor very kindly visited the asylum to discuss Van Gogh's possible admission and report back.[16]

All that the two brothers knew about Saint-Paul came from Reverend Salles and the asylum's prospectus. The booklet describes the 'house of health' in

glowing terms, with parlours for male patients that included 'billiard and music rooms and a study for writing or drawing'. In a key commitment, the prospectus stressed that 'humane understanding... has replaced the cruelty with which the insane were once treated'. Procedures were said to be 'without constraints' – normally avoiding the use of straitjackets, being locked into a bath or chained to a bed. Instead the asylum promised 'gentleness and benevolence'.[17]

On the very day of Theo's wedding, 18 April 1889, Vincent was agonising over whether he should try to live independently in Arles or move to Saint-Paul. Reluctantly, he realised that he would have to go, as a voluntary patient. Although representing a defeat, after his 'terrible attack', he acknowledged that 'one comes down the mountain instead of climbing it'.[18] A day after the wedding, when Theo and Jo were enjoying their overnight honeymoon in Brussels, Vincent made his final decision to leave Arles.[19]

On 24 April, less than a week after the marriage, Theo wrote what must have been one of the most heart-wrenching letters he had ever sent. To be admitted to the asylum, Vincent required the authorisation of a close relative. Theo posted Vincent a formal letter to hand over to Dr Peyron: 'With the agreement of the person involved, who is my brother, I am writing to request the admission into your institution of Vincent Willem van Gogh, painter aged 36, born at Groot Zundert (Holland) and at present living in Arles. I ask you to admit him with your 3rd-class residents.'[20]

In his covering letter to Vincent, the first since the wedding, Theo wrote nothing about the big day or the honeymoon, presumably fearing that this would appear insensitive in view of his brother's plight. Theo included only a few low-key words about the couple's new home in Paris: 'I also want to tell you that we've been here since last Saturday, we're almost settled in, and every day the apartment takes on a more lived-in aspect.'[21] At the very moment that Theo and Jo were savouring the initial delights of married life in their 'nest', 600 kilometres away his elder brother was giving up the Yellow House, a focus of his dreams and aspirations – and moving into an asylum for the insane.

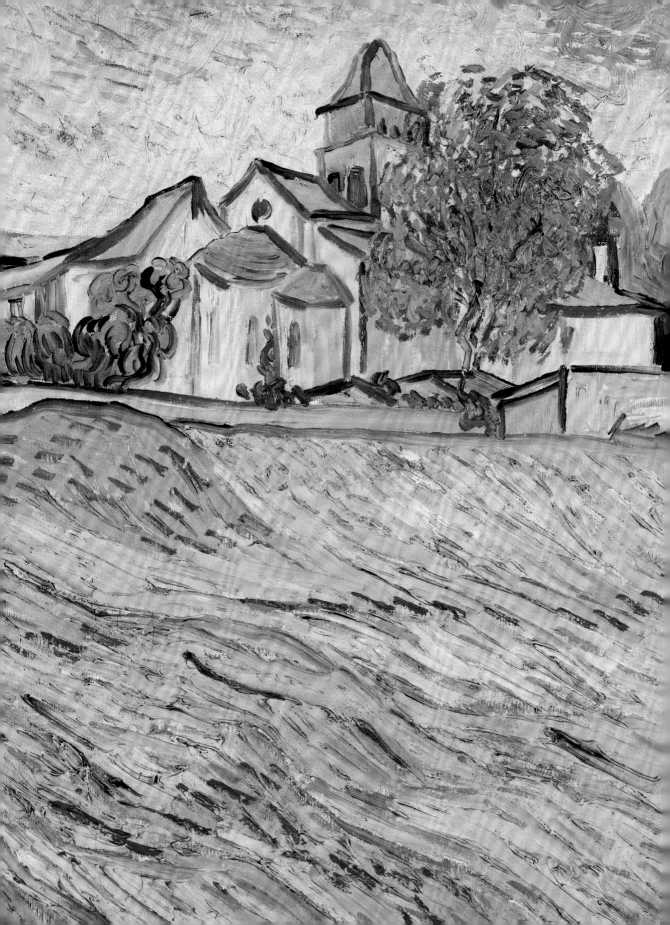

CHAPTER ONE

ARRIVAL

'It's possible that I'll stay here for quite a long time, never have I been so tranquil'[1]

Detail of fig. 33 *View of the Asylum and Chapel,* private collection

One spring morning two men could be seen stepping onto the platform at the railway station of Arles. The younger of the pair, the artist Vincent van Gogh, had come directly from the hospital where he had spent much of the past few months. The Yellow House, his home until the ear incident, was only three minutes' walk from the station, so he was a familiar face. However, since the night when he had mutilated his ear his neighbours had become increasingly hostile, adding to the pressure that accounted for the journey on which he was about to embark. In contrast, his travelling companion was a respected member of the community – the Protestant pastor, Reverend Salles.

It was on 8 May 1889 that the two men boarded the 8.51 train for the short journey to Tarascon, the next stop on the route to Paris. There they changed to a narrow-gauge train, which chugged through farmland to the market town of Saint-Rémy (fig. 12). Although only 15 kilometres, this ambling journey took almost an hour, as succinctly described by the writer Edouard Sayous later that year: 'Small station, small train, small speed, small distance – pleasant trip, delightful destination.'[2]

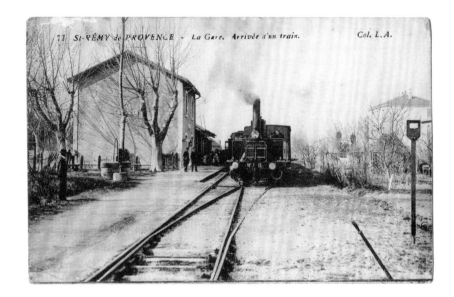

fig. 12 The Station, Arrival of a Train, Saint-Rémy, c.1905, postcard

On arriving, Van Gogh and Salles took a short ride by carriage to complete their journey. First, they were driven on the circular boulevard enclosing Saint-Rémy, giving the artist his first glimpse of a town which must have looked comfortingly quiet after Arles. Then they headed south, climbing past olive groves as the rugged outline of Les Alpilles rose into view. This alluring fertile landscape must have raised Van Gogh's spirits, helping to assuage the daunting prospect of what lay ahead. For this was not simply a rural excursion, but the delivery of the artist to an insane asylum.

One kilometre outside Saint-Rémy they arrived at the famed Roman monuments known as Les Antiques, the mausoleum tower of the Julii family and triumphal arch marking Caesar's conquest of the Gauls. These were a noted tourist attraction and a favourite subject for artists, local and international. Just a few months earlier they had been sketched by the American illustrator Joseph Pennell (fig. 13).[3]

The dramatic scenery around the Roman ruins is depicted in the background of a portrait of the Provençal writer and cultural leader, Frédéric Mistral, who had been painted by Félix Clément four years earlier (fig. 14). This picture shows the Roman monuments with the backdrop of the peaks of Les Alpilles (the asylum is near the left side of the landscape, but has just been cropped out). Mistral would return a few months before Van Gogh's arrival with a companion, the author Paul Mariéton. They visited the 'house for the mad' – and 'a few dazed eyes looked at us'.[4]

From the Roman monuments, the carriage with Van Gogh and Salles turned off on the short road lined with pines to the walled asylum, arriving just about

when the chapel's bell struck 11 a.m. Stopping at the gatehouse, they were probably greeted by the elderly concierge, Jean Résignier, who would later forge a bond with Van Gogh and is said to have received a drawing from him.[5]

At the gatehouse, a short avenue runs through the grounds of the former monastery of Saint-Paul-de-Mausole, named after a fifth-century Christian who had erected a place of worship near the Roman mausoleum. The monastery had been established in around 1000, with the earliest surviving parts of the cloister dating from the twelfth century. In 1605 the monastery was taken over by the Franciscans, who cared for the needy and the ill. After the French Revolution the property had been expropriated by the state and in 1807 it was bought by Dr Louis Mercurin, who

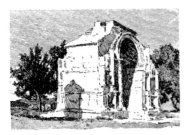

ROMAN REMAINS AT SAINT-RÉMY.

fig. 13 Joseph Pennell, *Roman Remains at Saint-Rémy*, September 1888, printed image, 3 x 5 cm

fig. 14 Félix Clément, *Portrait of Frédéric Mistral*, 1885, oil on canvas, 157 x 127 cm, Musée des Beaux-Arts, Marseille

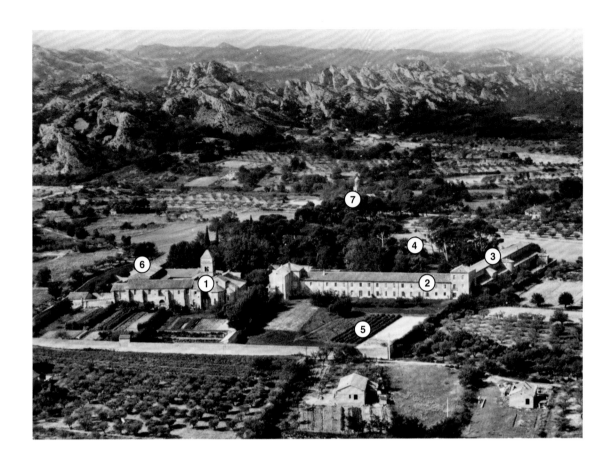

fig. 15 Aerial view of Saint-Paul, 1940s, postcard. This shows the monastic chapel (1), Van Gogh's former bedroom in the east wing (2), Van Gogh's former studio in the north wing (3), walled garden (4), former wheatfield (5), women's block (6) and Roman mausoleum tower (7), with Les Alpilles in the background and the town of Saint-Rémy (out of the view) to the right

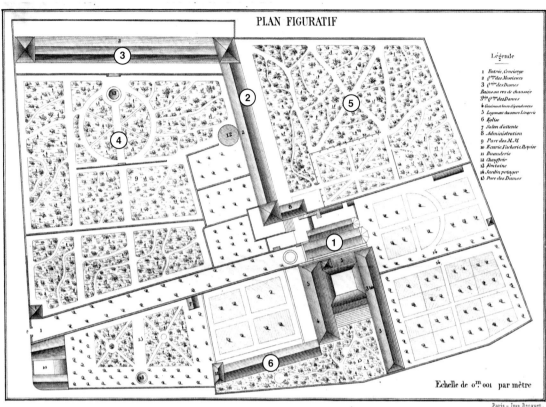

PLAN FIGURATIF

Légende

1 Entrée, Concierge
2 Q^res des Messieurs
3 Q^res des Dames
 Bains au rez de chaussée
3^bis Q^res des Dames
4 Cuisines et leurs dépendances
5 Logement des sœurs Lingerie
6 Église
7 Salon d'attente
8 Administration
9 Parc des M.M
10 Écurie Vacherie Remise
11 Buanderie
12 Chauffoir
13 Fontaine
14 Jardin potager
15 Parc des Dames

Echelle de 0^m 001 par mètre

Paris – Imp. Becquet.

fig. 16 Plan of Saint-Paul, 1866, engraving, 15 x 21 cm (see fig. 15 for numbers)

converted it into an asylum. The historic buildings were retained at the centre, with new blocks being constructed on either side for male and female patients (fig. 15).[6] An 1866 plan shows the layout of the asylum, including the L-shaped men's block (fig. 16[7]).

Salles and Van Gogh were taken to the director's office, in the building adjacent to the chapel, where they met Dr Théophile Peyron, who would play a key role in the artist's life over the following 12 months. The Protestant pastor immediately made it clear that his companion wished to be called Monsieur Vincent, since the French found the Dutchman's surname almost impossible to pronounce. The doctor, on his side, must have been relieved that his patient spoke excellent French, although with a strong accent.

Van Gogh looked haggard and rather older than his 36 years, since he had suffered much in life and the past few months had been extremely difficult. Dr Peyron presumably noted his mannerisms – the artist made quick gestures and walked with a jerky gait, and he would have been particularly nervous that morning.[8] The doctor must have been disturbed to see the scar in place of his left ear and he would certainly have worried about how his other patients might react to the sight.

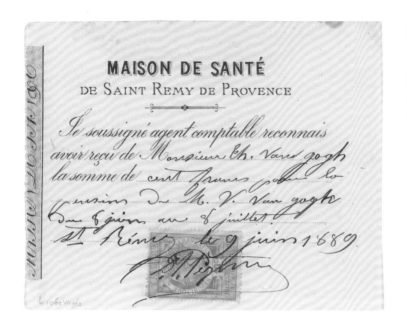

fig. 17 Receipt for 100 francs for the first month at Saint-Paul paid by Theo van Gogh, signed by Dr Théophile Peyron, 9 June 1889, 11 x 14 cm, Van Gogh Museum, Amsterdam (Vincent van Gogh Foundation)

But Dr Peyron, in this provincial backwater, would have been intrigued to have a well educated and travelled man who had lived in London and Paris – and who pursued a passionate vocation.

After the pleasantries, the pastor handed over Theo's letter formally requesting that his brother be admitted, as required under French law.[9] Theo also undertook to pay the fees for a third-class patient, at 100 francs a month (fig. 17).[10] First class cost 200 francs and second class 150 francs, but most patients, like Van Gogh, were in the lowest category.

Theo made two special requests in his letter. The first was that his brother should be given 'at least ½ litre of wine with his meals', presumably daily. This comes as a surprise, since Vincent sometimes felt that his problems had been exacerbated by alcohol. Inmates in French asylums were usually offered wine, although half a litre a day was considerably more than the normal allocation.[11] It is unclear whether Van Gogh actually drank this much, since a few weeks later he claimed to have observed 'absolute sobriety' in drinking.[12]

The other matter was very much more important: 'Since his confinement is requested primarily in order to prevent a recurrence of past crises, and not because his mental state is compromised at present, I hope you will have no objection to allowing him the freedom to paint outside the institution'. Without this concession, Vincent would have found life intolerable.

Salles felt the introductory meeting had gone well, as he reassuringly reported back to Theo: 'Mr Vincent was perfectly calm and explained his case to the director in person, like a man who is fully aware of his situation.' On parting, the artist 'thanked me warmly, and seemed somewhat moved at the thought of the entirely new life he was about to lead in this establishment'.[13]

In many asylums patients would have slept in dormitories, but fortunately Saint-Paul provided single bedrooms. Dr Peyron escorted Van Gogh to his room, which was sparsely furnished with an iron bed, an armchair and probably a table and chair. On entering, the artist immediately noted the iron bars on the window. Although these bars were restricting and oppressive, through the window he saw a breathtaking view which he would paint again and again during the coming months. Below his room lay a wheatfield, glowing yellow in the sunshine, and beyond this stretched silvery olive groves, a scattering of dark cypresses and the foothills of Les Alpilles. These were all subjects which Van Gogh would carefully observe and go on to capture in flowing lines and brilliant hues.

After the doctor's departure, Van Gogh unpacked his trunk, taking out his clothing, some books, stationery for writing and, most importantly, his art materials. Interestingly, he did not bring a single painting with him, having sent most of them to Theo and leaving a few behind with friends in Arles. It was as if he intended to make a fresh start artistically.

The following day Vincent wrote his first letter, jointly addressing Theo and Jo. He reassured them that he was now 'tranquil', feeling that he had made the right decision to come to Saint-Paul.[14] This must have reflected relief after weeks of indecision, rather than pleasure at being institutionalised.

That same day Van Gogh was given a thorough examination which was summarised in the asylum's medical register.[15] This represents the most detailed record of his medical condition. Dr Peyron had received a report from the Arles hospital, giving the necessary background.[16] After examining his patient, Dr Peyron wrote that a few months earlier Van Gogh had 'suffered an attack of acute mania with visual and auditory hallucinations that led him to mutilate himself by cutting off his ear'. The doctor then added: 'Today he appears to have regained his reason, but he does not feel that he has the strength or the courage to live independently and has himself asked to be admitted to the home'.

Dr Peyron recorded that Van Gogh was 'subject to attacks of epilepsy, separated by long intervals'.[17] The doctor concluded that 'it is advisable to place him under long-term observation'. After the consultation Vincent told Theo that 'madness' is 'an illness like any other' – presumably reflecting Dr Peyron's reassuring introductory words.[18]

ENCLOSED GARDEN

*'When you receive the canvases I've done in the garden you'll
see that I'm not too melancholy here'*[1]

Van Gogh had arrived at Saint-Paul at the most delightful time of the year. In May the flowers burst into bloom and the air grows warm, although not yet oppressively hot. Ever since childhood Vincent had loved nature, which provided an endless source of inspiration, and it was with great pleasure that he explored the large garden. It was there that he would spend many of his happiest hours during the asylum year.

The park – or garden, as Van Gogh more prosaically called it[2] – had been laid out in the early nineteenth century by Dr Mercurin, who held the progressive belief that walking and being surrounded by nature was therapeutic for troubled minds. Decades later, in 1872, the French doctor Alphonse Donné sang the praises of the asylum's grounds in a health guidebook. Apart from 'wild-looking faces', he wrote, visitors to Saint-Paul could fancy themselves in 'pleasure-gardens situated in the most wholesome locality' at the foot of Les Alpilles.[3]

Set on three gently rising levels, the garden had become rather overgrown by Van Gogh's time, with ivy covering the tree-shaded earth and creeping up the trunks of the pines. A full hectare in area, it was bordered by the L-shaped men's block and two stone walls, providing a secluded haven for the patients. Slightly wistfully, Vincent explained to Theo that as 'life happens above all in the garden, it isn't so sad'.[4]

On his first full morning in May 1889, the day after arriving, Van Gogh was already hard at work in this green retreat. His first two paintings were of irises and lilacs, both redolent of spring.[5] In *Irises* (fig. 18), the artist zoomed in on the transient beauty of the dramatic petals, with one prominent white bloom set among what originally was a sea of deep violet hues. Van Gogh achieved this rich colour by mixing blue and red, but the latter pigment has faded over the years,

Detail of fig. 26 *Garden
of the Asylum with
Dandelions and Tree
Trunks*, Kröller-Müller
Museum, Otterlo

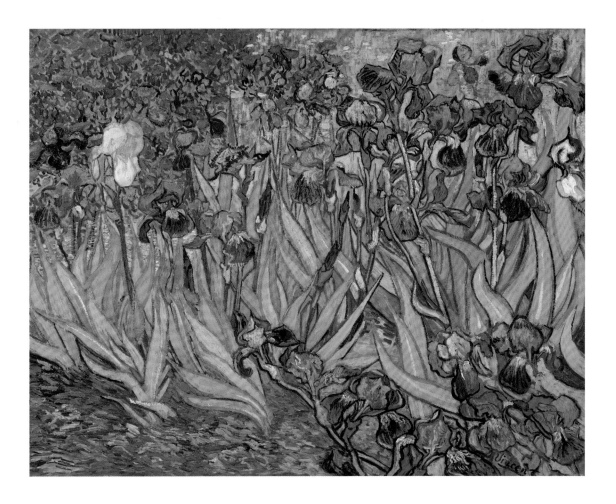

turning his formerly violet bearded irises blue. Beneath the luscious flowers the turquoise leaves form a marvellous swirling band. Irises were a favourite subject among Japanese artists, whose work Van Gogh greatly admired, and this may well have influenced his choice of subject.[6]

The other patients must have been astounded to see an artist set up his easel and produce these flower paintings at great speed. Fortunately, the men did not disturb him unduly, unlike his neighbours who had pestered him when he was painting near the Yellow House. Vincent reported back to Jo from Saint-Paul: 'They all come to see when I'm working in the garden, and I can assure you are more discreet and more polite to leave me in peace than, for example, the good citizens of Arles.'[7]

Only two other male patients were admitted in the year that Van Gogh was there, so the arrival of any new face broke the monotony of asylum life.[8] The fact that he was an artist – and a Dutchman too – can only have made him more intriguing

fig. 18 *Irises*, May 1889, oil on canvas, 71 x 93 cm, J. Paul Getty Museum, Los Angeles (F608)

fig. 19 *Garden of the Asylum*, May 1889, oil on canvas, 92 x 72 cm, Kröller-Müller Museum, Otterlo (F734)

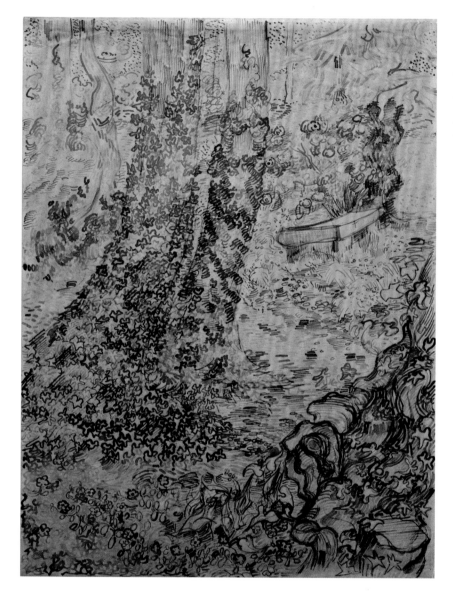

fig. 20 *Trees with Ivy in the Garden of the Asylum*, June 1889, pencil and ink on paper, 62 x 47 cm, Van Gogh Museum, Amsterdam (Vincent van Gogh Foundation) (F1522)

to people with few distractions. However, the scar in place of his left ear must have horrified his fellow patients, some of whom may initially have been reluctant to approach him.

Vincent 'spends the whole day drawing in the park', Dr Peyron reported back to Theo two weeks after his arrival.[9] *Garden of the Asylum* (fig. 19), another of the early works, shows the men's block partially framing the trees and garden. Van Gogh's bedroom was in the east wing (the building straight ahead in the painting) and he was given a second room for his studio in the north wing (on the left). The

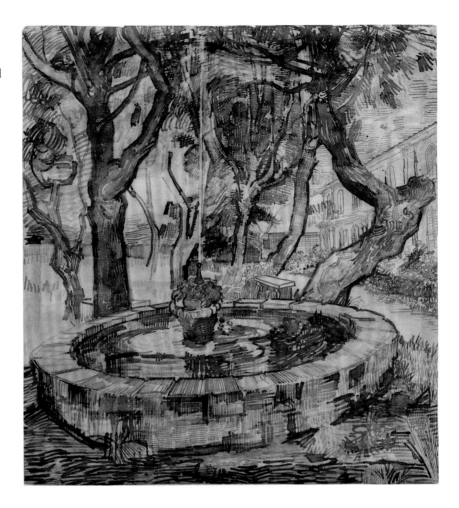

fig. 21 *Fountain in the Garden of the Asylum*, May–June 1889, chalk and pen and ink on paper, 50 x 46 cm, Van Gogh Museum, Amsterdam (Vincent van Gogh Foundation) (F1531)

dense trees appear to crowd around the block, creating a verdant although slightly claustrophobic effect. Pleased with the painting, the artist signed it in a corner – one of only seven pictures from Saint-Paul with his signature.

Although Van Gogh loved the garden, he acknowledged that it had seen better days. Describing it as neglected, he wrote to Theo about the pines 'under which grow tall and badly tended grass intermingled with various weeds'.[10] He conjured up this wild atmosphere in *Trees with Ivy in the Garden of the Asylum*[11], his most important painting of the scene, focusing on the dark leaves weaving around the pines. Van Gogh had always loved ivy, which he felt created a striking, albeit sombre mood. Over the coming months he went on to paint a number of atmospheric views of undergrowth, a popular subject among artists of his time.

Trees with Ivy in the Garden of the Asylum came close to being the first of Van Gogh's Provençal works to sell. Julien (Père) Tanguy, the Parisian paint seller

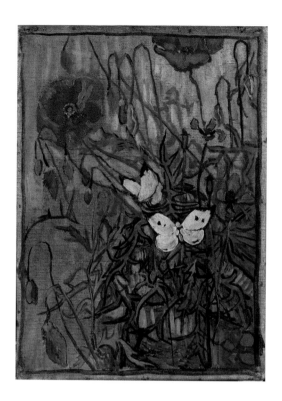

fig. 22 *Butterflies and Poppies*, June 1889, oil on canvas, 35 x 26 cm, Van Gogh Museum, Amsterdam (Vincent van Gogh Foundation) (F748)

fig. 23 *Pine Trees in the Garden of the Asylum*, September–October 1889, oil on canvas, 90 x 73 cm, Hammer Museum, Los Angeles (F643)

and part-time art dealer, told Theo in December 1889 that he was hoping to make a sale, but it was never finalised.[12] The picture was to become a particular favourite of Jo, who became completely absorbed in its atmosphere when it was displayed in an exhibition in Paris a few months later: 'I spent a quarter of an hour enjoying the wonderful coolness and freshness of the undergrowth – it's as if I know that little spot and have often been there – I love it so much.'[13]

Despite Jo's attachment to the painting, it was sold by Tanguy the following year. Decades later it was acquired by the Paris-based Baron de Rothschild family, but was then looted by the Nazis during the Second World War. Last seen being admired by Hitler's deputy, Hermann Göring, it disappeared.[14] This lost Saint-Paul work is recorded in a rather faded drawing done for Theo (fig. 20).

Reinvigorated by his new surroundings, Van Gogh channelled all his efforts into working in the garden and two weeks after his arrival he had finished nearly all the paints and canvas he had brought from Arles. While awaiting fresh supplies from Paris, he took to drawing in ink. Among the resulting works is *Fountain in the Garden of the Asylum* (fig. 21), depicting the round basin which lay just outside the doorway of the men's block (visible in a photograph taken from indoors, see fig. 2). Theo, who regarded this as his brother's 'most beautiful' drawing, must have have been delighted to receive an image which could have been a scene from an elegant pleasure garden rather than an insane asylum.[15]

As Vincent told his sister Wil, he sometimes felt 'obliged to go and gaze at a blade of grass, a pine-tree branch, an ear of wheat, to calm myself'.[16] Among his garden paintings were four close-ups of nature. The most striking, *Butterflies and Poppies* (fig. 22), shows two large scarlet flowers set against a patterning of complementary greens.[17] A pair of fluttering yellow butterflies, looking almost like flowers, really bring the picture to life. The artist left much of the unprimed ochre canvas unpainted, adding a rustic touch to the

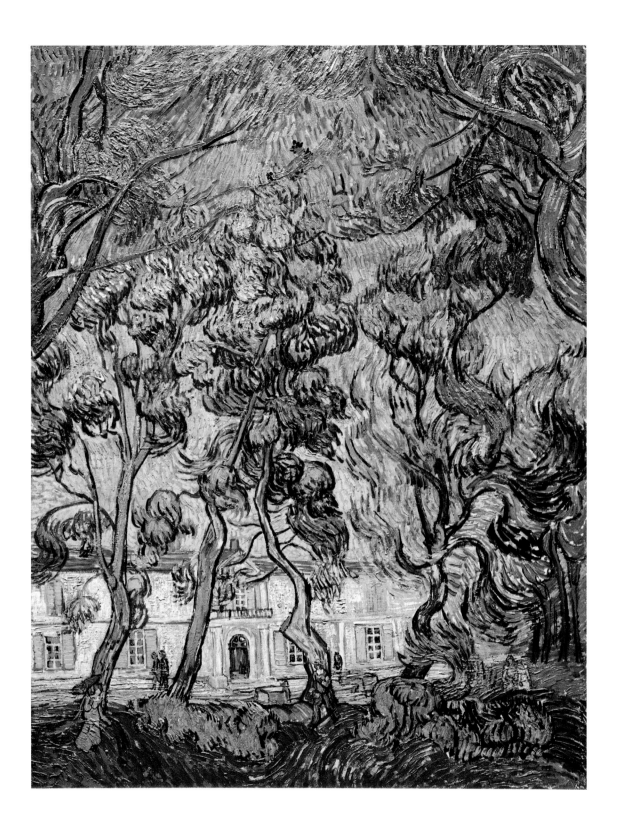

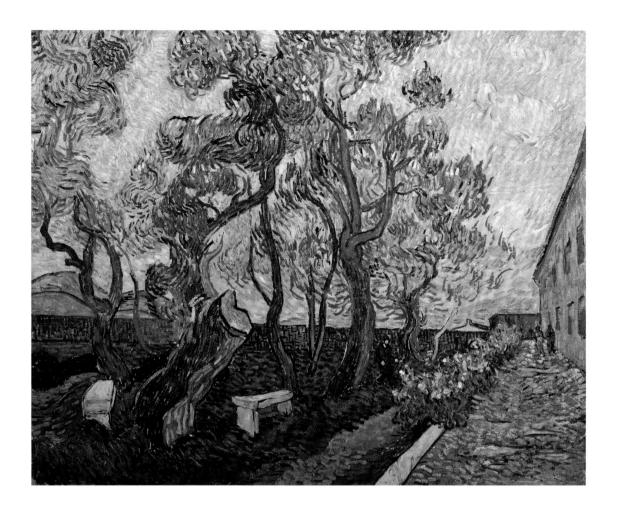

composition, which is enclosed within a painted green border. These nature studies were clearly inspired by Japanese art and, in particular, the work of Katsushika Hokusai, who had once painted a single blade of grass which won the admiration of Van Gogh.[18]

Throughout his stay, Van Gogh would continually return to the garden for inspiration. The vertiginous *Pine Trees in the Garden of the Asylum* (fig. 23) captures the drama of nature in this confined setting. The artist appears to have been lying on the ground, staring up at the lofty overhanging branches. Painted with great verve, the warm yellowy stone of the men's block contrasts with the strong blues of the sky, ranging from turquoise through to ultramarine. Several men, presumably patients, stroll through the grounds, while a graceful woman with a red parasol appears among them, a surprising flourish since the nursing Sisters were the only females normally allowed in the men's garden. The man in the middle, striding towards the woman, might even be the artist himself, in his straw hat and working clothes.

fig. 24 *A Corner of the Asylum Garden*, November 1889, oil on canvas, 74 x 92 cm, Folkwang Museum, Essen (F660)

fig. 25 *Trees in the Garden of the Asylum*, September–October 1889, oil on canvas, 64 x 59 cm, private collection (F640)

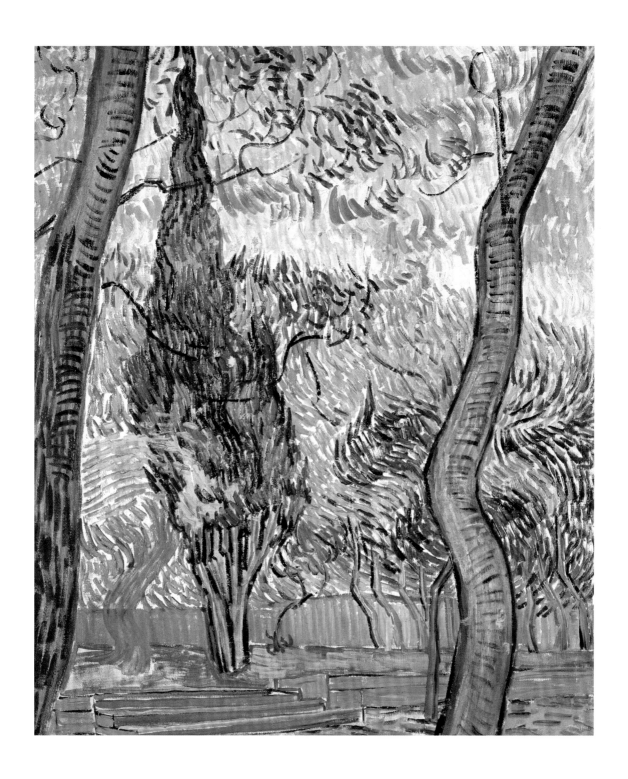

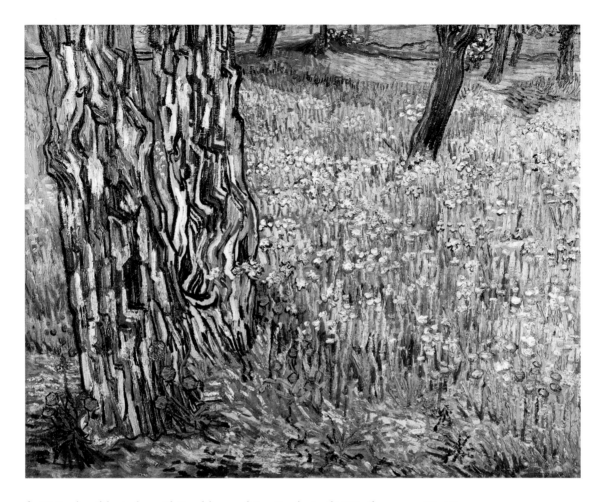

fig. 26 *Garden of the Asylum with Dandelions and Tree Trunks*, April 1890, oil on canvas, 73 x 92 cm, Kröller-Müller Museum, Otterlo (F676)

A Corner of the Asylum Garden (fig. 24), which includes the facade of the men's block viewed from the paved terrace, was completed a few weeks later.[19] The thick trunk of the nearest pine, which obviously caught Van Gogh's eye, had been cut fairly low down after being struck by lightning. Although painted in the late autumn, the row of rose bushes are still flowering. Strolling through the garden are several of Van Gogh's fellow patients, whom he described to his friend Emile Bernard as being in a state of psychological agitation – writing that they are 'seeing red'. Beyond the garden lies the garden wall, which Van Gogh pointedly noted 'blocks the view', with the colourful evening sky illuminated by the sun's 'last glimmer'.[20]

This scene beneath his studio window was strongly symbolic for Van Gogh, reflecting his own state of mind. He described the aged and damaged pine as a 'dark giant – like a proud man brought low', contrasting it with 'the pale smile of the last rose on the bush, which is fading in front of him'.[21] The tree will presumably survive the winter, and although the flowers will die, the rose bush should produce new growth in the spring. As always, the artist was sensitive to the effects of the changing seasons and the passage of time.

Another highly atmospheric painting, *Trees in the Garden of the Asylum* (fig. 25), shows a cypress framed by two stark trunks bent by the strong mistral wind. The background clump of trees forms a swirling, almost abstract pattern. This strong composition was inspired by Japanese prints, which often feature abrupt cropping of trees. Van Gogh was a great admirer of the artists of Japan and he collected several hundred woodblock prints, which he always treasured. Japanese prints must have seemed astonishingly bold and exotic to European eyes.

Garden of the Asylum with Dandelions and Tree Trunks (fig. 26) is one of Van Gogh's final works from his walled retreat. A spring scene, painted nearly a year after his arrival, its mass of budding flowers brilliantly captures the garden bursting into fresh life. This bold composition, from which the sky has been cropped out, is framed by stylised pine trunks with dramatic bark. A glimpse of a path is just visible at the top of the picture.

Van Gogh made a rough sketch of the painting in one of his last letters to Theo from the asylum, evidence that he considered it a success. In the accompanying text, he described it as 'the trunk of a pine tree violet pink, and then grass with white flowers and dandelions, a little rose bush and other tree-trunks in the background'.[22] Once again Van Gogh's violet has faded to blue.

The garden of Saint-Paul represented a haven of escape, a retreat where he could temporarily forget his institutionalised condition. Van Gogh would spend countless hours here – enjoying the soothing effect of being in the open air among the trees and flowers that were his passion, and turning them into some of his most glorious canvases.

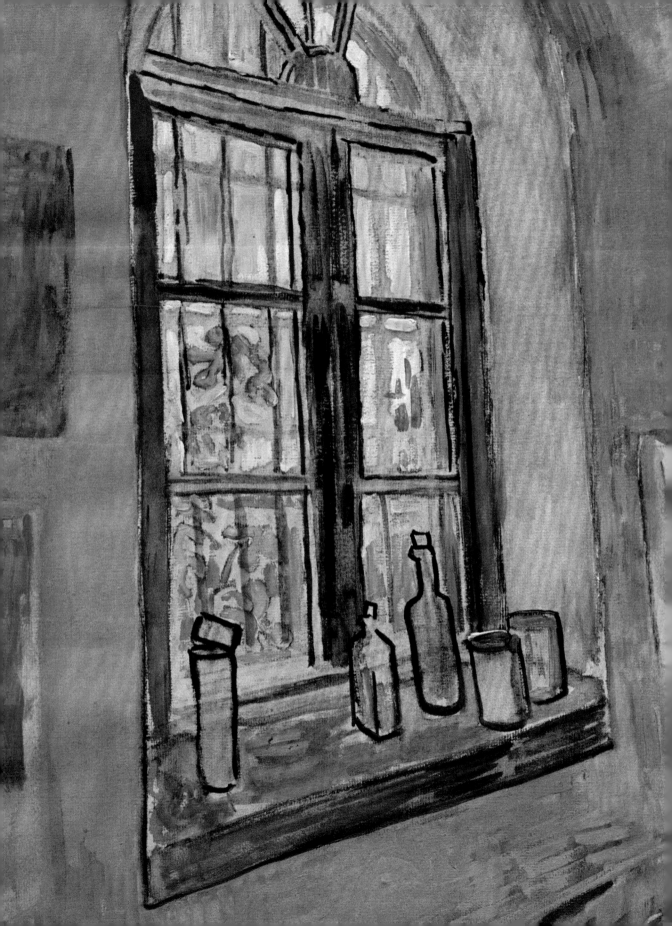

CHAPTER THREE

LIFE INSIDE

'It would be magnificent to hold an exhibition... all the empty rooms, the big corridors'[1]

Soon after settling into the asylum, Vincent used his artist's eye to describe his bedroom to Theo: 'I have a little room with grey-green paper with two water-green curtains with designs of very pale roses enlivened with thin lines of blood-red. These curtains, probably the leftovers of a ruined, deceased rich man, are very pretty in design. Probably from the same source comes a very worn armchair covered with a tapestry flecked in the manner of a Diaz or a Monticelli.'[2] Van Gogh was referring to two French nineteenth-century painters he admired, Narcisse Diaz and Adolphe Monticelli.

Reading was so important to the artist and the well-worn armchair provided a comfortable place for him to settle down with his astonishingly wide range of literature. Highly literate, he knew four languages: French, German and English, along with his native Dutch. Among the books he brought with him from Arles, or were sent by his family, were French novels by Voltaire, the Goncourt brothers, Alphonse Daudet and Emile Zola, as well as plays by the Norwegian Henrik Ibsen translated into German.

At Saint-Paul Van Gogh even read the complete works of Shakespeare in their original English, no mean feat. Theo sent him a one-volume compilation of just over 1,000 pages, with Vincent responding that 'it will help me not to forget the little English I know – but above all it's so beautiful'. He added that 'what touches me' in Shakespeare is that voices 'reach us from a distance of several centuries'.[3] Having gone back to the Bard, he then wanted to tackle Homer. Few of Van Gogh's fellow patients, or even the employees, would have considered reading the translated poetry of the ancient Greeks.

Although the asylum did boast a library for the patients, this probably housed lowbrow volumes and religious tracts placed there by the Sisters. Theo would occasionally send books and magazines.[4] However, it must have been difficult to find appropriate reading material to while away the hours.[5]

Vincent would also write to his brother from his bedroom. It is often assumed that they corresponded very frequently, but there are only 36 letters from Vincent to Theo, who was reasonably assiduous in saving them. Vincent was unable to write

Detail of fig. 28 *Window in the Studio*, Van Gogh Museum, Amsterdam (Vincent van Gogh Foundation)

fig. 27 *Studies of a Window and a Foot*, March-April 1890, black chalk on paper, 24 x 32 cm, Van Gogh Museum, Amsterdam (Vincent van Gogh Foundation) (F1605v)

fig. 28 *Window in the Studio*, probably September–October 1889, black chalk and diluted oil on paper, 62 x 48 cm, Van Gogh Museum, Amsterdam (Vincent van Gogh Foundation) (F1528)

when ill, so this represents around a letter a week from Saint-Paul when he was in good health. This was not all that often considering that Vincent had time on his hands in the evenings and correspondence was his main contact with the outside world. Theo, who was very busy in Paris, wrote roughly once a fortnight.[6]

While relaxing in his room Van Gogh also conceived many of his paintings – he was always thinking ahead, hatching future projects. As he had written from the Yellow House, 'the most beautiful paintings are those one dreams of while smoking a pipe in one's bed'.[7] It was there, in the evenings, that he would think back on what he had achieved that day – and plan how he would continue the next morning.

Van Gogh's bedroom was in the east wing of the men's block, overlooking the wheatfield that was to become one of his favourite motifs (fig. 15). Since the field is usually depicted from an elevated position, his room must have been on the upper floor. Most of the paintings of the wheatfield include a section of its left wall, suggesting that the bedroom was located towards the far end of the wing, away from the chapel.[8]

The only visual evidence Van Gogh left of his bedroom are two casual sketches of the window (fig. 27).[9] The artist has emphasised the oppressive iron bars, forcefully rendering them with heavy lines. On this sketchbook page he also included two curious depictions of a man's foot and shoe, presumably his own. This sheet probably dates from when he was ill and confined to his room.

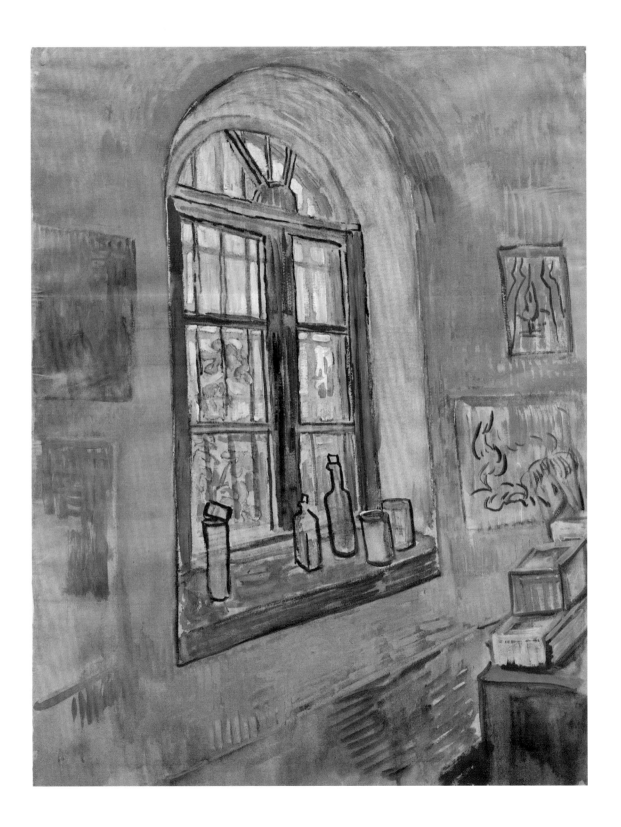

Façade d'une partie du quartier des Messieurs.

fig. 29 Facade of the men's block, north wing, 1866, print, 7 x 11 cm

fig. 30 *Vestibule in the Asylum*, probably September–October 1889, black chalk and diluted oil paint on paper, 62 x 47 cm, Van Gogh Museum, Amsterdam (Vincent van Gogh Foundation) (F1530)

Van Gogh was fortunate to be allocated a second room for his studio, in the north wing. As he told Theo soon after arriving, 'there are more than 30 empty rooms – I have another room in which to work'.[10] It was to this sanctuary, which overlooked his beloved garden, that he could retreat when he wanted to paint indoors. A few months later Vincent told his mother Anna: 'I work almost without stopping from morning till night, day after day, and I lock myself up in the studio to have no distractions.'[11]

The artist invites us to step inside this room in *Window in the Studio* (fig. 28), its subject emphasising Van Gogh's tenuous link with nature and the outside world. Surprisingly, the window is firmly closed, although in October, when it was painted, the temperature would normally be as pleasant as the blue sky suggests. Perhaps a mistral was blowing and had kept him indoors or possibly he wanted to underline his feeling of separation from outside life. Whatever the reason, the mood of the interior, with its ochres and greys, contrasts with the lively colours beyond the panes.

Van Gogh's sparsely furnished studio probably contained just a table and single chair, along with his easel. On the windowsill stand bottles and pots, some presumably with turpentine for diluting oil paint and cleaning brushes. These objects must have been deliberately arranged for the painted scene, since the inward-opening window would have made it impractical to store anything on the sill. On the table are more artists' materials: two boxes, probably for paint tubes, with a taller receptacle for brushes.

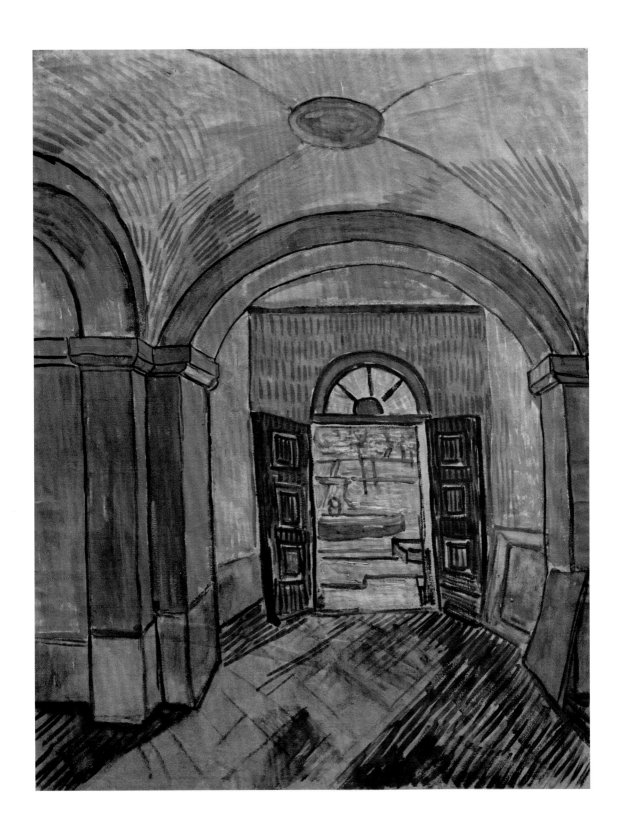

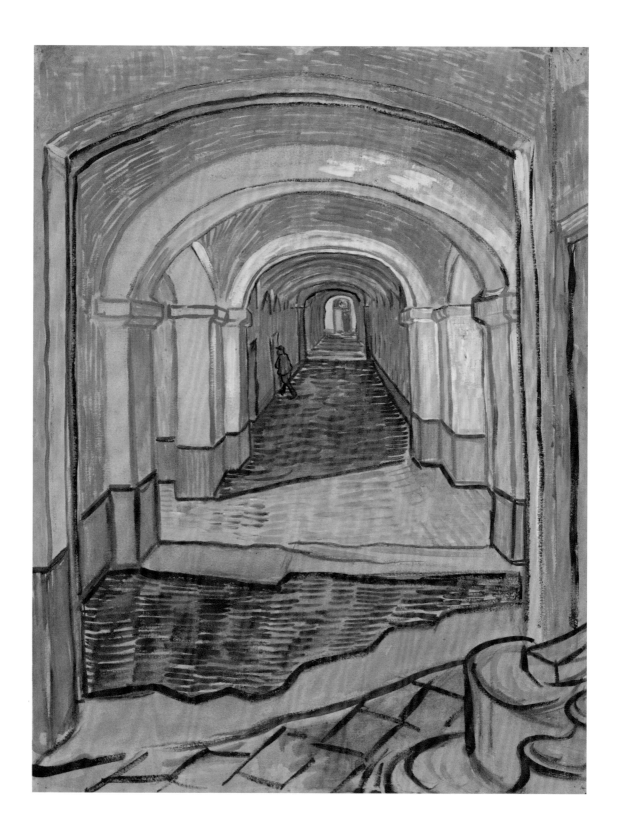

Four of Van Gogh's works hang on the wall, with the two on the right apparently framed.[12] The upper framed picture depicts two tree trunks on either side of a cypress, most likely *Trees in the Garden of the Asylum* (fig. 25). The lower one is probably his *Starry Night* (fig. 49), with the rough lines suggesting the twisting cypresses on the left, the curved shaded area on the lower right side Les Alpilles, the five streaks in the middle of the sky the spiralling cloud and the curved mark in the upper-right corner the moon. The relative sizes of *Trees in the Garden of the Asylum* and *Starry Night* are consistent with the two framed works.

Specialists at the Van Gogh Museum recently stated that the artist's studio was on the ground level of the men's block[13], but clues within this painting show that it was on the upper floor (fig. 15). The sky fills half of the view through the window, whereas a ground-level perspective would have been almost entirely obscured by greenery. The most compelling evidence for the higher location is the window, which is three panes high, with a rounded top. This was the configuration on the upper level, whereas the ground floor windows were taller, with four panes beneath the rounded top (fig. 29).[14] An upper floor room would also have been much better for an artist, because of its stronger light, and would have provided more of a view into the garden.[15]

Along with *Window in the Studio*, Van Gogh made two other paintings of the asylum's interior. Until recently it was assumed that these were all watercolours, but conservators have now discovered that they were made from diluted oil paint.[16] These works are not mentioned in Vincent's correspondence with Theo, which strongly suggests that they remained with the artist and were not, as some specialists have suggested, sent to his brother to give him an idea of what the asylum was like.[17] Perhaps they were preliminary studies for oil paintings which were never completed or else they may have originally been conceived as gifts for staff, but never given.

Since the trio of interior views are unrecorded in the letters, it is difficult to date them, although the colouring suggests that they could well have been done in the early autumn, when he was frequently using ochres. Van Gogh had run out of canvas by 8 October and did not receive fresh supplies until the 24th, indicating a possible mid-October date for these works on paper.[18]

In contrast to his intimate studio picture, *Corridor in the Asylum* (fig. 31) sweeps down the full length of the ground floor of the north wing.[19] In the bottom-right corner is the base of the staircase leading to the upper level, where Van Gogh had his studio. A man, most likely a fellow patient, turns to enter one of the rooms overlooking the garden. But the painting's most striking feature is the sheer length of the corridor, which was 100 metres long. Although this tunnel-like feature may appear oppressive, it sparked off an intriguing thought in Van Gogh's imagination. If it were possible to move the building somewhere else, he wrote, its 'big corridors' would make a magnificent place to exhibit art.[20]

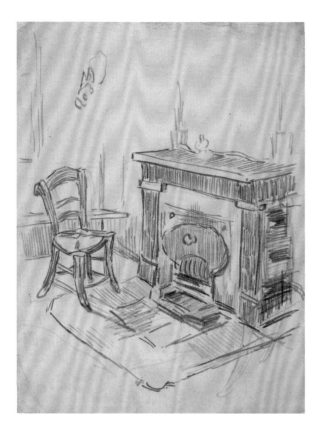

fig. 32 *Chair by a Fireplace*, April–May 1890, pencil and black chalk on paper, 33 x 25 cm, Van Gogh Museum, Amsterdam (Vincent van Gogh Foundation) (F1511)

Half way down, the corridor opened out into the hall depicted in *Vestibule in the Asylum* (fig. 30), with its view towards the external door and the circular fountain beyond (fig. 21). Just inside, leaning on the right wall, is a framed painting in greenish tones, suggestive of a garden landscape. Under the arch is either a drawing portfolio or, more likely, an unframed painting. The inclusion of these artworks may reflect Van Gogh's notion of hanging pictures on the spacious corridor walls.

Along with these ambitious interior paintings, Van Gogh also made a more modest sketch of a corner of a room. *Chair by a Fireplace* (fig. 32) probably represents the common room just off the vestibule to the right. Known as a *chauffoir* (a heated communal area), it was one of the few comfortable places to escape the winter chill. Van Gogh's drawing shows a solitary chair beside the stove, with part of another chair very lightly drawn in pencil on the right side. On the mantelpiece stands a small paraffin lamp, which would have provided a little light in the evenings, and to the left is a window, with a bench built into the wall below. This poignant scene, bereft of human life, can be identified from a 1920s description of the common room as 'surrounded by benches fixed to the wall, lit by windows overlooking the garden'.[21]

fig. 33 *View of the Asylum and Chapel*, autumn 1889, oil on canvas, 45 x 60 cm, private collection (F803)

Surprisingly, Van Gogh made only one picture of the exterior of Saint-Paul, *View of the Asylum and Chapel* (fig. 33). Setting up his easel in the wheatfield below his bedroom, he turned to face the wall in front of the bell tower and the buildings nestling all around. Even by Van Gogh's time the monastic chapel and cloister had become a visitor attraction, but its ancient architecture hardly caught the attention of the artist, who only painted the scene from some distance.

View of the Asylum and Chapel went on to have an eventful history, having been acquired in 1963 by Elizabeth Taylor, who sometimes hung it in her yacht Kalizma, which was moored on the Thames in London. The painting was later subject to a Nazi-era spoliation claim from the descendants of the German Jewish collector and writer Margarete Mauthner, who had edited an early volume of Van Gogh's letters and owned the picture until the 1930s. Mauthner's heirs argued that *View of the Asylum and Chapel* had been subject to a forced sale under the Nazis, but the US Supreme Court later dismissed their claim. The painting was eventually sold by the film star's estate in 2012, going for £10 million.[22]

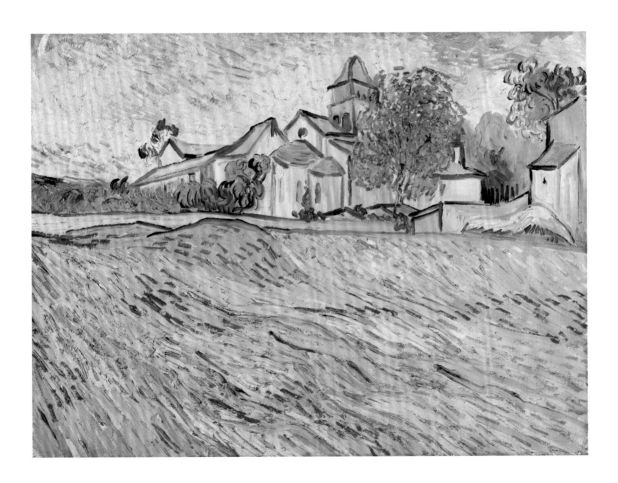

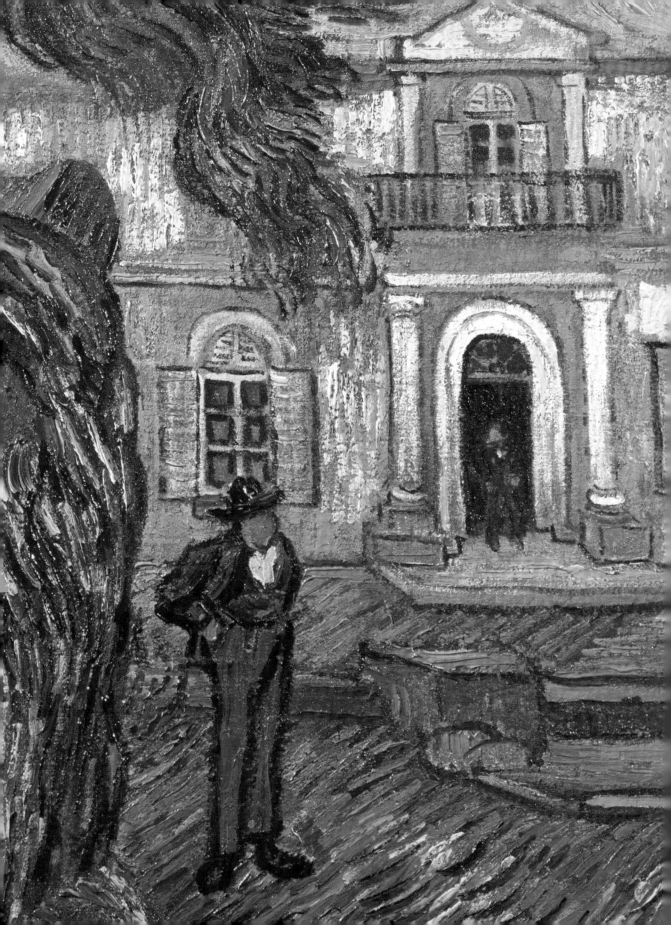

ALIENISTS

*'How much more practical and solid are the ideas of doctors... than
those of artists'*[1]

Saint-Paul had become known as one of the most progressive asylums in France
by the mid-nineteenth century. Some of the innovations of its founder Dr Louis
Mercurin now seem surprisingly modern, especially his creation of a spacious
garden to give patients access to nature and the use of music and dance as therapy.[2]
Dr Mercurin was himself a lover of the visual arts and was reputed to be 'as good
an artist as a distinguished doctor', although sadly none of his pictures survive.[3] In
a fictionalised, but barely disguised account of Saint-Paul, a writer described the
doctor's home as having walls 'decorated with paintings' and his sitting room filled
with books, musical instruments and vases of flowers.[4]

The asylum even featured in verses on the memorable places of Provence. The
poet André Thévenot described Saint-Paul as 'a new Bedlam', a complimentary
reference to London's Bethlem Royal Hospital, which had recently moved to
modern premises. In his poem, the author recalls meeting a female patient with a
beautiful voice who laughed and sang. Thévenot wrote lyrically: 'The mad, who I
love – we converse together under the blossoming almond tree, the cypress.'[5]

But despite Dr Mercurin's attempt at creating a pleasant and even cultured
environment, the science of psychiatry was still in its infancy and little was understood
about mental illnesses and their treatment. The relatively small number of specialists
in this field were then known as alienists, who cared for the insane (*les aliénés*).

After Dr Mercurin's death in 1845 his descendants inherited the privately owned
asylum, but it then began to fall into decline.[6] In 1874, when the French government
commissioned a national survey of asylums, an inspector visited Saint-Paul, finding
that with dwindling resources standards had fallen. Food, for instance, was 'mediocre
with little variety'. Far more distressing is the horrific revelation that the straw of the
mattresses of the senile demented patients was 'literally reduced to manure'.[7]

Dr Théophile Peyron had been brought in as the new director in 1874, a few
months before the inspection. Van Gogh writers have suggested that as Peyron had
previously been a naval doctor and later an oculist in Marseille, he was ill-equipped
to head an asylum.[8] However, some three decades earlier he had written his thesis
on paralytic dementia, which is linked to syphilis.[9]

Detail of fig. 34 *View of the
Asylum with a Pine Tree*,
Musée d'Orsay, Paris

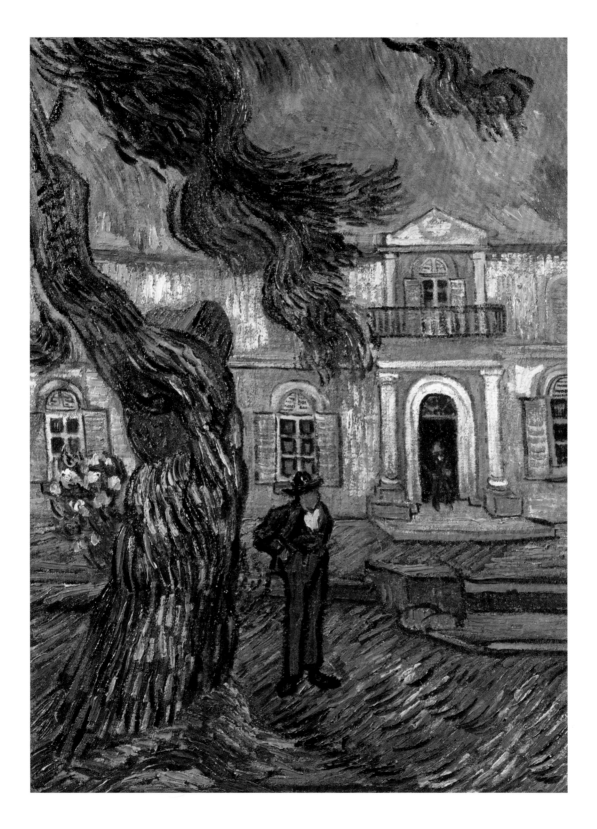

The task of improving conditions at Saint-Paul proved a considerable challenge. In 1884, five years before Van Gogh's arrival, Dr Peyron became the subject of an abusive book entitled *Dix Lettres d'un Aliéné* (Ten Letters from an Insane Person). Although the title page of what is now an extremely rare publication bears no name, its author was Edouard Viry, a former civil servant who had been held at Saint-Paul for a year.[10] His litany of complaints includes a claim that he was moved around the asylum in a wheelbarrow.[11] The book contains nine letters from Viry, with 10 replies from Dr Peyron – so Viry's title is not referring to himself, but mocking the doctor, whom he accuses of being insane.

Fortunately Van Gogh found Dr Peyron to be very much more caring. Initially the artist was slightly critical, complaining that as the asylum was 'a little moribund, the man appears to take only a rather half-hearted enjoyment in this profession'.[12] However, their relationship soon warmed and on six occasions Van Gogh describes him as 'kind'. In two other letters the artist called the 61-year-old doctor Père (father) Peyron, a respectful term for an older, wise man.[13] The doctor kept Theo informed of his brother's progress in monthly letters and took time off to visit him while on a short trip to Paris to see the Exposition Universelle and the newly erected Eiffel Tower.[14]

Van Gogh never painted a portrait of Dr Peyron, who declined to sit for him, but the doctor does feature in *View of the Asylum with a Pine Tree* (fig. 32), as the smartly dressed elderly man standing proprietorially in front of the north wing. Van Gogh described him as 'a little gouty man – widowed a few years ago – who has very dark spectacles'.[15] By '*petit*' (little), he must have meant short, since Viry wrote scathingly of the doctor's 'enormous stomach', which is also visible in the painting.[16]

The artist gave *View of the Asylum with a Pine Tree* to Dr Peyron, although he is said to have 'loathed' it.[17] Van Gogh may well have presented him with other works. The doctor's son Joseph later claimed that when he was 20, he and a friend had used a group of Van Gogh paintings for 'target' practice.[18] The friend was Henri Vanel – who became a clockmaker, photographer and amateur artist and who also apparently owned a number of Van Goghs.[19] This story may well be apocryphal, but it does show the negative attitude in Provence towards Van Gogh's work in the early twentieth century. One picture which Joseph did save was *View of the Asylum with a Pine Tree*, presumably because it depicted his father, and he later gave it to a local writer, Marie Gasquet.[20] The painting survived relatively unscathed, and is now safely ensconced in the Musée d'Orsay in Paris.

Gasquet later wrote that she believed that around 20 paintings had been left behind on Van Gogh's departure, but hers is the only one which seems to have survived.[21] She probably sold *View of the Asylum with a Pine Tree* in the 1910s. Since then none of the artist's paintings have remained in the Saint-Rémy area.

Along with Dr Peyron, Van Gogh was overseen by a second doctor, since French

fig. 37 *Farmhouse among Olive Trees*, December 1889, oil on canvas, 70 x 60 cm, private collection (F664)

fig. 38 Jean-François Poulet (lower right) with friends, 1888–90, photograph by Duval, Saint-Rémy, Musée Estrine, Saint-Rémy

law governing asylums required that new arrivals needed to be checked by both a resident medical director and another physician. Fifty-year-old Dr Paul Mercurin, a descendant of the founder's family, was the other. Alluding to him in a letter, Van Gogh noted that a second doctor had told him of a case when someone had, as the artist put it, 'injured his ear'.[22]

Although Dr Peyron supervised the asylum, Van Gogh's day-to-day contact was with the orderlies, who were responsible for non-medical matters. Their supervisor, 58-year-old Charles Trabuc, had previously cared for cholera victims during a serious outbreak in Marseille in 1884–85. 'He's a man who has seen an enormous number of people die and suffer, and there's an indefinable contemplation in his face', Vincent wrote movingly to Theo.[23] In September Van Gogh painted portraits of Charles Trabuc and his wife Jeanne (figs. 35 and 36). Clad in his best clothes, the chief orderly appears stern and resolute, reflecting the authority of his position. Van Gogh described him as having 'something military about him, and dark eyes that are small and lively'.[24]

Jeanne, portrayed by Van Gogh in dark clothing decorated with a pink geranium, comes over as a very different character. Although he believed that she was 'forty or more', she was actually 55. Describing Jeanne as 'faded and tired, pockmarked, an olive-tinged, suntanned complexion, black hair', Van Gogh said she was 'an unfortunate, quite resigned'.[25]

Although the portraits of Charles and Jeanne are the same size, they fail to work as a conventional pair. Traditionally, separate husband and wife figures would turn slightly to face each other. These, however, not only look in different directions, but Jeanne also stands further away from the artist and Charles is clearly seated. The original portraits, which Van Gogh gave to the couple, have disappeared, possibly after Jeanne's death in 1903. The two which survive are copies that the artist made for Theo.[26]

Charles and Jeanne lived in 'a little farmhouse a stone's throw' from the asylum, which is believed to be depicted in *Farmhouse among Olive Trees* (fig. 37).[27] It lay just off the road to Saint-Rémy, near the Roman monuments and in the grounds of what is now the Villa Glanum hotel. Van Gogh would sometimes paint among these olive trees, taking the opportunity to converse with Jeanne. Apart from the Sisters, she must have been one of the few women with whom Van Gogh would talk. 'She didn't think that I was ill', he told Theo, 'anyway, you would say that too at present if you saw me working'.[28]

Van Gogh also got to know Jean-François Poulet, the 25-year-old carriage driver at Saint-Paul, who often accompanied the artist on his excursions outside the asylum. In an unpublished photograph of the time, Poulet is shown with three friends (together with what must be a stuffed dog, since a live one would not have remained still enough for a long exposure) (fig. 38).[29] In January 1890 Van Gogh wrote that he had done 'a little portrait of one of the lads from here which he wanted to send to his mother', and Poulet was probably the sitter.[30] The young man's mother may not have appreciated Van Gogh's picture of her son, which could explain why it is now lost.

Decades later Poulet recalled that he often took 'Monsieur Vincent' outside the asylum to paint, but when it was time to return, the artist always seemed annoyed. He remembered Van Gogh being dressed in workmen's clothes, looking like a tramp. The artist never laughed, probably never smiled and spoke slowly, with a strong accent. Poulet recalled Van Gogh as 'a good fellow, though he was strange and silent', but 'when he was painting he forgot his suffering'.[31] Poulet himself lived until the age of 90, dying at Saint-Paul in 1954.

Thanks to Poulet, it is now finally possible to name the sitter in Van Gogh's greatest portrait from his asylum year (fig. 39). It shows a lively young man with a friendly expression, dressed in bright clothing and standing confidently in a verdant glade. The setting is the garden of the asylum, with a slightly raised area at the back and the rear wall. It has always been assumed that the young man worked at Saint-Paul, and until now he has been variously described as a gardener, farmer, peasant, reaper or harvester.[32]

The gardener is identified in an unpublished note recording the memories of Poulet's grandson, Louis, who knew his elderly grandfather well. The young man in Van Gogh's portrait can therefore now be named as Jean Barral.[33] Further

fig. 40 Abbot Eugène de Tamisier, 1880s, photograph by A. Arnaud, Digne, author's collection

research shows that Jean was born in 1861 on a cart owned by his father, a travelling basket-maker from the village of Eyragues, just north of Saint-Rémy.

Jean was 28 when Van Gogh was at the asylum, which accords well with the youthful appearance of the man in the portrait. When Jean had married in Saint-Rémy two years earlier, he had given his profession as *cultivateur* (farmer), which helps explain the portrait's traditional title.[34] As well as cultivating farmland, it is quite possible that he also worked as a part-time gardener at Saint-Paul, in which case he would frequently have seen the artist painting. Van Gogh is said to have painted portraits of the gardener's parents, Jean Pierre and Marguerite Barral, but these are lost.[35] The surviving version of the young man's portrait was later stolen from Rome's Galleria Nazionale d'Arte Moderna by gunmen in 1998, but it was recovered by the Carabinieri art squad a few weeks later, hidden wrapped up in a blanket underneath a bed in a nearby apartment.

In his portrait, Jean looks the epitome of youthful optimism, but tragedy was to hit him. On 10 May 1890 his wife had their first child, a girl called Adeline, who died five days later. Her death occurred the day before Van Gogh's departure, so he may never have learned about their loss.

The religious leader of the asylum was the almoner or chaplain, 65-year-old Abbot Eugène de Tamisier (fig. 40). Without naming him, Vincent once told Theo that he had visited the almoner's home, where he admired a portrait of his mother Elisabeth.[36] This portrait may have disappeared, but an old photograph of it survives, showing an alert woman with two very large curls of hair covering her ears. The fact that Van Gogh visited the chaplain's home suggests that they were on friendly terms.

Although Van Gogh had become an evangelical Protestant in his early twenties, he later rejected organised Christianity in a change of heart that was to become a bitter source of conflict with his pastor father, Theodorus. At the asylum Van Gogh probably rarely, if at all, set foot inside the chapel and never mentions it in his letters.[37]

Abbot Tamisier wrote poetry and one of his verses sings the praises of the Sisters at Saint-Paul, the 'humble virgins of the Lord' who 'calm the cries of the wretched'.[38] The female staff at the asylum were Sisters of the Order of Saint-Joseph[39], who cared for the female patients and also organised the meals and laundry for the men's block. Although Van Gogh referred to them as nuns, they were Catholic Sisters, who do not lead a cloistered life.

fig. 41 A Sister at Saint-Paul, viewed from the south, c.1950, postcard

fig. 42 Sister Epiphane (Rosine Deschanel) and Van Gogh specialist Jacob-Baart de la Faille in the garden of the asylum, mid-1920s, photograph

The mother superior was Rosine Deschanel, then 47 and known as Sister Epiphane (fig. 42).[40] The Sisters no doubt did their best for the patients, but Vincent, with his suspicion of organised religion and Catholicism, felt uneasy about living among women clad in their habits (fig. 41): 'What disturbs me is constantly seeing those good women who believe in the Virgin of Lourdes'. Theo, understanding his brother's concerns, responded that being surrounded by the Sisters during a mental crisis would 'not have a calming effect'.[41]

After Dr Peyron died in 1896, Sister Epiphane took more responsibility and helped run the asylum right up until her death in 1932. In later life she still remembered the artist, who had been always been addressed as Monsieur Vincent. Although the other Sisters were astonished and even disturbed by Van Gogh's art, Sister Epiphane was more broad-minded. She would have been willing to accept Monsieur Vincent's offer of several paintings to hang in their common room, but her colleagues had objected. She vividly recalled the artist's impasto technique, describing the surface of his pictures as like 'a swallow's nest' – built up with layers of mud.[42] Van Gogh, she recalled, was 'polite, submissive, gentle and well mannered'.[43]

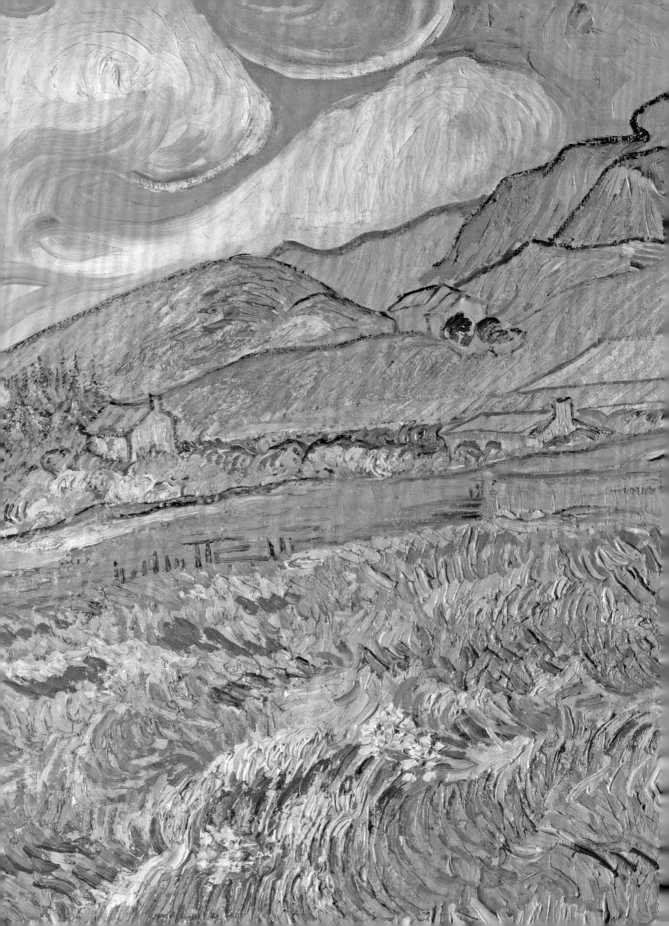

CHAPTER FIVE

WHEATFIELD

*'Through the iron-barred window I can make out a square of
wheat in an enclosure... above which in the morning I see the sun
rise in its glory'*[1]

Van Gogh's bedroom window framed a magnificent vista of the Provençal land-
scape, stretching from the wheatfield immediately below towards the distant hills.
'What a beautiful land and what beautiful blue and what a sun', the artist exclaimed
shortly after his arrival.[2] The walled area immediately beneath his room had orig-
inally served as another garden for patients, but a decade or so earlier it had been
turned over to wheat.

In a revealing comment to his sister Wil, Vincent wrote: 'I, who have neither
wife nor child, I need to see the wheatfields.'[3] Theo had recently married and Jo
would become pregnant. Without a family of his own, Vincent sought consolation
in nature. Wheat held a symbolic importance for him, as representative of the
cycle of life. 'The story of people is like the story of wheat', he said, 'one is milled in
order to become bread'.[4]

Van Gogh eventually depicted the wheatfield in no fewer than 14 paintings and
a similar number of drawings.[5] Done in different seasons, at various times of the
day, in all weathers and in evolving styles, they therefore represent a microcosm
of the artist's work at Saint-Paul. Van Gogh was not striving for topographical
accuracy.[6] As he came to know the view so intimately, he used it as a foundation
that allowed his imagination to run free.

His first painting, *Wheatfield after a Storm* (fig. 43), may well have been
inspired by a torrential downfall on 15 May 1889.[7] The ripening wheat lies on

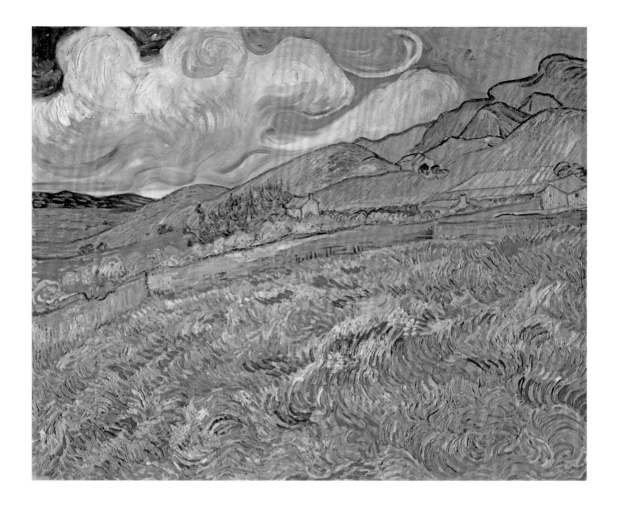

the ground in swirls, like a tempestuous sea, with the swirling field echoed by the clouds above. Painted in thick impasto, the powerful brushstrokes appear to dance. Vincent described the picture to Theo: 'A field of wheat, ravaged and knocked to the ground after a storm. A boundary wall and beyond, grey foliage of a few olive trees, huts and hills. Finally, at the top of the painting a large white and grey cloud swamped by the azure. It's a landscape of extreme simplicity.'[8] The scene so fired his imagination that the painting became the first of what would unfold as a series.

When harvesting took place in June, Van Gogh returned to the motif, introducing the figure of a reaper. Pleased with the result, three months later he painted two further versions, taking a more stylised approach. He saw the harvest in symbolic terms, telling Theo that the reaper was 'struggling like a devil in the full heat of the day to reach the end of his toil' – and adding that the subject reminded him of the Grim Reaper and his deathly task.[9]

fig. 43 *Wheatfield after a Storm*, June 1889, oil on canvas, 71 x 89 cm, Statens Museum for Kunst, on long-term loan to Ny Carlsberg Glyptotek, Copenhagen (F611)

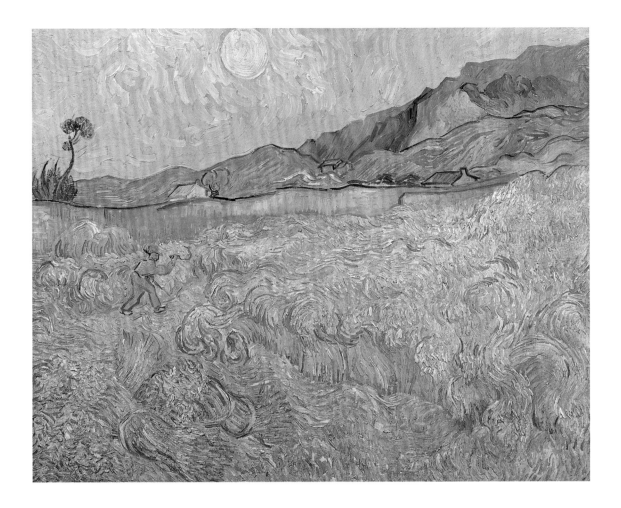

fig. 44 *Reaper*, September 1889, oil on canvas, 74 x 92 cm, Van Gogh Museum, Amsterdam (Vincent van Gogh Foundation) (F618)

But on a more optimistic note, Van Gogh also saw the gathering of the wheat as part of the eternal cycle, a joyous time of plenty that would be followed a year later by a fresh crop. As he explained to Theo, harvesting 'takes place in broad daylight with a sun that floods everything with a light of fine gold'. His only sorrowful note was to remark in an aside to Theo that he had observed the reaper 'through the iron bars of a cell'.[10]

Reaper (fig. 44), the larger of the two later versions, shows the farmer wielding his sickle under a powerful sun. In the earlier original the sky is yellow, but in the later pictures it has a greenish tinge, giving greater emphasis to the sun. Van Gogh had interrupted his letter to get back to the easel, but the following day he returned to writing, exclaiming with relief: 'phew – the reaper is finished'.[11] Pleased with the result, he suggested that the picture might be suitable to hang in Theo and Jo's Parisian apartment.

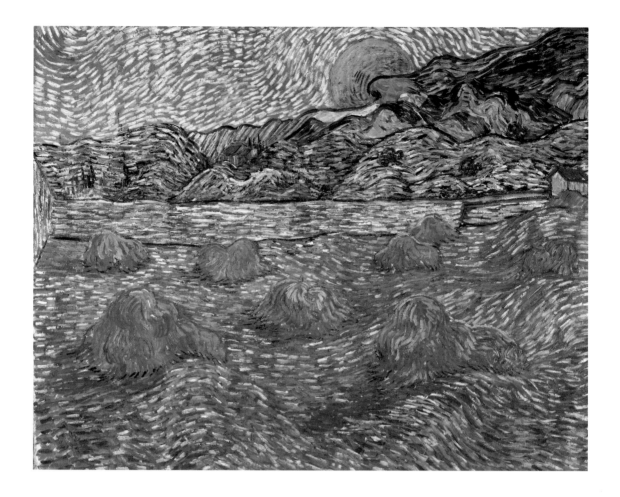

Vincent adopted a quite different approach in *Wheatfield with Sheaves and Rising Moon* (fig. 45), dividing his composition into horizontal bands, for a decorative, more two-dimensional result. Although the orange colour of the disc blazing in the sky might suggest the sun, Van Gogh clearly states that it represents the 'rising moon', which can take on an orangey tinge when observed near the horizon.[12] To finish his painting, Van Gogh added purply-pink brushstrokes over the entire scene in an attempt to render the moon's silvery light. These have now faded to become near-white, creating a curious flickering effect.

Wheatfield with Sheaves and Rising Moon was painted after the harvest in mid-July, when the sheaves were drying in stacks.[13] It is possible to pinpoint the precise time that he may have conceived the work: the full moon would have risen in this position above Les Alpilles at 9.08 in the evening of 13 July.[14] Van Gogh could well have seen the moon appear shortly before going to bed – and begun the picture

fig. 45 *Wheatfield with Sheaves and Rising Moon*, July 1889, oil on canvas, 72 x 92 cm, Kröller-Müller Museum, Otterlo (F735)

fig. 46 *Rain*, November 1889, oil on canvas, 74 x 93 cm, Philadelphia Museum of Art (F650)

in his studio the following morning, perhaps taking a couple of days to complete it.

With the approach of autumn, the ground was ploughed, ready for sowing. Heavy rain fell on 31 October and Van Gogh finished another wheatfield scene a few days later.[15] In *Rain* (fig. 46), Van Gogh covered the composition with slanting streaks, a technique favoured by Japanese artists, capturing all the drama of a downpour beating down on the landscape below his window.

Wheatfield at Sunrise (fig. 47) could hardly conjure up a greater contrast of mood. Although dating from mid-November, at the beginning of winter and just two weeks after *Rain*, its kaleidoscope of brilliant colours sing out with optimism. As Vincent told Wil, this was 'the gentlest thing I've painted'. He went on to describe his composition: 'The fleeing lines of the furrows rise high into the canvas towards a background of purplish hills.'[16] Delighted with the result, Van Gogh later chose it for display at two exhibitions in Brussels and Paris the following year.[17]

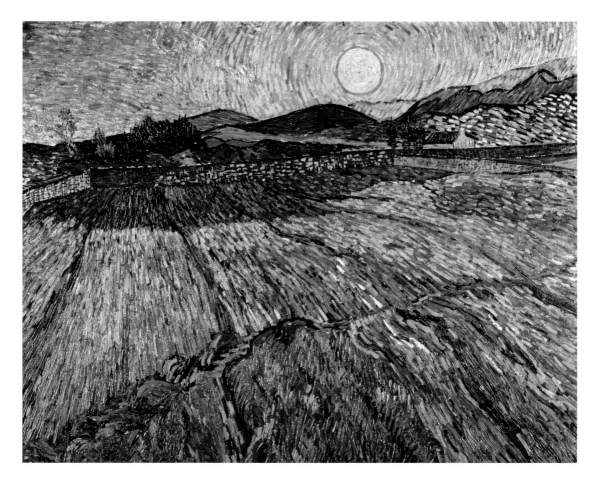

fig. 47 *Wheatfield at Sunrise*, November 1889, oil on canvas, 72 x 91 cm, private collection (F737)

fig. 48 *Green Wheatfield*, May 1890, oil on canvas, 73 x 92 cm, private collection, Zurich (F718)

Winter came and went, and as spring returned the landscape burst into life again. *Green Wheatfield* (fig. 48) shows the familiar view, but this time covered with fresh shoots, rendered with a wide range of rippling greens. In the foreground, small clumps of red poppies mingle with white flowers to bring a vibrant contrast to the emerald hues. *Green Wheatfield* was painted in early May 1890, just days before Van Gogh's departure from the asylum.[18] It marked his farewell to the view that had sustained him throughout his difficult year at Saint-Paul. It is poignant to think of the numerous times that the lonely artist peered through the bedroom bars, observing every detail of the changing seasons as they unfurled.

Van Gogh regarded his work in similar terms to that of the farmer – who sows, nurtures and harvests. Writing to his mother, who had spent most of her life in the Dutch countryside, he told her that since coming to Provence he had taken on the appearance of a peasant. He then added, 'I plough on my canvases as they do in their fields'.[19]

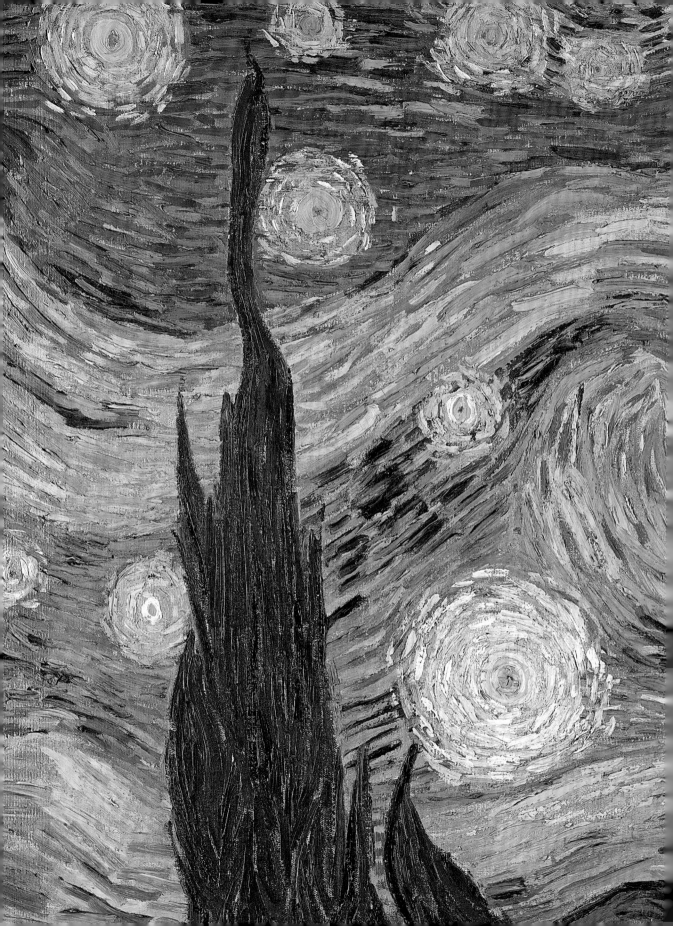

CHAPTER SIX

THE STARS

'This morning I saw the countryside from my window a long time before
sunrise with nothing but the morning star, which looked very big'[1]

I have 'a starry sky', Vincent wrote to Theo a month or so after his arrival at Saint-Paul.[2] The idea of such a nocturne had been germinating in Van Gogh's imagination since his time in Arles a year earlier, when he had first contemplated painting 'a starry night with cypresses'. Later on during his stay in Arles he had posed a rhetorical question to his friend Bernard: 'When will I do the starry sky... that painting that's always on my mind?'[3] In October 1888 he completed *Starry Night over the Rhône*[4], with a pair of lovers by the river, the streetlights of the promenade of Arles reflecting on the dark waters and the big dipper overhead. But the artist had by no means exhausted the subject, and he developed more ambitious plans, considering where it might lead him next.

Vincent had elaborated on the challenge of painting nocturnes in a letter to Willemien (Wil). The night, he wrote, is 'even more richly coloured than the day, coloured in the most intense violets, blues and greens'. He urged his sister to look up to the heavens, where 'some stars are lemony, others have a pink, green, forget-me-not blue glow'. He concluded, 'to paint a starry sky it's not nearly enough to put white spots on blue-black'.[5]

Detail of fig. 49 *Starry Night*, Museum of Modern Art, New York

Soon after his arrival at Saint-Paul, Vincent described how he had gazed up at Venus, before sunrise, seeing it looking 'very big' above the countryside. In late spring he would have needed to awaken very early to catch Venus before the dawn sky became too bright for the planet to be visible. Vincent added that painters he admired such as Charles Daubigny and Théodore Rousseau had tackled starry landscapes, creating scenes conveying 'great peace and majesty'.[6]

Over the weekend of 15–16 June 1889, two weeks after observing Venus, Van Gogh set to work with gusto and by the Tuesday *Starry Night* (fig. 49) was already completed.[7] He built up the picture with layers of thick impasto, making full use of the paint supplies he had just received from Theo.[8] The package, which had arrived a week before he started work, included two vital colours – the ultramarine that covers most of the sky and the cobalt blue that vividly highlights the moon.[9] The resulting picture is a marvellous harmony of blues. Van Gogh had also ordered six large tubes of white, which he used with almost profligate abandon, squeezing them empty in just nine days, with a considerable quantity appearing in the *Starry Night* sky.[10] The picture would originally have been more vibrant, since specialists have recently determined that the white has darkened over time.[11] The colours in many of Van Gogh's paintings have deteriorated over the decades and it is often not appreciated that the colouration would have been even more striking in his own time.

Although Van Gogh may well have painted part of his Arles nocturnes outside after dark[12], *Starry Night* was created during the day in his studio. It captures the artist's recollections of the night sky – filtered through his creative vision. A year earlier in Arles Van Gogh had written to Bernard that he regretted not working more from his memory: 'Imagination is a capacity that must be developed, and only that enables us to create a more exalting and consoling nature than what just a glance at reality... allows us to perceive.' He then gave an example, 'a starry sky... it's a thing that I'd like to try to do'.[13]

In the landscape part of *Starry Night*, the village with its towering church was loosely inspired by that of Saint-Rémy. Van Gogh could not see the distant church from his bedroom or studio, but it was visible from the refectory window and he would have viewed it from just outside the asylum's walls.[14] For his first month at Saint-Paul he was confined to the asylum, but from 7 June, a week before he conceived *Starry Night*, he was at last allowed out to explore the glorious countryside. On one of his first excursions he took out his sketchbook and drew *View of Saint-Rémy* (fig. 50), looking down on the town from near the asylum entrance, close to the Roman monuments. Although probably conceived as a preparatory work for *Starry Night*, he used it only very loosely when he came to render his landscape in paint.

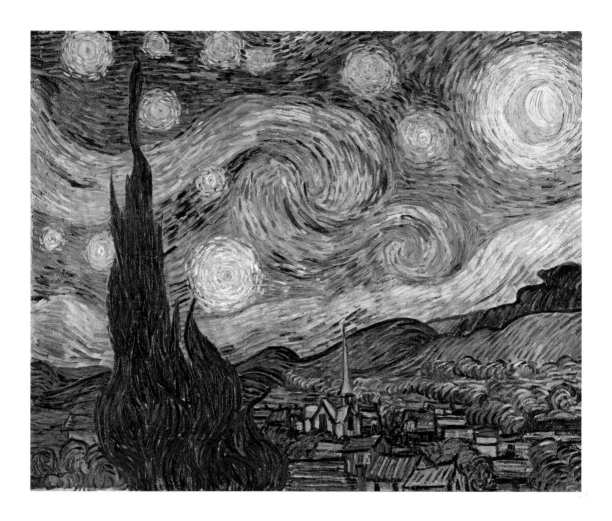

fig. 49 *Starry Night*, June 1889, oil on canvas, 74 x 92 cm, Museum of Modern Art, New York (F612)

In the painting Van Gogh exaggerated the height of the spire of the church of Saint-Martin and transformed its circular dome (fig. 51) into a pitched roof, giving it a more welcoming, domestic feel. The houses surrounding the church in the painting barely resemble those of Saint-Rémy and there are only around a dozen or so buildings in the picture, whereas there were then over a hundred in the centre of the town. The painting shows their windows illuminated, suggesting a human presence, with the brightness of their distant oil lamps greatly exaggerated to balance the yellows in the stars above.

But it is the cypresses, rather than the village, that dominate the painting's landscape, echoing in larger form the trees in *Wheatfield* (fig. 70), which he had finished the weekend that he began *Starry Night*. Van Gogh captured all the dynamism of the twisted forms of the cypresses as they reach up into the sky, their upward surge creating a powerful visual link between earth and

the heavens. More modest olive trees embrace the village, their silvery, green-blue leaves glinting in the moonlight.

The silhouette of Les Alpilles forms a backdrop to the scene, although in reality the hills lay in the opposite direction, behind the artist as he faced towards town. Van Gogh took the crest of the hills which he had captured in paint a week or so earlier in *Wheatfield after a Storm* (fig. 43), inserting it into *Starry Night*. In choosing to paint Les Alpilles in vibrant blues, Van Gogh was following Gauguin's bold advice on colouring: 'For Christ's sake, were the mountains blue, then chuck on some blue.'[15] Interestingly, Alphonse Daudet in *Tartarin sur les Alpes*, a novel that Van Gogh loved, described Les Alpilles as a 'horizon of blue waves' – just as they appear in *Starry Night*.[16]

Hovering above the mountains is the painting's dominant feature, the tumultuous night sky. The crescent moon almost vibrates within a circular yellowish halo, somewhat suggestive of the sun. Curiously, the moon's light does not strike the village as it should, since the church appears to be illuminated from the opposite direction. When Van Gogh began the painting, he left

fig. 50 *View of Saint-Rémy*, June 1889, pencil on paper, 24 x 32 cm, Van Gogh Museum, Amsterdam (Vincent van Gogh Foundation) (F1541v)

fig. 51 View of Saint-Rémy from the southern outskirts, c.1910, postcard

spaces for ten stars on the blue background, but conservators have found that in most cases he made the stars slightly larger than he had originally planned, by expanding them over the blue to create an even bolder composition.[17] The whitish band floating above the hills could represent clouds or mist, but the artist may well have had in mind the Milky Way.

Tumbling across the centre of the sky is the painting's most extraordinary feature, a whorl of flickering brushstrokes that roll across the canvas, imparting a strong sensation of movement to the scene. Van Gogh could have been thinking of the sea, recalling the Mediterranean, which he had seen exactly a year earlier on his visit to Les Saintes-Maries-de-la-Mer in the Camargue. It is likely that he was partly inspired by Hokusai's *The Great Wave* (fig. 52), a powerful image that he greatly admired. Van Gogh vividly wrote that Hokusai's 'waves are *claws*, the boat is caught in them, you can feel it'.[18] In the print, the wave towers over the volcanic peak of Mount Fuji, whereas in Van Gogh's painting the swirling mass hurtles towards the more gentle slopes of Les Alpilles. Both works share a similar colouring of rich blues and white.

Astronomers have investigated exactly what Van Gogh might have observed when contemplating the night.[19] In the evening of Friday 14 June, immediately before he conceived *Starry Night*, it would have become dark just after 9 p.m. and the near-full moon would have risen about 90 minutes later towards the east, almost directly in front of his bedroom window, illuminating the countryside beneath. However, Van Gogh chose to depict a crescent moon in his painting, albeit one which glows in a disc of light.

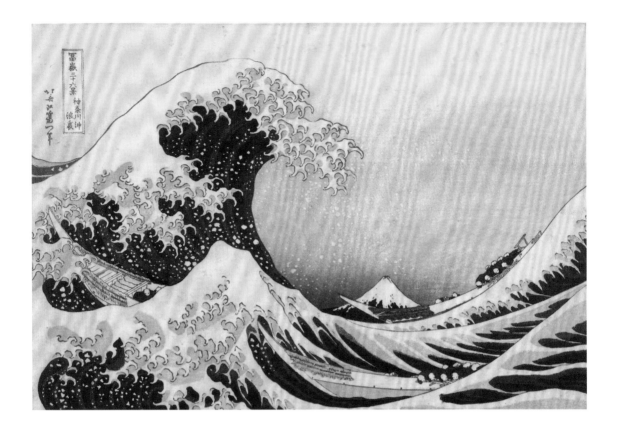

fig. 52 Katsushika Hokusai,
The Great Wave, c.1831,
woodblock print,
26 x 38 cm, Rijksmuseum,
Amsterdam

The most powerful 'star', just touching the tip of the lower cypress, might represent Venus, the brightest object in the night sky after the moon. Van Gogh had been very struck by the sight of the planet two weeks earlier, but while he was working on *Starry Night* it could only have been seen low in the sky very early in the morning, just before 3 a.m. – by which time it would no longer have been visible from his window. However, Jupiter, the second brightest planet, would have been within his line of sight in the evening, shining brightly near the moon.

The Milky Way would have been a prominent feature in the evening sky towards the east, directly in front of his window, but seen higher up in an arching curve, rather than undulating just above Les Alpilles as in the painting. A year earlier Van Gogh had written with enthusiasm about the 'blue whiteness' of the Milky Way, which he witnessed from the beach during his few days at Les Saintes-Maries-de-la-Mer.[20]

With Van Gogh's eye for beauty, it is hardly surprising that he spent hours gazing up at the night sky from his bedroom at Saint-Paul. Entertainment in the evenings was limited and even reading would be difficult under a paraffin

lamp. With very little artificial light, the night sky would have appeared blanketed with stars. But despite the intense observation that lies behind *Starry Night*, it does not capture a particular astronomical moment in time.

Some commentators have looked to literature as a source of inspiration. The artist was an enthusiastic reader of the American writer Walt Whitman, whose recent poems had included a series entitled 'From Noon to Starry Night'.[21] In Arles, a month before he painted his Rhône nocturne, Vincent had urged Wil to read Whitman, who, he said, wrote movingly of 'the great starry firmament'.[22] In his youth he had also often recalled a line in a poem by the English writer Dinah Mulock Craik: 'When all sounds cease, God's voice is heard under the stars'.[23]

The meaning of *Starry Night*, although endlessly debated, remains elusive – as so often in great works of art. The key to the picture most likely lies in Van Gogh's view that the night sky evokes the eternal, the infinite and life after death. He had long ago abandoned organised religion; instead he looked towards the heavens for comfort and consolation.

Van Gogh had beautifully expressed his thoughts the previous summer, writing from Arles that 'the sight of the stars always makes me dream in as simple a way as the black spots on the map, representing towns and villages, make me dream'. He continued: 'Just as we take the train to go to Tarascon or Rouen, we take death to go to a star... While alive, we cannot go to a star, any more than once dead we'd be able to take the train.' The artist then described illnesses such as cholera and cancer as 'celestial means of locomotion', concluding that 'to die peacefully of old age would be to go there on foot'.[24]

On completing *Starry Night* Van Gogh had ambivalent feelings about what was to become one of his most celebrated masterpieces. Although somewhat dismissively referring to it as a 'study', he seems to have hung it in his studio (fig. 28). Realising that the painting marked something of a departure from his recent work, Vincent warned Theo that the composition might appear an 'exaggeration' – not a realistic landscape.[25]

After *Starry Night* arrived in Paris a few months later, Theo responded with a few carefully chosen words of mild criticism, commenting that 'the search for style takes away the real sentiment of things'. This reaction must have worried Vincent, who shortly afterwards told Bernard that the painting represented a 'setback', saying that 'once again I'm allowing myself to do stars too big'.[26]

What, then, was the fate of *Starry Night*? Vincent had sent the painting to Paris in September 1889 and on Theo's death, just over a year later, it passed with the rest of the collection to Jo. *Starry Night* was not exhibited for a decade, so until then it was seen only in a very limited circle.

Intriguingly, the painting seems to have inspired the first literary work based on Van Gogh's life, at a remarkably early date. Octave Mirbeau, a writer and critic, presumably saw the painting in Paris in early 1891, since he then wrote a passing reference to it in a review of the artist's work, mentioning the Dutchman's 'admirable madness of skies where drunken stars spin and totter, spreading and stretching into scruffy comets' tails'.[27]

Mirbeau's subsequent novel *Dans le Ciel* (In the Sky), published in 1892–93, centres around a tragic artist named Lucien. In the novel, Lucien paints trees with 'their branches twisted' and landscapes 'under whirling stars', with a 'drunken moon that made the sky look like a noisy dancehall'.[28] It ends with an horrific scene in which the artist saws off his right hand with a hacksaw and then dies. The novel's main theme is the links between genius and insanity.

For fifty years after Van Gogh's death *Starry Night* attracted scant attention, since it was hidden away in private collections, rarely exhibited[29] and never reproduced in colour. In 1900 Jo sold the picture along with two other Van Goghs to the Symbolist poet Julien Leclercq, who organised the artist's retrospective held in Paris the following year, when *Starry Night* was first exhibited.[30] Leclercq had worked on the show with the artist Emile Schuffenecker and it is unclear exactly where ownership of the picture resided,

but by 1906 it was back once again with Jo. She then sold *Starry Night* to a dealer for 1,000 guilders, about £80.[31]

A Rotterdam woman, Georgette van Stolk, bought *Starry Night* in 1907. She hung the painting in her conservatory, but fortunately it appears to have escaped damage from sunlight and damp.[32] In 1936 Van Stolk offered to sell *Starry Night* to New York's Museum of Modern Art, but it failed to raise her asking price of 100,000 guilders.[33]

Two years later Van Stolk sold the Van Gogh for the same sum to the Paris-based dealer Paul Rosenberg (fig. 53).[34] As a Jew, Rosenberg felt increasingly threatened by the Nazis and he fled from occupied France in 1940, eventually reaching America via Spain and Portugal. Although much of his stock was looted by the Germans, the Van Gogh was among the paintings which he had safely evacuated. Had Rosenberg not managed to bring out *Starry Night*, it might may well have suffered the same fate as *Trees with Ivy in the Garden of the Asylum* (see the drawing, fig. 20), which was seized by the Nazis and then disappeared.

In 1941 *Starry Night* was finally acquired by the Museum of Modern Art. It is often assumed to have been bought with funds bequeathed by the distinguished collector of modern art Lillie Bliss, who had died in 1931, but it was actually an exchange. Three Bliss paintings were given to Rosenberg – Cézanne's *Portrait of Victor Choquet in an Armchair* and *Fruit and Wine,* and Henri de Toulouse-Lautrec's *May Belfort in Pink* – to secure the masterpiece.[35] *Starry Night* became the first Van Gogh to be acquired by a New York museum. Although relatively unknown until then, the picture burst onto the art scene with an impact that has remained undimmed.

Van Gogh himself never actually referred to the painting as 'starry night', giving it the less evocative descriptions of 'starry sky', 'night study' and 'night effect'. Theo called it 'the village in the moonlight', perhaps regarding it more as a landscape than a depiction of the heavens.[36] After the artist's death it was normally known as 'The Stars', and it was not until its exhibition in Rotterdam in 1927 that it received the more lyrical title 'Starry Night'.[37] Along with the Sunflowers, it is now arguably the world's best-loved Van Gogh.[38]

BEYOND THE WALLS

*'Outside the cicadas are singing fit to burst, a strident cry
ten times louder than that of the crickets, and the scorched
grass is taking on beautiful tones of old gold'*[1]

After arriving at Saint-Paul, Vincent had impatiently awaited permission to be allowed to leave the asylum to explore the surrounding landscape and capture it in paint. In the meantime, he asked Theo for further supplies: 'I'll go out a bit to see the countryside. Since it's just the season when there are lots of flowers and thus colour effects, it will perhaps be wise to send me another 5 metres of canvas.'[2]

On 9 June 1889 Dr Peyron reported back to Theo that during the past few days his patient had gone outside to seek 'viewpoints in the countryside', initially accompanied by an orderly[3]. Saint-Paul could hardly have been better located for a landscape artist, and in less than five minutes Vincent was deep among the olive groves, with dramatic views towards Les Alpilles. Nestling among the trees were a few scattered farms, offering a welcome opportunity to encounter people from the outside world. A print gives a good idea of Saint-Paul's attractive setting (fig. 54).[4] The long east wing, on the right of the image, is where Van Gogh had his bedroom on the upper floor, overlooking the bucolic Provençal landscape.

Dr Peyron was pleased with Van Gogh's progress, and he was allowed to visit Arles for the day on 7 July, accompanied by an orderly, probably Trabuc. After

Detail of fig. 62 *Road Menders* (second version), Phillips Collection, Washington, DC

two months away, he visited his former neighbours, Joseph and Marie Ginoux, who ran the Café de la Gare, and met his cleaning lady, Thérèse Balmossière.[5]

Meanwhile Van Gogh's first month among the olive groves and hills had proved highly productive. The chance to discover new places amid the springtime greenery and flowers proved a great stimulus. Among his earliest efforts was *Fields with Poppies* (fig. 55), a view just beyond the walled wheatfield, with the topography modified for artistic effect. Van Gogh's raised perspective, together with the cropping out of the sky, focuses the eye on the patchwork patterning of the fields. A scattering of poppies, singing out against the variegated greens, gives this springtime picture its rich vitality and exuberance.

Les Alpilles with a Hut (fig. 56), done a couple of weeks later, was painted on the road that led past the Roman monuments up towards the pass in the hills. This is Van Gogh's only close-up of Les Alpilles, painted with a flourish of twisted forms that positively reel. Although done in the midsummer heat, he explained that his inspiration was a passage in a newly published novel by the Swiss writer Edouard Rod, which referred to the homes of mountain dwellers: 'Their wooden huts are small and dark, meagre against the terrible cold of their winters'.[6] Van Gogh later exchanged this painting with a work by Eugène Boch, a Belgian artist he had known in Arles.[7]

Just south of Saint-Paul lie vast quarries dating back to Roman times, which provided the stone to build the nearby settlement of Glanum and, a millennium later, the monastic cloister. Centuries of exploitation had left huge voids in the

fig. 54 View of Saint-Paul from the east-northeast, 1866, print, 7 x 10 cm

Vue générale prise de l'E -N.-E.

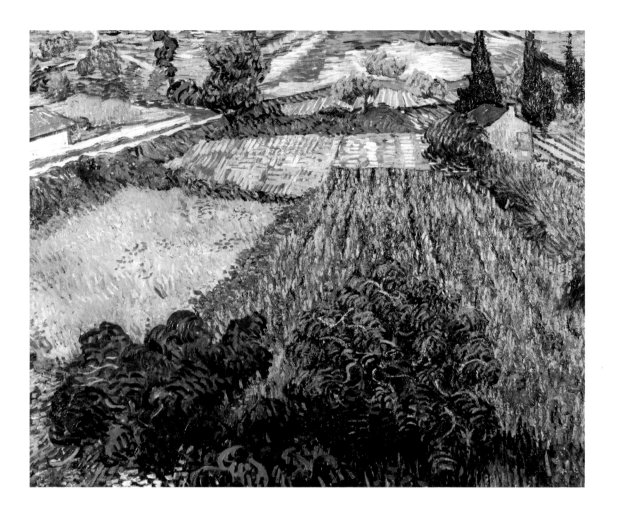

fig. 55 *Fields with Poppies*, June 1889, oil on canvas, 71 x 91 cm, Kunsthalle Bremen (F581)

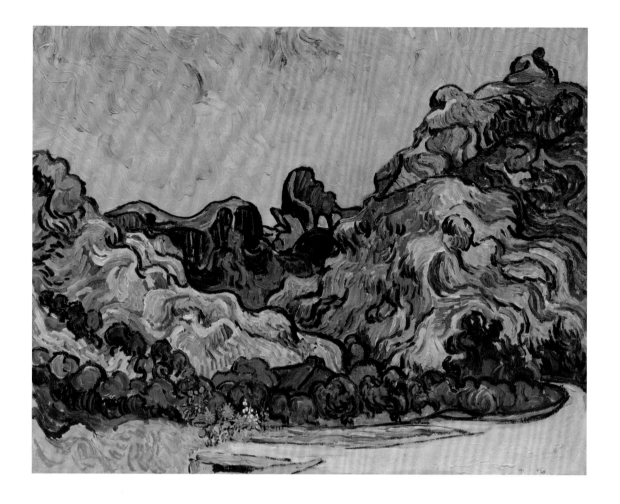

limestone, creating strange formations which caught the artist's attention. Sadly, it was while painting in the Noé quarry in July that Van Gogh suffered the first of his mental attacks at Saint-Paul. He began to feel disorientated, but somehow got back to the asylum, returning with his nearly completed quarry scene.

A month later, having recovered, Vincent reported back to Theo: 'This new crisis, my dear brother, came upon me ... when I was in the middle of painting on a windy day. I'll send you the canvas, which I nevertheless finished.'[8] The picture (fig. 57) shows the punctured ochre limestone viewed through a gap in the trees, with just a tiny sliver of sky visible on the horizon. Presumably the mistral was blowing and the gaps in the rocks must have funnelled the wind.

At first this painting appears an almost abstract design, although there is something disturbingly claustrophobic about the swirling lines of the greenery around the quarry. When Vincent sent the painting to Theo in September he

fig. 56 *Les Alpilles with a Hut*, July 1889, oil on canvas, 72 x 91 cm, Solomon R. Guggenheim Museum, New York (F622)

fig. 57 *Entrance to a Quarry*, July 1889, oil on canvas, 60 x 75 cm, Van Gogh Museum, Amsterdam (Vincent van Gogh Foundation) (F744)

wrote that he liked it because 'the dark greens go well with the ochre tones, there's something sad in them that is healthy'. He added that the 'sober' colours harked back to his earlier Dutch paintings.[9]

Setting out on another painting excursion a few months later, Van Gogh walked in the direction of Mont Gaussier up the steep valley of Les Peiroulets, nearly a kilometre south west of the asylum. There he painted *Ravine* (fig. 59), capturing the force of the water surging down between the rocks. The small figures of two women climb a path on the side of the steep valley, just above the torrent. This spectacular view would soon disappear, since two years later the ravine was dammed higher up to create a reservoir.

Van Gogh described the ravine as possessing 'a beautiful melancholy'. Despite a howling mistral, he averred that it was still 'enjoyable to work in really wild sites where you have to bury your easel in the stones so that the wind doesn't send

everything flying to the ground'.[10] Fragments of plant fibres and even a tiny twig have been discovered embedded in the surface of the picture, presumably whipped up by the mistral.[11] Painted mainly in blues, purples and greens, in a stylised form, it has an ethereal and almost abstract quality.[12]

Gauguin saw *Ravine* in the exhibition of the Société des Artistes Indépendants in Paris in March 1890, finding it 'beautiful and imposing'.[13] He asked Van Gogh whether he might be willing to exchange it for one of his own works and, flattered, the Dutchman readily agreed. In 1894, after Gauguin's return from his first stay in Tahiti, he hung *Ravine* over the bed in his Parisian apartment, flanked by two of Van Gogh's Paris sunflower paintings.[14]

In 2007 an x-ray and stereo-microscopy examination of *Ravine* revealed that it was painted on top of another picture.[15] The hidden image, *Wild Vegetation*, showed a profusion of flowers crowned by the jagged outline of Les Alpilles.

fig. 58 *Wild Vegetation*, June 1889, pen and ink on paper, 47 x 62 cm, Van Gogh Museum, Amsterdam (Vincent van Gogh Foundation) (F1542)

fig. 59 *Ravine*, October
1889, oil on canvas,
73 x 92 cm, Museum of
Fine Arts, Boston (F662)

Long assumed lost, the earlier painting was known from a faded drawing of the original which Vincent had made for Theo (fig. 58), before he reused the canvas. In spite of this exciting discovery, the hidden painting of *Wild Vegetation* will continue to remain concealed.

Why did Van Gogh paint over *Wild Vegetation?* Theo had been tardy in sending supplies from Paris, so Vincent had run out of canvas a few days earlier. But he must have been pleased with *Wild Vegetation,* since he had drawn a copy for Theo, so it does come as a surprise that he sacrificed it for another landscape. Perhaps Van Gogh was simply excited at the prospect of tackling a more dramatic view.

Van Gogh also ventured outside to paint what he considered to be 'the best' of his autumn paintings, *Mulberry Tree* (fig. 60). The canvas almost struggles to contain the tree's flaming leaves. Commenting on the picture to Wil, Vincent noted that the 'bushy foliage was a magnificent yellow against a

very blue sky and a white, stony, sunlit field behind'.[16] Camille Pissarro later admired this painting and just after Vincent's death, Theo exchanged it for one of the Impressionist's pictures.[17]

Constantly straining to get out of the asylum's confines, Van Gogh longed to exploit the far wider and more stimulating range of landscapes that lay beyond its gate. Dependent on permission to go outside, he complained to Theo: 'This half-freedom often prevents one from doing what one nevertheless feels able to do. Patience, however, you'll tell me, and it's indeed necessary.'[18]

Altogether, Van Gogh was allowed to work beyond the walls for around a third of his time at Saint-Paul.[19] It is often assumed that he needed to be accompanied by an orderly, but this was probably not always the case. On some days he appears to have walked a considerable distance, possibly as much as 20 kilometres, and it seems unlikely that an orderly would have been spared for such long excursions.[20] Van Gogh also made several short solo trips to Arles, which strongly suggests that he would have been allowed out in the asylum's neighbourhood by himself.[21]

Saint-Rémy, a kilometre away, was a small market town with a population of around 1,500 in its historic centre and on the circular boulevard.[22] Van Gogh seems to have had surprisingly little contact with the town and there is scant evidence that he shopped there or patronised its cafés.[23] Indeed the name of the town hardly features in the 62 letters which he sent from the asylum.[24]

Vincent did, however, write briefly to Theo about his first visit there, a month after his arrival: 'I once went into the village – accompanied, at that. The mere sight of the people and things had an effect on me as if I was going to faint, and I felt very ill.'[25] This discomfort suggests that Van Gogh felt insecure amongst the hubbub. Curiously, however, he does not appear to have had similar concerns about returning on four occasions to Arles, a very much larger town and a place where he had faced active hostility from his neighbours.

Van Gogh never seems to have drawn or painted inside the historic centre of Saint-Rémy. As in Arles, he was always much more attracted to rural landscapes than urban scenes. He also found it awkward to paint while being at the receiving end of comments and stares from passers-by. The only place in Saint-Rémy which did catch his eye was the circular boulevard with its impressive double row of mature trees.

The writers Edmond and Jules de Goncourt, who had visited the town four years earlier, wondered why artists had not depicted its magnificent plane trees, commenting: 'No landscapist, of any repute, has had the idea of doing a picture of one of these streets/boulevards'.[26] This Goncourt diary entry had not yet been published, so Van Gogh would have been ignorant about this call to action, but it does emphasise how the tree-lined boulevard appealed to those of an artistic temperament.

fig. 60 *Mulberry Tree,*
September 1889, oil on
canvas, 54 x 65 cm, Norton
Simon Museum, Pasadena
(F637)

The two paintings of *Road Menders* capture the chaotic scene when the pavement was being dug up. It may seem curious to have included this disruptive work, but the busy men add vitality and movement beneath the solid trees. Van Gogh described his first version, painted *in situ* (fig. 61): 'A view of the village – where people were at work – under enormous plane trees – repairing the pavements. So there are piles of sand, stones and the gigantic tree-trunks – the yellowing foliage, and here and there glimpses of a house-front and little figures.'[27] The scene is traditionally thought to represent the section of the road known as Boulevard de l'Est (now Boulevard Mirabeau)[28], an identification now confirmed from contemporaneous municipal documents which record the relaying of its pavement.[29]

Van Gogh had run out of canvas yet again and, surprisingly, for the first version of *Road Menders* he painted on a type of material normally used for tea towels.[30] This thin cotton fabric was decorated on one side with printed red

diamonds on which, even more curiously, the artist chose to work. He then failed to cover the fabric with a ground layer before starting the composition, leaving small areas only thinly painted or even untouched. Van Gogh may have wanted to experiment by leaving part of the patterning slightly visible to create a more lively effect. Alternatively, he may have rather casually begun what he initially intended to be a rough, preparatory oil sketch.

After the first picture, Van Gogh went on to paint a second version in his studio, describing it as 'a repetition... which is perhaps more finished' (fig. 62).[31] The brighter, more colourful studio picture features more clearly defined figures and he added an additional labourer near the right edge. There is also a telling detail that shows how the artist's eye was working. In this second version, the lamppost stands out more strongly against the yellowish wall, since the adjacent ground-floor

fig. 61 *Road Menders* (first version), December 1889, oil on cotton fabric, 74 x 93 cm, Cleveland Museum of Art (F657)

fig. 62 *Road Menders* (second version), December 1889, oil on canvas, 74 x 93 cm, Phillips Collection, Washington, DC (F658)

window and shutter have been shifted slightly to the right. Theo later told Vincent that he preferred the studio version, since 'you don't use so much impasto.'[32]

This pair of paintings illustrates how Van Gogh would sometimes make two versions of a picture, trying to introduce stylistic improvements. He would begin by doing an initial 'study' in front of the motif, full of inspiration and with a fresh eye. Later, he would make a 'repetition' in the studio, where he could refine his initial study, using heightened colouring and considered brushwork to create a more decorative effect and polished finish. Van Gogh described his general process: 'Out of doors, exposed to the wind, the sun, people's curiosity, one works as one can, one fills one's canvas regardless. Yet then one catches the true and the essential – that's the most difficult thing.' But later on, making a repetition, one 'orders one's brushstrokes', creating a picture that is 'more harmonious and agreeable.'[33]

OLIVE GROVES

'If you could see the olive trees at this time of year... an olive grove has something very intimate, immensely old about it'[1]

In the same week that Van Gogh finished *Starry Night* (fig. 49) he also completed a magnificent sun-drenched landscape, *Olive Trees with Les Alpilles* (fig. 63). Writing to Theo about the two pictures, he described them as compositional 'exaggerations', painted with 'contorted' lines.[2] Both show the hills in the background and are mainly executed in blues, greens and whites, dotted with glints of yellow. The pair of day and night pictures were separated in 1906, when Jo sold them to different owners, but fortuitously both eventually ended up at New York's Museum of Modern Art, where they can once again be appreciated together.[3]

Olive Trees with Les Alpilles is a powerful work, vigorously painted with a palpable sense of movement, quite likely capturing a mistral scene. Van Gogh loved setting out to portray the wind in his pictures, to make them livelier. The foreground's ochre-coloured earth swirls through a multiplicity of shades, with the twisting greenish ribbon probably representing a path. Foliage sprouting from the febrile trunks makes the ancient olive trees almost appear to dance. The peak of Mont Gaussier rises on the right, while to the left there is the distinctive rock formation of Les Deux Trous, where the slender crest has eroded to leave behind two huge holes (it also appears, less distinctly, on the horizon in the centre of *Les Alpilles with a Hut*, fig. 56). In the azure sky, the elongated cloud calls to mind the wave-like surging form in *Starry Night*.

It comes as no surprise that Van Gogh was attracted to olive trees, with their glimmering leaves contrasting with the aged, gnarled trunks. In *Olive Trees with Les Alpilles* he set out to capture the scenery at midday, 'when one sees the green beetles and the cicadas flying in the heat'.[4] It was painted on one of the artist's early excursions outside the asylum, at a spot just a few minutes' walk to the south.

Detail of fig. 63 *Olive Trees with Les Alpilles*, Museum of Modern Art, New York

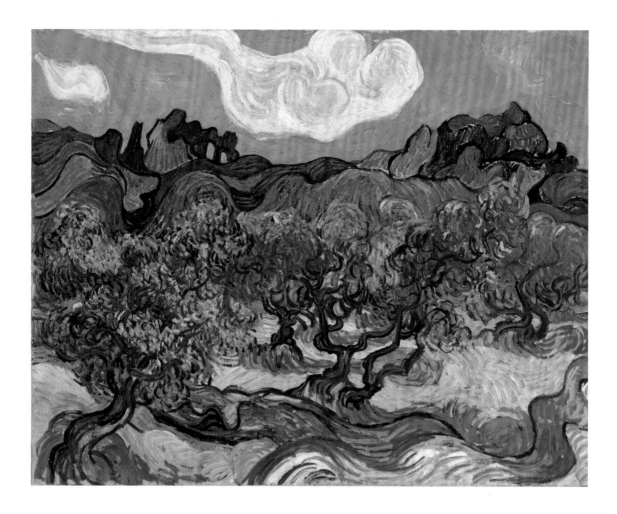

Although Van Gogh would not have known it, this grove probably lay above the buried remains of the Roman town of Glanum, which was hidden until excavations began in the 1920s. Dating mainly from the first century BC, the site with its spring of healing waters was abandoned in AD 260, when its inhabitants moved to establish what would become Saint-Rémy.

A few days after finishing the landscape with Les Alpilles in June 1889, Van Gogh painted *Olive Grove* (fig. 64), tackling the subject with a strikingly different approach. Compositionally the painting is divided in half, with the yellow-ochre soil and dark trunks below, set beneath shimmering leaves and a turquoise sky. The bluish-violet shadows create a wavy, patterning effect. In contrast to the longer brushstrokes in his earlier picture, here he uses short, curved brushwork. The leaves, in particular, are handled much more delicately. Signalling his satisfaction, the artist signed the painting, adding his name in flowing letters in the lower-left corner.

fig. 63 *Olive Trees with Les Alpilles,* June 1889, oil on canvas, 73 x 91 cm, Museum of Modern Art, New York (F712)

fig. 64 *Olive Grove*, probably June 1889, oil on canvas, 72 x 92 cm, Kröller-Müller Museum, Otterlo (F585)

Olive groves became a motif that would preoccupy Van Gogh for the remainder of his stay. The trees grew all around the asylum, with some just outside Trabuc's farmhouse. They provided a rich source of oil, much of it used for manufacturing soap. A quintessential feature of the Provençal landscape, the groves seemed dazzlingly exotic to a northerner. Mesmerised by their reflective, evergreen leaves, Van Gogh described the foliage as 'silver, sometimes more blue, sometimes greenish, bronzed, whitening'.[5] In his time many of the trees were centuries old, the rugged trunks a testament to their longevity. Altogether Van Gogh made 16 paintings of olive groves during his stay at Saint-Paul.[6]

As summer turned into autumn Van Gogh continued to explore the subject, tackling it in increasingly stylised ways. In *Olive Grove* (fig. 65), the trees, shadows and bare ground form an almost decorative pattern. In 2017 experts at the Nelson-Atkins Museum in Kansas City made a fascinating discovery: the remains of a

grasshopper were found embedded in the paint. Under strong magnification, the conservator Mary Schafer found the insect in the lower foreground of the landscape, just right of the centre. Almost invisible to the naked eye, it is only thanks to modern technology that the grasshopper has now come to light.[7] Schafer found no evidence of movement in the neighbouring paint, which would have been expected if the unfortunate grasshopper had tried to escape from the sticky surface. She therefore concluded that the insect was already dead when it got stuck in the paint, perhaps blown onto the canvas. This appears to confirm that Van Gogh was working outside among the trees, rather than back in his studio.

Weeks passed, but the cooler air did not blunt Van Gogh's appetite for the olive groves. He proceeded to experiment by creating two works of the same motif, but totally different in colouration. One (fig. 66) is composed of three brownish, greenish and bluish horizontal bands – an autumnal scene.[8] The other (fig. 67), even though painted in November, evokes memories of the midsummer heat. This

fig. 65 *Olive Grove*, probably September 1889, oil on canvas, 73 x 92 cm, Nelson-Atkins Museum of Art, Kansas City (F711)

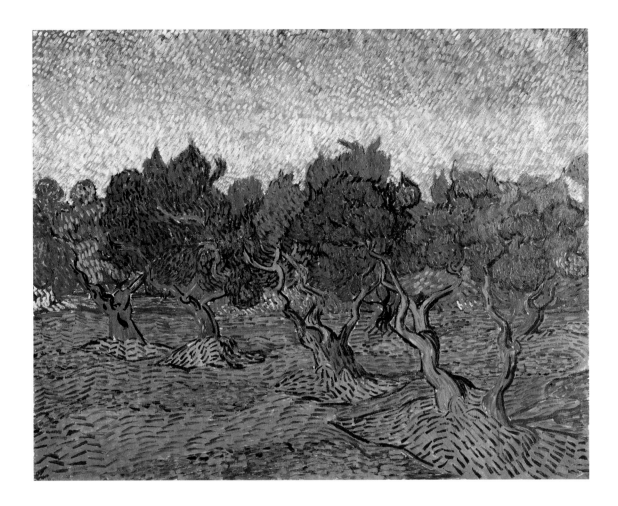

fig. 66 *Olive Grove*, November 1889, oil on canvas, 73 x 92 cm, Van Gogh Museum, Amsterdam (Vincent van Gogh Foundation) (F707)

sultry olive grove, set beneath the looming peak of Mont Gaussier, is illuminated by a huge haloed sun beaming out from a yellow sky. The trees cast bluish shadows which curiously fall towards the right, although with the position of the sun they should be vertical.

Van Gogh's olive groves are mostly devoid of people, but he did include them in a quartet of autumnal harvest scenes. Three versions of these show a similar view, including one of the female harvesters balanced on the wide triangular ladders so characteristic of Provence (fig. 68). The first, painted outdoors, is vigorously spontaneous, the second more stylised and the third even more simplified.[9] In the latter version (fig. 69), the scene unfolds beneath a pink sky, which has now faded and taken on a whiter tone. Conservators have found traces of Van Gogh's deeper pink on the edge of the canvas, where the frame had protected the pigment from light.

Vincent painted this version of *Women picking Olives* for his mother Anna and Wil, whom he had not seen for four years. Despite the endless problems with his

family in the past, at Saint-Paul he began to feel closer to them. Sending his mother and sister a small group of paintings was part of Vincent's attempt to heal the rift – and to emphasise that his retreat to an asylum did not signal the end of his vocation. Before dispatching *Women picking Olives*, Van Gogh showed his satisfaction with it by making a drawing for Gauguin, who responded that he liked it 'very much'.[10]

Throughout the autumn Van Gogh pursued a revealing correspondence with Gauguin and Bernard about the attempts of his two friends to paint Christ in the Garden of Olives at Gethsemane, the night before the crucifixion. Gauguin posted a small sketch of his picture and Bernard sent a photograph, but Van Gogh dismissed both as failures, because of the unrealistic way they had depicted the olive grove. Van Gogh simply disliked Gauguin's painting, and, as for Bernard, he had 'probably never seen an olive tree'.[11] Vincent believed that landscape paintings should 'smell of the soil'.[12]

fig. 67 *Olive Grove*, November 1889, oil on canvas, 74 x 93 cm, Minneapolis Institute of Art (F710)

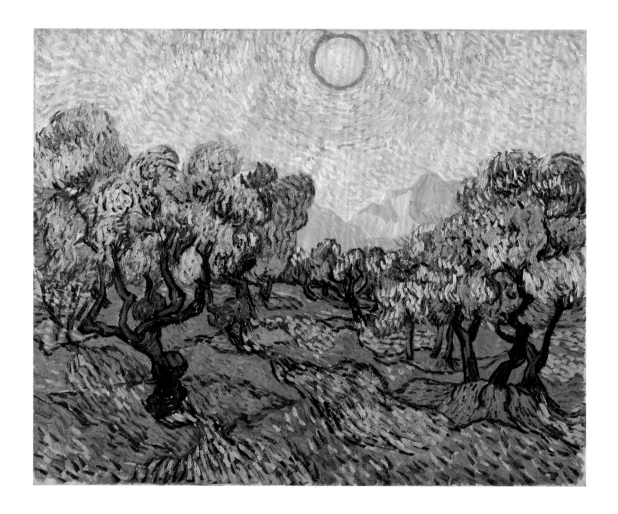

fig. 68 Olive harvest, c.1920, postcard

fig. 69 *Women picking Olives*, December 1889, oil on canvas, 73 x 90 cm, Metropolitan Museum of Art, New York (F655)

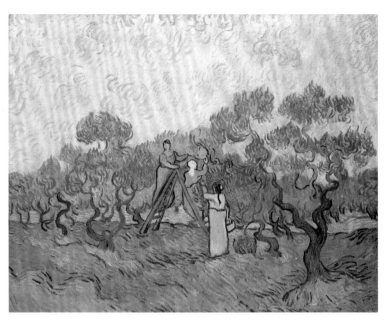

Van Gogh had himself twice tried to paint a religious Garden of Olives the previous year, in Arles. On the second occasion he had decided on the composition: a 'starry night' for the background, the figure of Christ in the strongest blues and the angel in a lemon yellow.[13] But unable to find anyone to pose for Christ, he was dissatisfied with the figure he had painted on both occasions, so he destroyed the works. Although the olive groves around Saint-Paul must have made Van Gogh think again about tackling Christ's Passion, it would have been even more difficult to find a model. Dr Peyron was hesitant to allow patients or staff to pose for portraits. One could hardly imagine the asylum director permitting one of his mentally disturbed men to be portrayed as Jesus.

When Van Gogh eventually departed from Saint-Paul he looked back on his efforts to capture the olive groves, feeling he had done his utmost to record the changing seasons: 'When the more bronzed greenery takes on riper tones the sky is resplendent and is striped with green and orange; or even further on in the autumn, the leaves take on the violet tones vaguely of a ripe fig.' The changing weather, too, would create different scenes. After a shower he had seen the sky 'coloured in pink and bright orange', with sunlight falling on 'the silvery greenish greys' of the leaves.[14] As with the wheatfield, the Provençal olive groves provided Van Gogh with a motif with endless opportunities to explore.

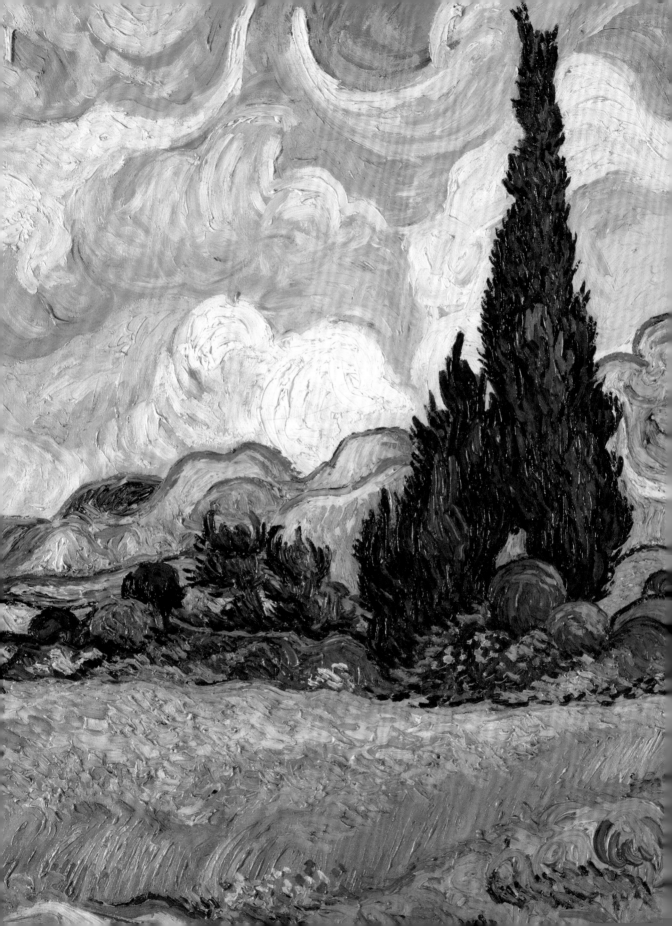

CYPRESSES

'The cypresses still preoccupy me, I'd like to do something with them like the canvasses of the sunflowers because it astonishes me that no one has yet done them as I see them'[1]

Detail of fig. 71
Wheatfield with Cypresses,
Metropolitan Museum of
Art, New York

Van Gogh found cypresses beautiful in both outline and proportion, 'like an Egyptian obelisk'.[2] From his bedroom window he looked out towards small groups of trees which had been planted along the edges of fields as windbreaks. When he was later able to explore the countryside, to observe them close at hand, he intently studied their twisted forms, which gave the trees the flexibility and strength to withstand the mistral.

Cypresses are not only visually dramatic, but have a deep symbolism, making them of even greater interest to an artist. In the classical world they represented death and mourning, but following the arrival of Christianity these evergreen trees, which live for centuries, were widely planted in cemeteries as representative of eternal life. The area around Saint-Rémy is noted for having some of the oldest and tallest cypresses in the region.[3]

Van Gogh compared the cypress with the sunflower, regarding the tree's dark green leaves and the flower's bright yellow petals as opposites. The longevity of the cypress evokes death and immortality, whereas the colourful but very much more transitory sunflower symbolises the joys of life. Tackling both the motifs, the artist wrote, requires 'a certain dose of inspiration... to do beautiful things'. Vincent was

only too aware of the challenge of capturing the cypress in paint. 'To do nature here, as everywhere, one must really be here for a long time', he told Theo.[4]

Van Gogh first tackled the subject in his June 1889 *Wheatfield* (fig. 70), in which a pair of cypresses rise up near a farmhouse on the edge of a field – not the one beneath his bedroom, but another slightly further away. In *Cypresses* (fig. 72) he zoomed in, focusing his attention on the trees. Using a technique employed in Japanese prints, he cropped out the top of the taller one, allowing its bulky, writhing form to take centre stage. Adding touches of lighter green on the leaves brought the cypresses to life. Painted a few days after *Starry Night* (fig. 49), this more modest and decorative picture reprises the ridge of Les Alpilles surmounted by a sky filled with swirling clouds and a large crescent moon, incongruously appearing in a bright, daytime scene.

Wheatfield with Cypresses (fig. 71) is among Van Gogh's finest landscapes, demonstrating how swiftly he mastered his daunting subject. A golden band of ripened wheat ripples across the foreground, enlivened by a scattering of scarlet poppies. Several olive trees lie marooned in a sea of wheat and slightly further away stands a pair of dark cypresses.[5]

With winter approaching, Vincent told Theo that he still had a 'great desire to do for the mountains and for the cypresses what I've just done for the olive trees'. He

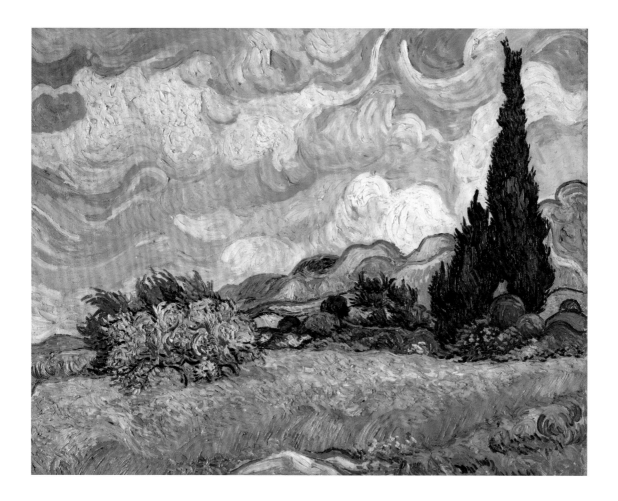

fig. 71 *Wheatfield with Cypresses*, June 1889, oil on canvas, 73 x 93 cm, Metropolitan Museum of Art, New York (F717)

suggested that the market for these cypress paintings would be in Britain. 'I know well enough what they're looking for over there', he wrote, presumably referring to his conversations in Paris two years earlier with the young dealer Alexander Reid.[6] A few weeks later Van Gogh reiterated that 'to give an idea of Provence it's vital to do a few more canvases of cypresses and mountains'.[7]

The cypress was to feature in the first serious published critique of Van Gogh's art, published by the writer Albert Aurier in the January 1890 inaugural edition of the *Mercure de France* journal. Aurier had visited Theo the previous month, to see Vincent's work and discover more about his life. Theo posted a copy of the published article to his brother, so it passed through the office of Dr Peyron. Although no admirer of Van Gogh's work, the doctor must have been impressed to discover that one of his patients was worthy of being the subject of a lengthy article in a Parisian journal.

Van Gogh, for his part, was curiously ambivalent about the honour. As he explained to his mother and Wil: 'When I heard that my work was having some success and read that article I was immediately afraid that I'd regret it – it's almost always the case that success is the worst thing that can happen in a painter's life.'[8] Coming from an artist who was constantly frustrated at being unable to sell his work, this remark comes as a surprise – but it reveals something of the complexities of Van Gogh's mind.

In his article Aurier referred to Van Gogh's 'cypresses shooting up their nightmarish silhouettes of blackened flames'.[9] This must be a reference to *Cypresses* (fig. 72), which he would have seen with Theo in Paris. Despite his ambivalence about being singled out for attention, Vincent was moved by Aurier's review and decided to give him another of his cypress paintings, after having first made a few modifications.

Van Gogh took another picture of cypresses that he had done in June, a somewhat similar work to the one which Aurier had admired. The artist added two female figures, probably intending to create a livelier composition. In *Cypresses with Two Women* (fig. 73) they walk through a swirling landscape of flowers, dwarfed by the towering line of the trees. Once again there is the contrast between the dark cypresses and the colourful, albeit transient, flowers.

Van Gogh wrote to Aurier about the gift, explaining that the cypress is 'so characteristic of the landscape of Provence'. He then confessed that while painting nature he sometimes felt like fainting, resulting in 'a fortnight during which I am incapable of working'. When Theo received the picture to pass on to the critic, he responded that it was 'one of the finest you've yet done, it has the richness of a peacock's tail'.[10]

Among Van Gogh's final pictures from Saint-Paul is another nocturne, *Road with a Cypress* (fig. 74), again a picture from the imagination. A tree soars up the middle of the composition, looming over a road. Two men, one with a spade over his shoulder, return from work in the late evening, followed by a couple in a small carriage. Behind them, sheltered by a group of smaller cypresses, lies a welcoming inn. Crowning the painting are a crescent moon and a bright yellow star surrounded by rippling circles of light, with a second, very much smaller star glimmering on the far left. The scene incorporates a number of elements from *Starry Night*.

Van Gogh later made a tiny sketch of *Road with a Cypress* in a letter for Gauguin, describing his painting as 'very romantic if you like, but also "Provençal" I think'. At Saint-Paul, Van Gogh would complete a dozen or so paintings of the dark, flame-like trees that fascinated him so much. *Road with a Cypress*, he wrote, represented his 'last try'.[11]

fig. 72 *Cypresses*, June 1889, oil on canvas, 94 x 74 cm, Metropolitan Museum of Art, New York (F613)

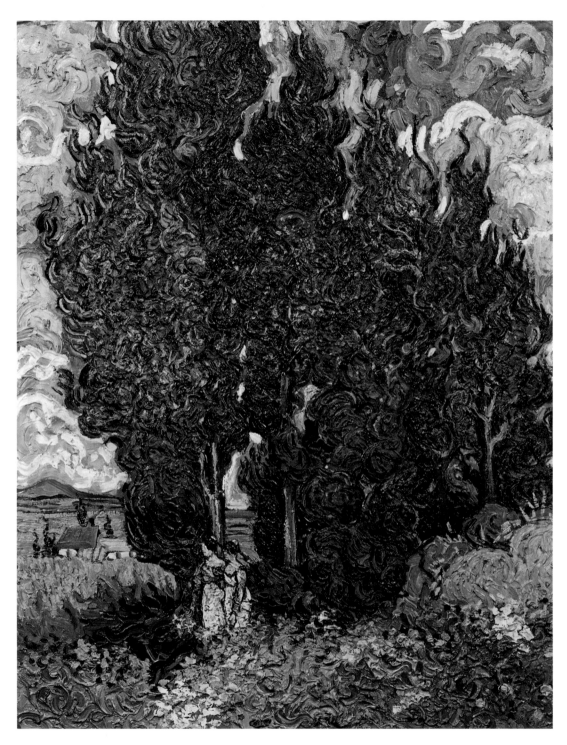

fig. 73 *Cypresses with Two Women*, June 1889 and reworked in February 1890, oil on canvas, 92 x 72 cm, Kröller-Müller Museum, Otterlo (F620)

fig. 74 *Road with a Cypress*, May 1890, oil on canvas, 91 x 72 cm, Kröller-Müller Museum, Otterlo (F683)

FELLOW TRAVELLERS

'The room where we stay on rainy days is like a 3rd-class waiting room in some stagnant village'[1]

Detail of fig. 76 *Portrait of a Man with a Cigarette*, Van Gogh Museum, Amsterdam (Vincent van Gogh Foundation)

Upon arriving at Saint-Paul, Van Gogh was shocked to encounter what he described as 'the diverse mad or cracked people in this menagerie'.[2] This must have been extremely disturbing, and yet biographers of Van Gogh have given comparatively little consideration to the impact of living among these tortured souls. Patients would surround him in the garden, the common room and the refectory – and even when alone in his bedroom or studio he was unable to escape their screams and howls.

Viry's diatribe *Dix Lettres d'un Aliéné*, published five years before Van Gogh's arrival, describes how newcomers were thrown in with the other patients and 'soon take on the appearance, manners and cries of their fellows'.[3] Van Gogh was only too aware of this danger. The artist likened the asylum's common room (fig. 32) to a 3rd-class railway waiting room and what struck him most forcibly was the men's boredom and sluggishness.[4]

The refectory was another regular gathering place, bringing the artist face to face with habits and meals which he found equally unappetising. Van Gogh described the food prepared by the Sisters as 'a little musty, as in a cockroach-ridden restaurant in Paris or a boarding school'. Avoiding the heavier dishes, he tended to eat 'nothing but bread and a little soup'.[5] *Plate, Bowl and Spoon* (fig. 75) is a poignant depiction of his simple tableware, drawn in a homemade sketchbook. There is no knife or fork on the table, since these were often not provided for patients, to avoid injuries.

fig. 75 *Plate, Bowl and Spoon*, March–April 1890, pencil and black chalk on paper, 20 x 29 cm (depicted image), Van Gogh Museum, Amsterdam (Vincent van Gogh Foundation) (F1604r)

fig. 76 *Portrait of a Man with a Cigarette*, probably October 1889, oil on canvas, 57 x 37 cm, Van Gogh Museum, Amsterdam (Vincent van Gogh Foundation) (F532)

In a somewhat scatological comment, Van Gogh made light of the behaviour of his fellow diners: 'As these unfortunates do absolutely nothing (not a book, nothing to distract them but a game of boules and a game of draughts) they have no other daily distraction than to stuff themselves with chickpeas, haricot beans, lentils and other groceries and colonial foodstuffs by the regulated quantities and at fixed times. As the digestion of these commodities presents certain difficulties, they thus fill their days in a manner as inoffensive as it is cheap.'[6] Haricot beans must have been something of a staple at Saint-Paul, since Viry complained about the food and treatment in another pamphlet on Saint-Paul, written five years earlier. 'Always the same diet', he wrote, 'at midday haricots and a kick and the evening a kick and cold haricots'.[7]

Socialising at table and observing his companions, Van Gogh must have quickly had the idea of painting portraits of these unusual characters, or at least the more amenable men who were capable of sitting still.[8] Dr Peyron, who wielded great authority, would presumably have only considered allowing patients in reasonable condition to sit for the artist. Nevertheless, by the autumn Dr Peyron seems to have relented and Van Gogh then captured two of his companions in paint.

Portrait of a Man with a Cigarette (fig. 76) is often said to depict a patient with only one eye, but in fact the sitter was suffering from a drooping eyelid, a condition known as ptosis. It was courageous of someone with a distorted face to have posed, especially as Van Gogh made no effort to disguise their affliction. Perhaps he and

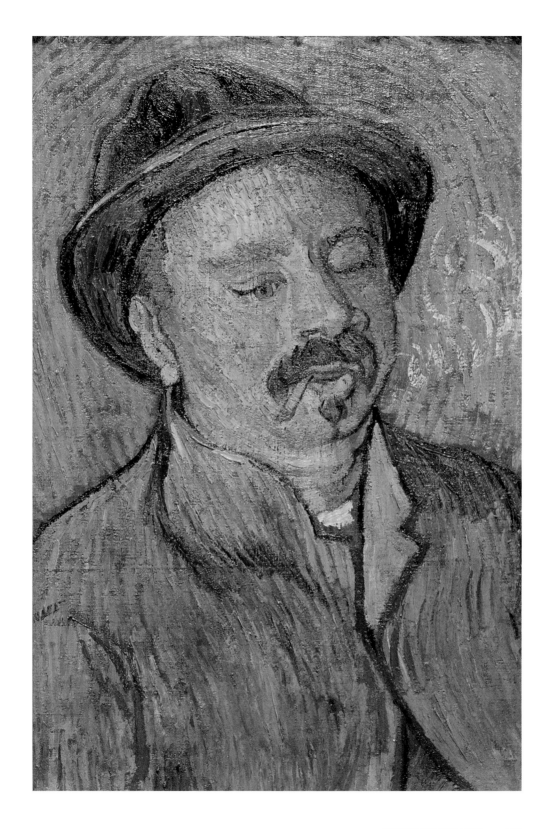

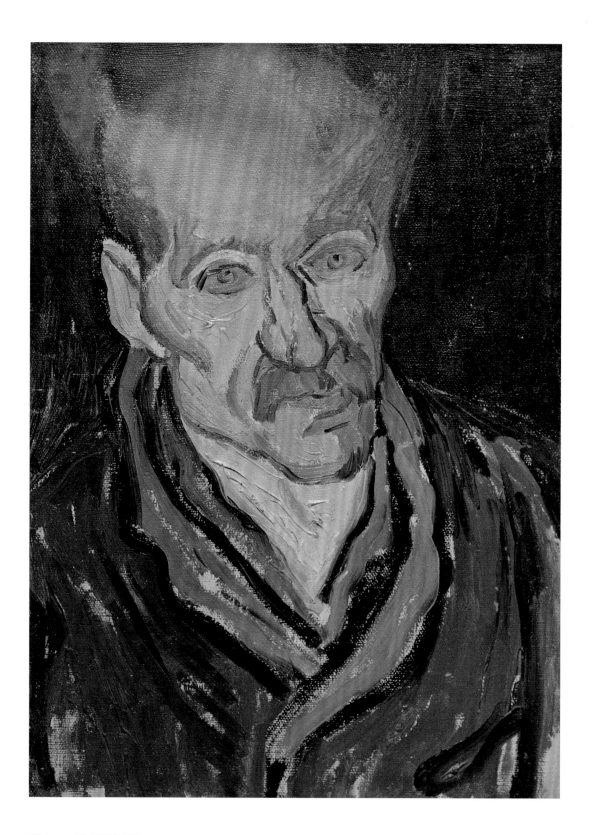

fig. 77 *Portrait of a
Man*, autumn 1889, oil
on canvas, 32 x 24 cm,
Van Gogh Museum,
Amsterdam (Vincent van
Gogh Foundation) (F703)

the artist, who was even more disfigured, felt a common bond. The orange of the burning cigarette, at the very centre of the portrait, creates a vivid burst of colour that zings out against the composition's darker hues.

Vincent probably completed this picture in late October, when he told his mother that he was doing 'a portrait of one of the patients'. The man's warm clothing certainly suggests it was not done earlier in the year. Referring to his fellow inmates, Vincent added that 'it's strange that when one is with them for some time and is used to them, one no longer thinks about their being mad'. On receiving the next consignment of paintings in Paris, Theo responded that the 'fellow with his swollen face' is 'extraordinary'.[9]

Van Gogh's disturbing *Portrait of a Man* (fig. 77) depicts an elderly patient, with the clothing again suggesting a late autumn or winter sitting. This sketchy, expressionist and rather crude image has at some point suffered deterioration in the forehead area, giving the gaunt face an even more bizarre appearance. Seeing this painting would surely have discouraged Dr Peyron from ever again allowing his patients to sit for the artist. Although something of an artistic failure, this unnerving portrait, which has rarely been exhibited and is little known, tellingly reveals something of the reality of asylum life.[10] The man's empty-looking eyes betray a deep sadness and sense of incomprehension.

Thanks to new archival research, it is now possible to gain a real insight into the lives and states of mind of Van Gogh's companions. For the first time, we know how many men were there on the day of Van Gogh's arrival. The unpublished daily register records 18 men (plus the artist), along with 23 women in a separate wing.[11] It also gives the number of staff as 22, comprising 10 Sisters, 8 male and 2 female staff, the director and the almoner. Two more male patients were admitted during the twelve months that Van Gogh was there.

Not one of Van Gogh's fellow patients have been previously named, but with the help of archival documentation most can now be identified (fig. 5). It is also possible to describe the backgrounds and medical symptoms of many of them. We can then begin to understand the environment in which Van Gogh lived – and worked – during his year at Saint-Paul.[12]

Jean Revello, who was 22 when Van Gogh arrived, had been admitted to the asylum in 1887, coming from Marseille. He was described as 'an idiot', a term then used for someone with a mental age of less than three years. Revello had never learned to speak and, according to the medical reports, he was sometimes in a 'state of nervous overexcitement', when he carried out 'acts of violence for the most trifling reasons'.[13]

Van Gogh must have been referring to Revello when he wrote about an unnamed patient 'who doesn't reply except in incoherent sounds'. Vincent told Theo that the man only responded to him 'because he isn't afraid of me',

suggesting that Van Gogh went to considerable effort to be kind to him.[14] The unfortunate Revello ended up spending his entire adult life in the asylum, dying there in old age.

Van Gogh's other companions also included 26-year-old Joachim Raineri, who had been admitted to Saint-Paul in February 1889, three months before the artist. The medical reports categorise him as 'a true suicidal monomaniac'.[15] He is not recorded at the asylum in the 1891 census, so by then he had been moved elsewhere – or he may possibly have died at a tragically young age.

Antoine Silmain (76) was a former priest who had served in Villar-Loubière, in Hautes-Alpes, and had most recently resided in the nearby monastery of Saint-Michel-de-Frigolet. He may well have been suffering from dementia.

Among the patients was a former lawyer who suffered from 'auditory hallucinations'. He feared that the secret police were pursuing him, accusing him of being 'a pimp, a pederast, a thief and an assassin'.[16] This was probably the patient described by Van Gogh: 'There's one person here who has been shouting and always talking, like me, for a fortnight, he thinks he hears voices and words in the echo of the corridors, probably because the auditory nerve is sick and too sensitive.' Van Gogh added that 'with me it was both the sight and the hearing at the same time'. Writing about some of his fellow patients, Van Gogh said that 'they too have heard sounds and strange voices during their crises'.[17]

It is surprising that in this small group of patients both Van Gogh and the lawyer appear to have shared very similar symptoms – described with the same terminology. Van Gogh's doctor in Arles stated that the artist had experienced 'hallucinations de l'ouïe' (hearing) and Dr Peyron later enlarged on this, noting that the Dutchman had suffered 'hallucinations de la vue et de l'ouïe' (sight and hearing).[18] Leroy cites the Saint-Paul medical records as showing that the lawyer also suffered 'hallucinations de l'ouïe'.[19] The two patients presumably discussed their common plights and the lawyer was probably one of the few educated men, which may have made him more interesting company for the artist.

One early Van Gogh specialist wrote that the patients included an unnamed 'Comte de G*' (Count), who continually cried out 'ma maîtresse, ma maîtresse' (my mistress)[20], beating his chest with a piece of wood and piercing his clothes. The count could well have been Joseph d'Esgrigny, from Nîmes, who was 42 when Van Gogh arrived. The d'Esgrignys were an aristocratic family from that city and when the name is spoken, it sounds very similar to 'de Grigny', which would explain the 'G*'.

Two patients had come from far away: Pierre Mille (25) had been born in Constantinople and Louis Roux (43) in Corsica. Van Gogh's other fellow patients included Charles Olszewski (43), Charles Siraud (45), Louis Bizalion (52) and Etienne Duffaud (55).[21]

Without naming them, the former hospital director Leroy cited the conditions of some of these men. They variously suffered from 'frequent paroxysms of maniacal agitation', lypemania (chronic melancholy) 'with delirium of persecution', syphilophobia (morbid fear of syphilis) and one had a condition which rendered him 'sometimes furious'. Another feared being poisoned or assassinated; he was violent and broke furniture and windows, crying 'constantly' and wearing his clothing in 'a disorderly way'.[22]

Two other men were admitted during Van Gogh's stay at the asylum in 1889. Henri Enrico arrived from Marseille on 27 May, two weeks after the artist.[23] Suffering from 'acute mania', he displayed 'frenzied agitation' and 'screams and breaks everything', according to his medical report.[24] Van Gogh described the man's condition in very similar terms, without naming him: 'A new person has arrived who is so agitated that he breaks everything and shouts day and night, he also tears the straitjackets and up to now he scarcely calms down, although he's in a bath all day long, he demolishes his bed and all the rest in his room, overturns his food etc. It's very sad to see – but they have a lot of patience here'.[25] The admission register records that a Thérèse Louise Enrico and Jacques Eugène Enrico had earlier been at Saint-Paul, and they were probably siblings, perhaps suffering from a genetic condition.[26] One more man was admitted while Van Gogh was there: Joseph Célestin Pontet, aged 73, who arrived on 6 September 1889.

Van Gogh appears to have got on remarkably well with this motley group of troubled men. He is often regarded as an awkward person, who for much of his life had very poor relations with most of his family and sometimes had bitter rows with friends[27], but his letters from Saint-Paul give little indication of difficulties with his fellow patients. Van Gogh probably realised that the way of making life tolerable was to avoid problems with his fellow inmates.

It is heartbreaking to think of Van Gogh living with such disturbed patients. It is even more difficult to conceive of an artist being able to create such vibrant and optimistic paintings surrounded by men suffering such distress. Van Gogh was well aware of the dangers: 'What would be infinitely worse is to let myself slide into the state of my companions in misfortune who do nothing all day, week, month, year.'[28]

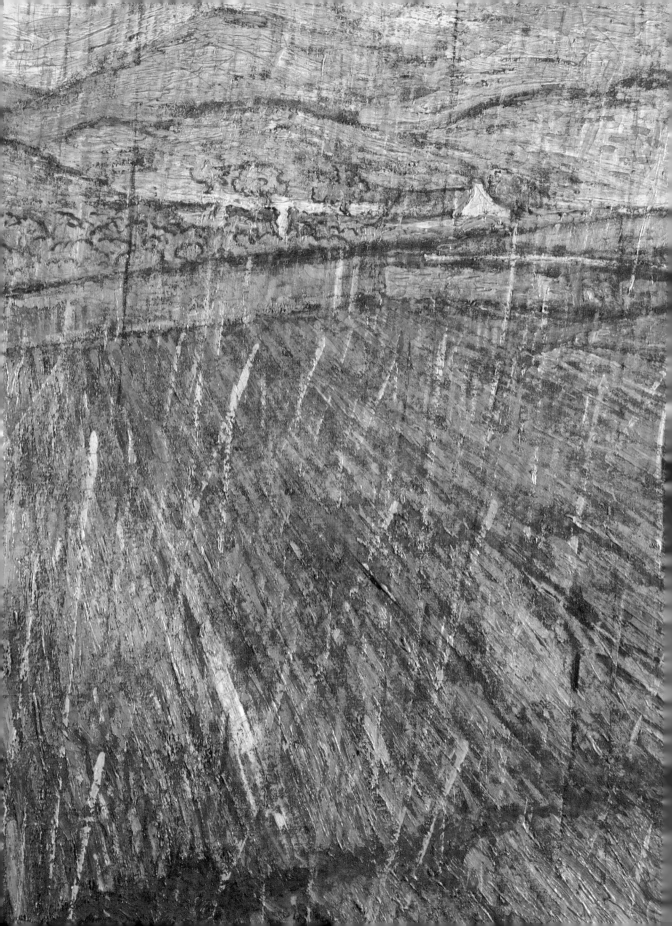

CHAPTER ELEVEN

CRISES

*'A more violent crisis may destroy my ability to paint forever...
anyway I'm trying to get better now like someone who, having
wanted to commit suicide, finding the water too cold, tries to
catch hold of the bank again'*[1]

Van Gogh remained lucid for most of his year at Saint-Paul, but he did suffer four
crises – when he became completely disorientated and very distressed.[2] These
bouts of frightening confusion were similar to several earlier episodes in Arles. The
first, on 23 December 1888, had been the worst, when Van Gogh had mutilated
his ear. But he then went on to suffer three further crises in Arles in the weeks that
followed, leading to his decision to retreat to Saint-Paul. As Theo put it, 'genius
roams along such mysterious paths in the mind that a spell of dizziness can bring it
hurtling down from its heights'.[3]

Vincent retained only a vague idea of what lay behind his gruesome self-
mutilation. As he explained to Theo a month after his arrival at Saint-Paul,
whenever he thought back to the ear incident 'a terrible terror and horror seizes
me and prevents me from thinking'. There must be 'something, I don't know what,
disturbed in my brain'. One point that he did acknowledge, a month after the ear
incident, was that he had suffered 'unbearable hallucinations', although these had
since receded.[4]

Detail of fig. 46 *Rain*,
Philadelphia Museum
of Art

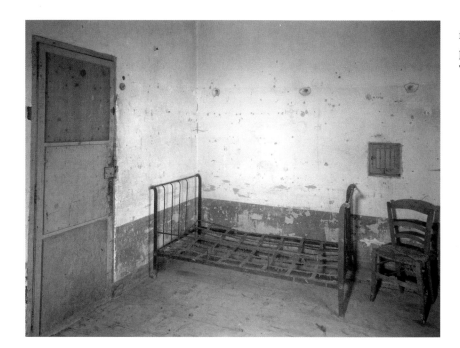

fig. 78 'The true cell', photograph by Marc Tralbaut, 1955–6

It is important to go back to what the artist's own doctors recorded. Dr Albert Delon examined Van Gogh on 7 February 1889, after he had suffered a second crisis. Van Gogh was then subject to 'auditory hallucinations' and he 'hears voices uttering reproaches against him'.[5] On his arrival at Saint-Paul, Dr Peyron recorded that in Arles his patient had suffered 'an attack of acute mania with visual and auditory hallucinations that led him to mutilate himself by cutting off his ear'.[6]

Although the ear incident has been endlessly discussed in the Van Gogh literature, insufficient attention has been devoted to these brief references to 'auditory hallucinations'.[7] These could well have made the artist feel that he was hearing some unbearable words or sounds, possibly screams. In the utmost desperation, Van Gogh might have believed that by removing his ear he would no longer hear the dreadful sounds that were driving him crazy.[8]

Initially Van Gogh's mental health improved at Saint-Paul, but two months after his arrival, in mid-July 1889, he succumbed to a sudden attack when he was outside painting near the quarry. Dr Peyron reported to Theo that Vincent had tried 'to poison himself with his brush and paints'.[9] Van Gogh vomited, but his throat then became very badly swollen. For four days he was in agony and unable to eat, and even a month later he still found it painful to swallow. Vincent admitted to Theo that during these attacks he would 'pick up filthy things and eat them, although my memories of these bad moments are vague'.[10] Unusually, this letter was written with black chalk, since the doctor had not yet allowed him access to ink.

Immediately after this first attack Van Gogh was taken to one of the ground floor rooms set aside for the most disturbed patients, near Dr Peyron's office.[11] This could well be the room photographed in the 1950s by the Belgian Van Gogh specialist Marc Tralbaut, who captioned it 'the true cell'[12], although it was not the artist's own bedroom (fig. 78). In the photographed room there appears to be no handle on the door, so it could not be opened from the inside, imprisoning the patient.

Throughout this crisis, Vincent suffered harrowing nightmares. As he reported shortly afterwards: 'All the people I see then seem to me, *even if I recognise them* – which isn't always the case – to come from very far away and to be *entirely different* from what they are in reality.'[13] Despite this traumatic experience, Vincent expressed his gratitude to Dr Peyron, who was 'really kind to me'. But it had been a terrible time, as he recounted to his brother: 'For many days I've been *absolutely distraught*, as in Arles, just as much if not worse, and it's to be presumed that these crises will recur in the future, it is ABOMINABLE.'[14] One can only imagine how dismayed Theo must have been to receive such a letter.

A month or so after the crisis Vincent settled down. Acknowledging that he had tried to commit suicide, he explained that 'finding the water too cold' he was struggling to regain the river bank. Still being denied access to his paints, he asked Theo to intervene with Dr Peyron to insist that 'working on my paintings is quite necessary to me for my recovery'.[15] Eventually Vincent was allowed to resume painting in early September and began with another view of the wheatfield and its surroundings from his bedroom window.

Field with Ploughman amply demonstrates that the ordeal had in no way affected Van Gogh's artistic skills (fig. 79). This energetic depiction of rippling furrows dwarfs a farmer working in the early hours beneath a rising sun. Striding behind his horse, the ploughman could be a metaphorical self-portrait, for Vincent was returning to his vocation with a vengeance, determined to make up for lost time. As he told Theo, 'I'm ploughing on like a man possessed, more than ever I have a pent-up fury for work, and I think that this will contribute to curing me'.[16]

Dr Peyron added a postscript to one of Vincent's letters to Theo, confirming that his patient had now 'fully regained his lucidity'. The doctor added: 'His ideas of suicide have disappeared; there remain only his bad dreams, which are tending to disappear, and are of lesser intensity.'[17] A month later Vincent told Theo: 'Peyron is right when he says that strictly speaking I'm not mad, for my thoughts are absolutely normal and clear between times, and even more than before, but during the crises it's terrible however, and then I lose consciousness of everything.' Vincent went on to compare his determination to work quickly to a coal miner, who as he is 'always in danger makes haste in what he does'.[18] Ten years earlier, in the Borinage, Van Gogh had learned at first hand about a terrible underground

explosion which had killed over one hundred miners, so he was only too aware of the risks they faced.

Van Gogh was in reasonable health in the autumn and in mid-November Dr Peyron allowed him out by himself for a two-day visit to Arles, his first night away.[19] The artist must have felt a mixture of exhilaration and fear at suddenly being thrust into the bustle of a large town. There he met Reverend Salles and probably his friends Joseph and Marie Ginoux.

One can only speculate, but he might have been tempted to visit Rue du Bout d'Arles, just five minutes' away from the Ginouxs' Café de la Gare. It was in one of the brothels there, nearly a year earlier, that he had handed over a gruesome packet containing his severed ear to a young woman, Gabrielle Berlatier.[20] While living in Arles he had made regular visits to prostitutes, explaining that he lived 'like a monk who goes to the brothel once a fortnight – I do that'. But in the small town of Saint-Rémy there was no opportunity to enjoy the company of what Van Gogh called the 'good little ladies'.[21]

Back at Saint-Paul, on Christmas Eve, precisely one year after he had been taken to the hospital in Arles, Van Gogh suddenly suffered another crisis. Because of the timing, it is difficult to avoid the conclusion that he was recalling the ear incident, and that this sparked off a further attack. As he later told Theo, 'all at once, without any reason, the confusion took hold of me again'.[22] Once again Vincent had tried to poison himself by eating paint.[23] Fortunately this proved to be a short attack, lasting only a week.

This second crisis led to Van Gogh receiving his only visitor during the 12 months at Saint-Paul. Theo knew about the attack, and, very worried, he had written to Reverend Salles, who had immediately dropped everything to make a day trip from Arles on 2 January 1890. However, unknown to Theo, by this time Vincent had just regained his mental balance. Touched by the pastor's concern, Van Gogh presented his visitor with a still life of pink and red geraniums on a black background.[24] Sadly, Reverend Salles was the only visitor who came to see the artist during his year at Saint-Paul. Theo never travelled, and neither did Vincent's friends from nearby Arles, Dr Rey and Joseph and Marie Ginoux, or the postman Joseph Roulin, who had just moved to Marseille.

Dr Peyron once again felt that Van Gogh had made a good recovery and he allowed his patient to set off on a third trip to Arles in mid-January 1890, although this was surprisingly soon after the Christmas episode. Two days after his return Vincent was struck down by yet another attack. The doctor wrote to Theo: 'He is incapable at present of any kind of work, and only responds with incoherent words when asked questions'.[25] Vincent himself later explained that 'I no longer know where I am and my mind wanders'.[26] Fortunately this crisis also lasted only a week or so.

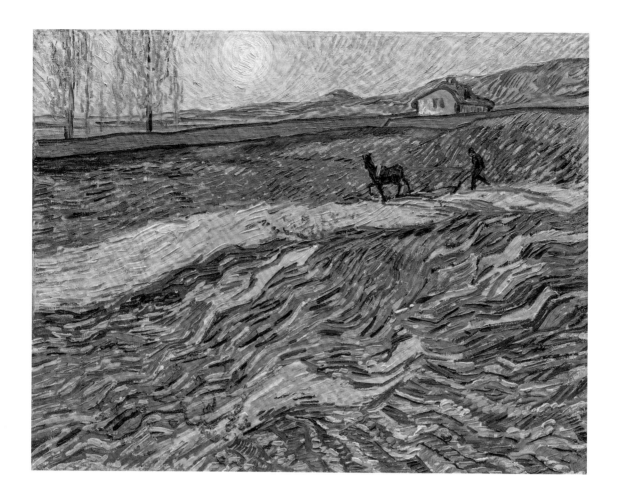

fig. 79 *Field with Ploughman*, September 1889, oil on canvas, 49 x 62 cm, private collection (F625)

Van Gogh enjoyed a short respite before suffering a further episode. During a fourth visit to Arles in late February 1890 he was struck down by yet another attack. Dr Peyron told Theo that 'it is not known where he spent the night of Saturday to Sunday'.[27] The following day someone alerted the doctor, who sent a carriage with two men to pick him up. Poulet, the driver, presumably went with one of the orderlies.

It is surprising that Dr Peyron did not give Theo any details of the circumstances in which Vincent had been found, which raises the possibility that it might have been near Rue du Bout d'Arles. Vincent had intended to visit his friends the Ginoux couple, but he never arrived. In the same letter the doctor commented that he did not believe Van Gogh was 'succumbing to any excesses when he is able to move freely, as I have only ever known him to be sober and reserved'. 'Sober' presumably referred to alcohol and 'reserved' possibly euphemistically to sex, but one wonders why the doctor felt obliged to even raise these issues.

Belatedly, Dr Peyron acknowledged that 'the crises are recurring more frequently and come after each journey he makes outside this home'.[28] The February visit to Arles proved to be Van Gogh's last. Despite having several close friends there, he never returned to say his goodbyes before his eventual departure for Paris.

Van Gogh's last crisis at Saint-Paul turned out to be by far the longest. Although experiencing a brief respite in mid-March, when he took advantage of a good day to write to Theo,[29] he then reverted to a disturbed state. As Dr Peyron explained to Theo on 1 April: 'At times, he seems almost himself again; he understands what he is feeling, only for the situation to change again a few hours later, when the patient once more becomes sorrowful and troubled, and no longer answers the questions put to him.'[30]

Vincent's 37th birthday on 30 March may well have passed in a daze. His 70-year-old mother, Anna, had sewn him a tobacco pouch and posted it along with a tin of chocolates and a book from Wil. Theo sent him a set of reproductions of Rembrandt prints, together with a moving letter, saying: 'How pleased I would be to be able to go and see you tomorrow to shake your hand on your birthday... My dear brother, how sad it is to be so far from one another and to know so little of what the other is doing'. It was not until the end of April that Vincent was able to resume correspondence.[31]

During his previous attacks, Van Gogh was incapable of working and it had also been necessary to bar him from his painting materials to prevent further poisoning attempts. But during this two-month crisis, he worked intermittently, although for the first time his drawings and handful of paintings show signs of his troubled mental condition.

Looking back on Van Gogh's attacks at Saint-Paul, it is disturbing that during the first two episodes he had tried to poison himself with paint, turpentine or paraffin. This was confirmed by Dr Peyron, who recorded on his departure: 'On several occasions he has attempted to poison himself, either by swallowing colours that he used for painting, or by ingesting paraffin, which he had taken from the boy while he was filling his lamps.'[32] These incidents were later recalled by two witnesses, Sister Epiphane and Poulet.[33]

Curiously, Van Gogh feared that other people were trying to poison him, rather than realising that this is what he was doing to himself. In February 1889, in Arles, Reverend Salles had informed Theo that 'for three days he has thought he is being poisoned and just sees poisoners and victims of poison everywhere'.[34] This was confirmed by the Arles hospital, with Dr Delon recording that Van Gogh had 'an *idée fixe*, according to which he is supposed to have been the victim of an attempted poisoning'.[35] In short, it seems that Van Gogh ingested poison during his attacks – but believed that others had poisoned him.

Van Gogh certainly represented a very real suicide risk. Dr Peyron must have faced a terrible dilemma over whether to allow his patient to work outside the asylum, to visit Arles and to have access to potentially dangerous painting materials, but Van Gogh must have insisted that he wanted these freedoms. Fortunately, his attempts at self-harm were all dealt with just in time, thanks to vigilant care.

What, then, was the cause of Van Gogh's self-mutilation in Arles? Fear of abandonment, by Gauguin and much more importantly by Theo, could well have been one of the triggers for the initial episode. Auditory hallucinations, and an attempt to block off terrible noises, might explain why he cut off his left ear. But it is much more difficult to determine his underlying medical and psychological condition.

Van Gogh's doctors in Arles and at Saint-Paul diagnosed epilepsy. Writing to Wil, Vincent reported that Dr Peyron 'does *not* consider me a lunatic but that the crises I have are of an epileptic nature'.[36] At that time it would have been regarded as *épilepsie larvée* (creeping epilepsy), which leads to alternating periods of over-excitement and depression, irritability, memory loss and hallucinations. This condition would now be categorised as a form of temporal lobe epilepsy, a disorder of the nervous system.[37]

However, if the diagnosis of epilepsy was correct, little was then understood about the condition and even less about appropriate treatment. The only medication Van Gogh is known to have been given, and that was in Arles, was potassium bromide – a sedative for epilepsy patients which reduced hallucinations.[38] In the twentieth century the drug was no longer prescribed, due to its toxicity. Other than that, it seems that Van Gogh was required to have a two-hour bath twice a week, which he said was to 'calm one down'.[39] Vincent was only too conscious of the lack of medical care. As he told Theo, 'the treatment of the patients in this hospital is certainly easy to follow... for they do absolutely nothing about it, they leave them to vegetate in idleness and feed them with stale and slightly spoiled food'.[40]

Since his death Van Gogh's symptoms have been studied by numerous physicians and psychologists, but there is still no consensus on what caused his suffering.[41] Along with a form of epilepsy, other plausible conditions include cycloid psychosis or borderline personality disorder, but the most widely accepted current diagnosis is bipolar disorder – previously known as manic depression.[42] Despite all the evidence contained in Van Gogh's detailed letters, the nature of his illness remains almost as elusive today as it was in his own time.

CHAPTER TWELVE

MIRROR IMAGES

'People say... that it's difficult to know oneself – but it's not easy to paint oneself either'[1]

Detail of fig. 81
Self-portrait with swirling Background, Musée d'Orsay, Paris

After recovering from his first crisis at the asylum, Van Gogh picked up his brushes, looked in a mirror and set to work on a self-portrait. 'I began the first day I got up, I was thin, pale as a devil', he told Theo (fig. 80).[2] A few weeks earlier he had swallowed paint, trying to poison himself, yet he was now using those very same tubes to produce magnificent self-portraits that plumbed the recesses of his psyche. Van Gogh is rightly regarded, along with his compatriot Rembrandt, as art history's greatest self-portraitist. In less than four years, from 1886 to 1889, he painted himself on 35 occasions, capturing a wide range of expressions and moods.

The trio of September 1889 self-portraits, done from the same angle, depict the artist's undamaged right ear, although his use of a mirror means that they show a reversed view. Until the ear episode Van Gogh's self-portraits had been almost evenly divided between those showing his left and right sides. A month after the incident he had produced two paintings which prominently depict his bandaged ear, but these were deliberately done to record his condition (fig. 11).[3] By September he no longer wished to dwell on his disfigurement.

At the asylum, patients would presumably have been forbidden free-standing mirrors, due to the risk of injury, and wall-mounted ones were probably only found in the wash room. One wonders how Van Gogh got access to a mirror, but somehow he succeeded. He peered into it with profound concentration, probing his physiognomy and psychological condition towards the end of what had been an extremely difficult year.

fig. 80 *Self-portrait with Palette*, September 1889, oil on canvas, 57 x 44 cm, National Gallery of Art, Washington, DC (F626)

fig. 81 *Self-portrait with swirling Background*, September 1889, oil on canvas, 65 x 54 cm, Musée d'Orsay, Paris (F627)

Why did Vincent turn to self-portraiture after his recovery? He told Theo that it was 'for want of another model', but there was a deeper reason, too.[4] The self-portraits sent out a message – to fellow patients, staff, family and, most importantly, to himself: having emerged from a crisis, he was absolutely determined to pursue his vocation as an artist. The inclusion of his palette and brushes in the first of these reinforces this resolve.

Begun very soon after gaining access to his studio, Van Gogh's first self-portrait was probably one that he had been contemplating during his recuperation. In *Self-portrait with Palette* (fig. 80) the artist appears gaunt and tired, hardly surprising after his ordeal. His piercing green eyes and ginger beard stand out against the dark blues of his clothing and the backdrop. Vincent later decided to give the painting to a friend of Theo, the writer and artist Joseph Isaäcson.[5]

A few days later Van Gogh set to work on his magnificent *Self-portrait with swirling Background* (fig. 81). This time the tools of his trade have been omitted, with his smock replaced by his best clothes. The jacket must be the 35-franc suit which he had bought in Arles just a few days before his departure from Arles.[6] The artist stares straight ahead, his sunken eyes fixed on the viewer with a determined, even defiant air. His stern, somewhat distant mien hints at a facade which he created to protect himself from the indignities of asylum life.

Equally striking is the ebullient brushwork of the turquoise blue background, a rhythmical patterning full of dynamism. While the artist's face appears slightly less haggard than in his previous work, it is tempting to see the whirling brushstrokes of the background as a reflection of what was going on in his mind. But Vincent assured Theo that 'my physiognomy has grown much calmer', so it is equally possible that the painter was simply aiming for an integrated, yet lively composition in a range of blues, balancing the background against the suit.[7]

Van Gogh was certainly happier with the second of his September self-portraits, dispatching it to Theo less than a fortnight later. Vincent suggested that his brother should compare it with those he had painted several years earlier in Paris. 'I look healthier than then, and even a great deal more so', he commented. This latest picture, Vincent said, was more eloquent than words – 'the portrait will tell you better than my letter how I am'.[8]

Another reason for sending *Self-portrait with swirling Background* to Paris so promptly was that Vincent wanted Theo to show it to Pissarro. By September Vincent was already thinking of leaving the asylum and wondered whether he might be able to lodge with the Impressionist painter, who lived in Eragny, a village northwest of the capital. Vincent presumably felt that the self-portrait would reassure Pissarro that he was not mad – and that he had certainly lost none of his artistic skills. In the end, he did not move to Eragny, but to the village of Auvers-sur-Oise. There Van Gogh would develop a friendship with Dr Paul Gachet, who would later receive the

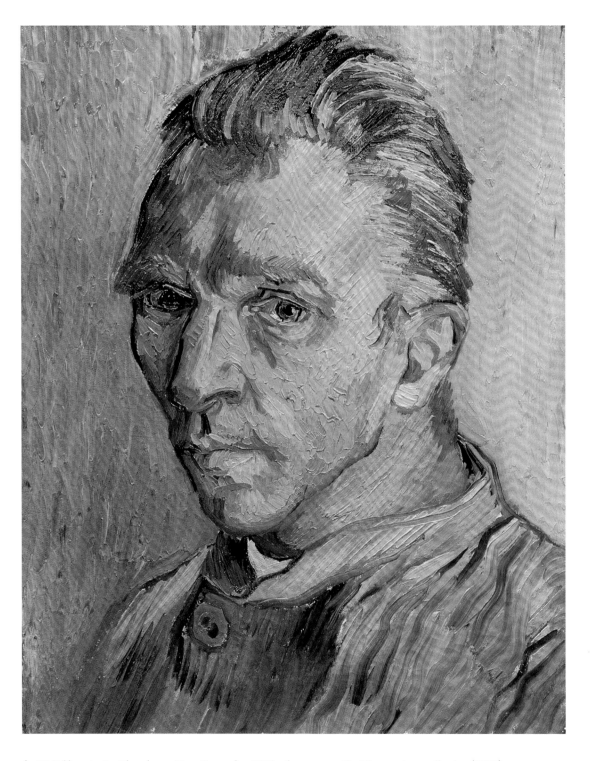

fig. 82 *Self-portrait with a shaven Face*, September 1889, oil on canvas, 40 x 31 cm, private collection (F525)

self-portrait as a special gift. The doctor, he said, was 'absolutely *fanatical*' about the painting.[9]

Vincent also made a third self-portrait later in September 1889. *Self-portrait with a shaven Face* (fig. 82), done for his mother Anna and sister Wil, captures a fresher-looking appearance. In a letter to his mother, alluding to his birthplace, he wrote that 'I still look more or less like a peasant from Zundert', rather than a city man from London or Paris.[10] Vincent was anxious to suggest to his mother that he remained the son she had once known.

Van Gogh is, unusually, without a beard in this final self-portrait. A year earlier, in the summer of 1888, he had shaved, probably because of the heat, and he then told Theo that he no longer looked like a 'mad painter'.[11] Immediately after the self-mutilation he was presumably shorn for medical reasons (fig. 11). However at the asylum he once again grew his beard, a decision perhaps spurred by having only supervised access to a razor. Sideburns might also have helped a little to disguise his terrible disfigurement, although in the two bearded self-portraits his sideburns are thin, possibly because of scarring he may have suffered around his lost ear. It is also possible that he still had a beard, but depicted himself without facial hair to please his mother. In any case, this penetrating image of the beardless artist would turn out to be his final self-portrait.

The main reason for dating *Self-portrait with a shaven Face* to the second half of September is that it appears in the background of his replica of *The Bedroom*, done at the end of the month (fig. 84).[12] The original painting of his room in the Yellow House had been done a year earlier in Arles. In that first version, two portraits hang above his bed – those of the Zouave soldier Paul-Eugène Milliet and the Belgian artist Eugène Boch. But in this later and smaller repetition he replaced his two friends with an unidentified woman and the beardless self-portrait.

fig. 83 Vincent van Gogh aged 19, January 1873, photograph by Jacobus de Louw, The Hague

fig. 84 *The Bedroom* (later version), September 1889, oil on canvas, 57 x 74 cm, Musée d'Orsay, Paris (F483)

This new repetition of *The Bedroom* was, like the clean-shaven self-portrait, also painted for Anna and Wil, who were about to move to a new home in Leiden.[13] Vincent may have enjoyed the conceit of sending them a self-portrait which then appeared as a 'painting in a painting' in his Arles bedroom. Altogether he sent his mother and sister seven paintings, saying 'don't feel uncomfortable about hanging them in a corridor, in the kitchen, on the stairs'.[14]

We know Van Gogh's physiognomy almost entirely from his self-portraits, since the only two surviving photographs of him were taken at the ages of 13 and 19 (fig. 83). He always resisted being photographed as an adult, explaining to Wil that 'I myself still find photographs frightful and don't like to have any, especially not of people whom I know and love'. He went on to say that photographs become 'faded more quickly than we ourselves', while paintings remain 'for many generations'.[15]

TRANSFORMING INTO COLOUR

'It's not copying pure and simple... It is rather translating into another language, the one of colours'[1]

During the autumn of 1889 Van Gogh set off on a new and quite unusual venture: to 'translate' black-and-white images of prints by other artists into his own paintings in oils. These are not simply copies, but his own personal interpretations, done on a larger scale than the originals and, most importantly, in colour. Altogether he made 28 such works, representing nearly a fifth of his Saint-Paul paintings.[2] They demonstrate how the more traditional artists he admired could be reinterpreted for a new generation.

In what is among Van Gogh's most evocative letters from Saint-Paul, he compared creating art to making music. If a performer 'plays some Beethoven he'll add his personal interpretation to it', he wrote – adding 'it isn't a hard and fast rule that only the composer plays his own compositions'. Van Gogh went on to make another musical analogy, describing how 'my brush goes between my fingers as if it were a bow on the violin'. The process of making painted versions of black-and-white prints was, he said, setting out to 'improvise colour'.[3] Van Gogh had long been interested in the links between painting and music, and six years earlier he had actually taken piano lessons in order to explore the similarities of colours in pictures and musical notes.[4]

There were also practical considerations behind his project. With winter approaching, it would become less comfortable to work outside, and he was not always allowed to leave the asylum. 'Even half locked up I'll be able to occupy myself for a long time' with the reinterpretations, he wrote.[5] Within the asylum, finding sitters for portraits was difficult and there were few flowers for still lifes at this time of year. Using his imagination to create paintings from prints presented a new opportunity.

Detail of fig. 90 *Noon: Rest* (after Millet), Musée d'Orsay, Paris

fig. 85 Célestin Nanteuil-Leboeuf, *Pietà* (after Eugène Delacroix), c.1850, lithograph (Van Gogh's damaged copy), 22 x 17 cm, Van Gogh Museum, Amsterdam (Vincent van Gogh Foundation)

fig. 86 *Pietà* (after Delacroix), September 1889, oil on canvas, 73 x 61 cm, Van Gogh Museum, Amsterdam (Vincent van Gogh Foundation) (F630)

Van Gogh had always been inspired by prints of works by other artists and had collected them since he was a young trainee art dealer in London. Most were modest reproductions cut out of illustrated journals and throughout his life he had saved hundreds, probably thousands of images, lovingly mounting many of them on light card. The bulk of the collection remained behind in Paris, but those he brought to Saint-Paul or which Theo sent provided a great visual stimulus.

Vincent embarked on his project in September 1889, starting with the *Pietà* by the French mid-nineteenth century Romantic artist Eugène Delacroix. Basing it on a lithograph which he had once pinned to the wall in the Yellow House, he created his own interpretation. Vincent explained the rationale: 'During my illness a misfortune

happened to me – that lithograph of Delacroix, the Pietà, with other sheets had fallen into some oil and paint and got spoiled. I was sad about it – then in the meantime I occupied myself painting it.'[6] His copy of the print, with the disfiguring damage, still survives (fig. 85).

Working from the print, Van Gogh painted a first version and then a second, larger interpretation of the *Pietà* (fig. 86).[7] Having never seen Delacroix's original painting, his picture is not surprisingly coloured quite differently. Vincent has also given the dead Christ ginger hair and a beard that resemble his own. This may have been deliberate, although artists sometimes unconsciously incorporate their own features into their work. Vincent described his version of the *Pietà* to Wil, with 'the exhausted corpse' being held by the Virgin at the entrance to a cave. The Virgin, clad in blue, stands out 'against a sky in which violet clouds fringed with gold are floating', following an evening storm.[8]

The Pietà may seem an odd choice of subject for Van Gogh, since many years earlier he had rebelled against his father's faith. Even more surprisingly, he then hung his painting in his bedroom. Considering the marvellous Provençal landscapes which the artist could have displayed, it seems astonishing that he should choose the dead Christ to watch over him at night.

Van Gogh explained that 'I don't much like seeing my own paintings in my bedroom', suggesting that reinterpretations of works by other artists were somehow more acceptable. This seems rather unconvincing, since his Arles bedroom paintings show his own pictures hanging in the Yellow House. His choice of the Pietà may have been spurred on by his profound suffering for, as he admitted, 'religious thoughts sometimes console me a great deal'.[9] It is certainly telling that he tackled the Pietà at a moment of extreme vulnerability, presumably appreciating the Virgin's tender care in cradling the body of her dead son.

fig. 87 Adrien Lavieille, *Reaper with a Scythe* (after Jean-François Millet), 1853, wood engraving (Van Gogh's copy), 14 x 8 cm, Van Gogh Museum, Amsterdam (Vincent van Gogh Foundation)

fig. 88 *Reaper with a Scythe* (after Millet), September 1889, oil on canvas, 44 x 25 cm, private collection (F688)

LA SIESTE. — Composition et dessin de J. Millet.

The artist may well have intended the smaller version of the Pietà for the Sisters, since many years later Epiphane recalled that he had offered paintings for their common room. These would most likely have been his versions of religious works.[10] However, the other Sisters had politely refused the artist's generous suggestion. Through a satisfying twist of fate, the smaller version of the Pietà eventually ended up at the Vatican, in its Museum of Modern Religious Art.[11]

Van Gogh next turned to Jean-François Millet, the painter of peasant life who had died in 1875.[12] Since Vincent's youth, Millet was the established nineteenth-century artist whom he most admired. At Saint-Paul he ambitiously set out to produce paintings based on all ten of Millet's prints of 'Labours of the Fields', which Theo had sent him in Arles. *Reaper with a Scythe* (figs. 87 and 88), arguably the finest of Van Gogh's paintings from the series, is worked with vigorous brushstrokes that make the golden corn blaze out against the deep blue sky.

As Vincent was putting the finishing touches to the 'Labours of the Fields', he asked Theo to post him prints of Millet's 'Four Times of the Day', which again he had admired since his younger days. In 1875, as a trainee art dealer in Paris, he had hung them in his Montmartre bedroom and five years later, as he embarked on becoming an artist, he drew copies of the prints. On receiving 'Four Times of the Day' at Saint-Paul, Vincent thanked Theo, saying that 'I was growing flabby by dint of never seeing anything artistic, and this revives me'.[13]

Van Gogh finished a coloured version of one of the set in early November, but he delayed doing the other three and was then struck down by another short attack just before Christmas. He completed the remainder early in the new year. In *Noon: Rest* a peasant couple are taking a siesta, lying atop the wheat they have just harvested (fig. 89).[14] In Van Gogh's interpretation, he once again used the contrast between blues and rich golden tones to striking effect, evoking the heat of midday (fig. 90). He had not set out to copy the prints, but 'rather *to translate them into another language*' – the one of colours, with 'a most profound and sincere admiration for Millet'.[15]

Vincent went on to tackle the *Sower*, his favourite Millet print, which he had twice copied as a drawing many years earlier. During his time in Arles he had asked Theo to send him an etching (fig. 91) and from this he painted two versions at Saint-Paul, the first in November 1889 and a larger one just over two months later (fig. 92).[16]

fig. 91 Paul LeRat, *Sower* (after Millet), 1873, etching (Van Gogh's squared-up copy), 12 x 10 cm, Van Gogh Museum, Amsterdam (Vincent van Gogh Foundation)

fig. 92 *Sower* (after Millet), January 1890, oil on canvas, 81 x 65 cm, private collection (F690)

In February Van Gogh embarked on making a painted copy of an illustration by Gustave Doré which had been originally published in *London: A Pilgrimage*, a book which Van Gogh had known from his time in England. He selected the image of *Newgate – Exercise Yard*, but rather than using a print from the book, he squared up a reproduction republished in a Dutch magazine to make a larger, coloured version (fig. 93).[17]

Van Gogh can hardly have avoided seeing parallels between the incarceration of prisoners in Newgate and his own life at Saint-Paul. The Doré image depicts several dozen inmates patiently shuffling around in an endless circle, compressed into a forbidding, claustrophobic courtyard. Although nearly all Doré's men are faceless, in Van Gogh's coloured version (fig. 94) the nearest man in the foreground looking out has ginger hair and similar features to his own.

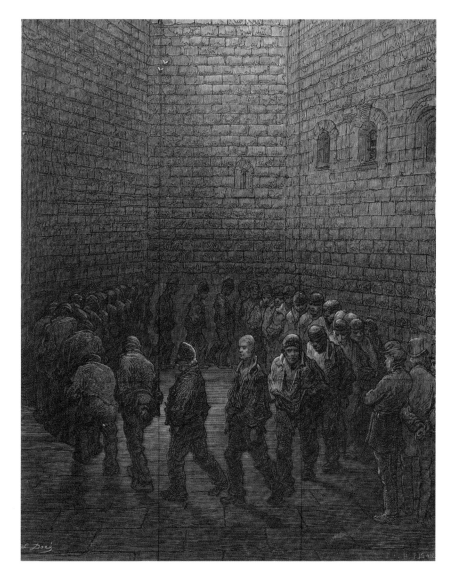

fig. 93 Héliodore Pisan, *Newgate – Exercise Yard* (after Gustave Doré), 1872–73, wood engraving (Van Gogh's squared-up copy), 25 x 19 cm, Van Gogh Museum, Amsterdam (Vincent van Gogh Foundation)

Fig. 94 *Exercise Yard* (after Doré), February 1890, oil on canvas, 80 x 64 cm, Pushkin State Museum of Fine Arts, Moscow (F669)

The next reinterpretation was rather different, since it was based on a drawing by his colleague Gauguin. While they were working together Gauguin had sketched Marie Ginoux, the proprietress of the Café de la Gare (fig. 95), whom the two artists dubbed the Arlésienne because of her traditional costume. Gauguin had drawn her in preparation for his painting *The Night Café* and gave the sketch to Van Gogh, who brought it with him to Saint-Paul.[18]

Van Gogh used Gauguin's drawing as a starting point to develop his own painting (fig. 96). Adjusting the composition, he added two books on a table in front of Madame Ginoux – Harriet Beecher Stowe's *Uncle Tom's Cabin* and

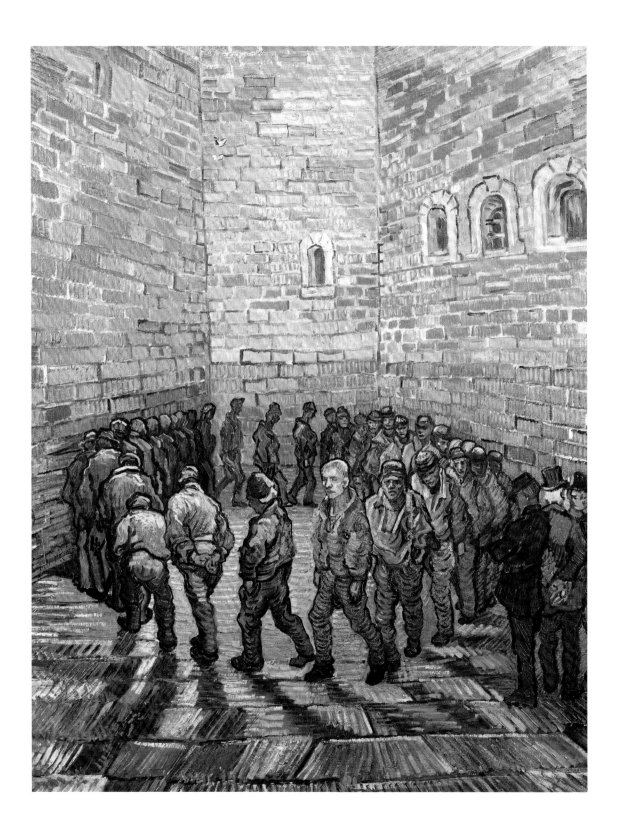

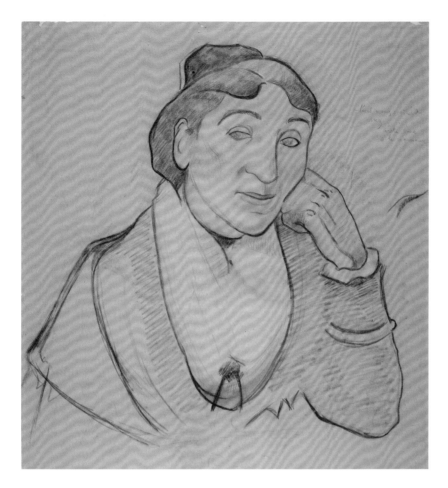

fig. 95 Paul Gauguin, *Portrait of Marie Ginoux (The Arlésienne)*, November 1888, coloured chalk and pastel on paper, 56 x 49 cm, Fine Arts Museums of San Francisco

fig. 96 *Portrait of Marie Ginoux (The Arlésienne)*, February 1890, oil on canvas, 60 x 50 cm, Galleria Nazionale d'Arte Moderna, Rome (F540)

Dickens's *Christmas Books*. These titles were on his mind and a few weeks earlier he had commented how edifying it was to read 'a fine book like one by Beecher Stowe or Dickens'.[19]

Van Gogh completed no fewer than five versions of *The Arlésienne*, including one for Madame Ginoux herself which was sadly lost during the crisis he suffered in Arles in February 1890.[20] The artist blamed his hard work on the portraits for the attack, complaining that he had paid for them 'with another month of illness'.[21]

Van Gogh presented another version of *The Arlésienne* to Gauguin, to thank him for the drawing and as a friendly gesture to maintain cordial relations after their difficult time in Arles. Responding with polite enthusiasm, Gauguin said that his friend's painting was 'very fine and very curious, I like it better than my drawing'. Van Gogh felt he had remained 'respectfully faithful' to the drawing, while interpreting it through colour. In a heartfelt gesture, he wanted Gauguin

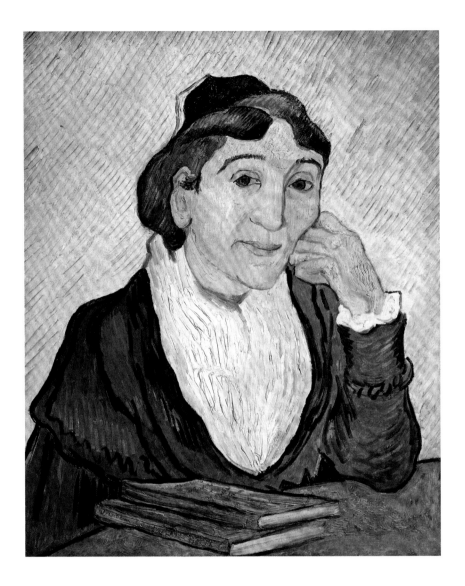

to regard the painting as 'a work by you and me, like a summary of our months of work together'.[22]

The most poignant of Van Gogh's 'translations' into colour was from one of his own works, *At Eternity's Gate*, depicting an old man resting his head in his hands (fig. 97).[23] Dating from 1882, when Van Gogh was working in The Hague, he had inscribed an English title on one of the prints – the copy now in the Tehran Museum of Contemporary Art. As the title suggests, the elderly and sorrowful man is approaching death. Van Gogh's painting of *At Eternity's Gate* (fig. 98) dates from early May 1890, just after he had emerged from his two-month crisis.

The artist introduced a few modifications to the composition in his large painted version. Stylistically, the changes reflect the artist's development over the intervening eight years. In the print, Van Gogh had done his best to depict the man's figure accurately, whereas in his maturity he worked in a looser manner to convey the deep emotions. In painting the figure, Van Gogh may have partly had in mind the elderly patients he encountered in the common room. Antoine Silmain, the retired priest, and Jean Biscolly were then both 77.

In *At Eternity's Gate*, the man's clenched fists suggest the anguish that Van Gogh himself must also have been feeling. Two weeks before starting work on the picture Dr Peyron had written to Theo, reporting that Vincent was still depressed: 'He usually sits with his head in his hands, and if someone speaks to him, it is as though it hurts him, and he gestures for them to leave him alone.'[24] *At Eternity's Gate* would be among the last works that the artist painted at Saint-Paul. In a sense it represents a self-portrait, not in physiognomy, but in posture.

When Van Gogh began his project to reinterpret black-and-white works into colour he thought that he might eventually 'give the whole lot to a school'. Referring to Millet, he wanted to make the earlier artist's work 'more accessible to the ordinary general public', but he worried that his own versions would be 'despised as copies'.[25] Van Gogh's reinterpretations may not rank among his finest works, but the small *Reaper with a Scythe* (fig. 88), based on a Millet print, sold for over £24 million in 2017. Had a school actually ended up with Van Gogh's full collection of painted copies they might be worth something approaching £1 billion, on the basis of this recent sale. Although in Van Gogh's time Millet had become one of the most expensive nineteenth-century artists, the current record auction price for any of Millet's pictures now stands at just £2 million for a harvest scene.[26] Tastes in art can radically change.

fig. 97 *At Eternity's Gate*, November 1882, lithograph (with inscribed title), 52 x 34 cm, Tehran Museum of Contemporary Art (F1662)

fig. 98 *At Eternity's Gate*, May 1890, oil on canvas, 82 x 66 cm, Kröller-Müller Museum, Otterlo (F702)

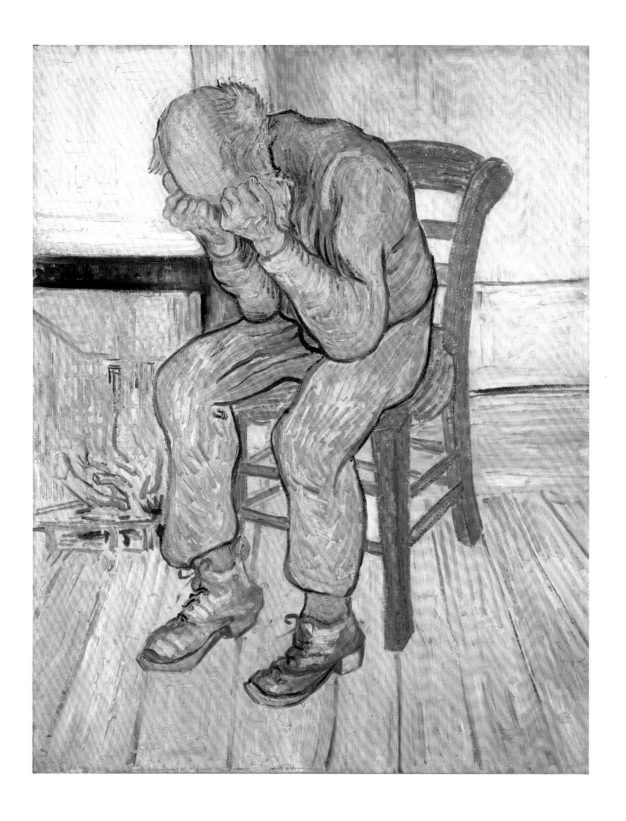

MEMORIES OF THE NORTH

'While I was ill I nevertheless still did a few small canvases from memory... reminiscences of the north'[1]

Detail of fig. 101 *Two Peasant Women Digging*, Van Gogh Museum, Amsterdam (Vincent van Gogh Foundation)

In an astonishing burst of activity while enduring his last crisis at Saint-Paul, Van Gogh produced at least 60 drawings and several paintings over the course of two months. Suffering deep mental anguish, his thoughts turned to his Dutch homeland and his youth. As Vincent explained to his mother Anna and Wil, 'while my illness was at its worst, I still painted, among other things a reminiscence of Brabant' – the region in the southern Netherlands where he grew up.[2] He had also stayed there during his early days as an artist in 1883–5, when his parents were living in the village of Nuenen and he was developing as an artist, focusing on peasant life. Lying ill in his bed in Saint-Paul, these images flooded back.

Vincent had experienced similar feelings in Arles just after the ear incident, when he recalled the village of his birth. As he then told Theo: 'During my illness I again saw each room in the house at Zundert, each path, each plant in the garden, the views round about, the fields, the neighbours, the cemetery, the church, our kitchen garden behind – right up to the magpies' nest in a tall acacia in the cemetery.'[3]

Van Gogh's final crisis at the asylum turned out to be the longest, lasting from late February to late April 1890. Unlike the earlier and shorter attacks, he had brief periods of remission when he felt more like his usual self.[4] His claim that he continued to paint while at his 'worst' must have been an exaggeration, but Dr Peyron seems to have permitted him access to his studio on better days and he certainly frequently drew.

On recovering, Vincent wrote to Theo about a handful of paintings which he described as 'reminiscences' of his childhood and younger days in the Netherlands.[5] Despite his parents' love and care, there were sometimes painful moments and Vincent's childhood was often unhappy. As an adult, relations with his father Theodorus ended disastrously. When Vincent was 27 his father had tried to get him admitted to the Gheel mental institution and Vincent eventually broke off relations with Theodorus just before his death in 1885.

fig. 99 *Reminiscence of Brabant*, March–April 1890, oil on canvas, 29 x 37 cm, Van Gogh Museum, Amsterdam (Vincent van Gogh Foundation) (F675)

fig. 100 *Cottages at Sunset*, March–April 1890, oil on canvas, 52 x 40 cm, Barnes Foundation, Philadelphia (F674)

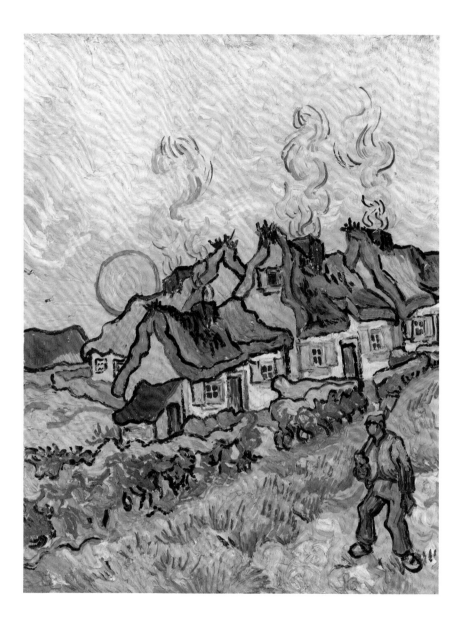

Yet despite these deep family problems, Vincent retained a strong empathy with the Brabant countryside, and in particular with its peasantry. While at Saint-Paul, images from this formative period reasserted themselves. 'I think a lot about Holland and about our youth', Vincent told Wil.[6]

Some of the paintings Van Gogh worked on during the crisis may well have been only partially completed or discarded, but five survive as emotional mementoes.[7] All five are expressionist works, built up with jerky brushstrokes,

fig. 101 *Women Digging*,
March–April 1890, oil on
paper on canvas,
50 x 64 cm, Bührle
Collection, Zurich (F695)

fig. 102 *Two Peasant
Women Digging*, March–
April 1890, black chalk
on pink paper,
24 x 28 cm, Van Gogh
Museum, Amsterdam
(Vincent van Gogh
Foundation) (F1586v)

reflecting something of his tortured state of mind. They are almost the only paintings from Saint-Paul in which signs of his mental instability are readily visible. These works are unsettling, but they do not seem to reveal anything of the hallucinations that he had suffered during his crises. Really disturbing images rarely surface in his art. He presumably had no wish to recall the terrible things that he felt he had witnessed.

Reminiscence of Brabant (fig. 99) is dominated by a turbulent sky, with dark clouds fringed by the last rays of the setting sun. Beneath lies a village, with the figures of two peasants returning from the fields. Some of the houses on the left are similar to cottages in the Netherlands, with low thatched roofs sweeping down towards the ground. In *Cottages at Sunset* (fig. 100) the artist seems to zoom in on the same village.[8] The steep roofs tilt at crazy angles and the walls contain few straight lines. Thick smoke rises from the chimneys. Fading has probably occurred in the pigments, turning the reds of the sky at dusk into whitish pinks. The fact that Van Gogh painted what he termed an 'autumnal' scene in springtime emphasises that they are works of pure imagination.[9]

Women Digging (fig. 101) depicts two peasants bent over their spades in a snow-covered field that stretches back towards their village.[10] The faces of the women, who wear Dutch bonnets, are not depicted, deepening the picture's bare, sombre atmosphere. This wintery scene under a setting sun evokes the

harsh, exhausting conditions faced by the Brabant peasantry.

Along with this handful of paintings, Van Gogh produced more than 60 drawings during this short period, many with numerous small figures filling his sketchbook pages. Accounting for over half the surviving drawings from his twelve months at Saint-Paul, most pages are studies of peasants tilling the land, figures on a road, winter landscapes, thatched cottages, families gathering around a hearth and studies of hands – subject matter which again harks back to Van Gogh's Nuenen days. His ability to draw during a period of ill health demonstrates his determination, although their crude, clumsy lines sometimes indicate the artist's fragile mental state.

The drawing of *Two Peasant Women Digging* (fig. 102), done as a preparatory work for the painting of *Women Digging*, is a typical example. Originally part of a homemade sketchbook, conservators have recently noted tiny dots of pigment spattered on the page, suggesting that it sat on his table as he worked at his easel on the painting.[11] Among the small differences between the drawing and the painting is the presence of two loosely sketched cypresses rising up behind the cottage in the sketch – a Provençal touch to a Brabant scene.

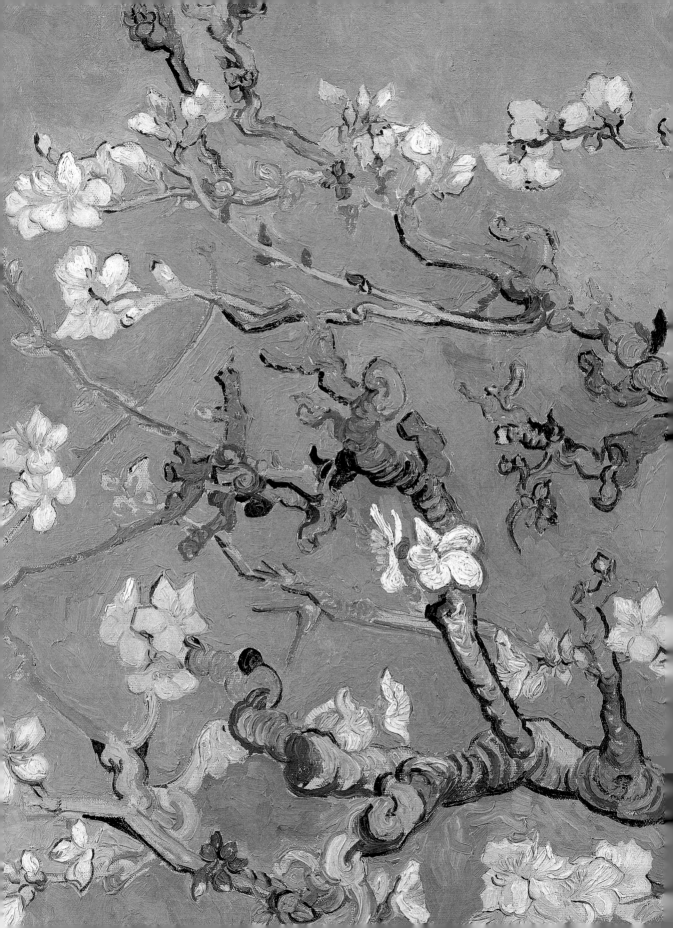

ALMOND BLOSSOM

'It was perhaps the most patiently worked, best thing I had done, painted with calm and a greater sureness of touch'[1]

'I'm going to begin by telling you a great piece of news which has greatly occupied us lately', Jo had written to Vincent in July 1889. 'This winter, around February probably, we're hoping to have a baby, a pretty little boy – whom we'll call Vincent if you'll consent to be his godfather.' Jo added that 'it could also be a little girl, but Theo and I always imagine it as a boy'.[2]

Vincent's first reaction to news of the pregnancy was pure joy, responding that it was 'a very great piece of news'.[3] But despite initial pleasure at the coming arrival, he soon began to worry that Theo seemed to be ignoring him and had not written for several weeks.[4] Vincent may have started to again fear that the advent of a baby would entail the loss of support from his brother. In mid-July, ten days after receiving news of Jo's pregnancy, Vincent was struck down by his first crisis at Saint-Paul. There is no direct evidence to link the two events, but thoughts of the arrival of a child may have disturbed his fragile equilibrium and created ambivalent feelings.

Six months later, a week or so before the birth, Vincent suffered yet another crisis at Saint-Paul. Dr Peyron wrote to Theo with the bad news, in a letter that reached Paris on the day before the new arrival.[5] One can hardly imagine a worse moment for Jo and Theo. The previous evening Jo had written an emotional letter to Vincent, saying that she would be giving birth very shortly, but feared she might not survive. As she put it delicately: 'If things don't go well – if I have to leave him – you tell him... that he must never regret that we were married, because he's made me so happy.'[6]

Detail of fig. 106 *Almond Blossom*, Van Gogh Museum, Amsterdam (Vincent van Gogh Foundation)

Despite the worries, the birth proved straightforward and the baby – who was indeed a boy – was born on 31 January 1890 and named Vincent Willem (fig. 103).[7] His uncle Vincent, the artist (after whom he was named), initially responded with genuine delight, saying it 'gives me more pleasure than I could express in words'.[8] A fortnight later he demonstrated his happiness in his own way, by creating a magnificent painting.

Almond Blossom (fig. 106) was Vincent's gift to his godson. As he explained to his mother Anna, he had painted it for the bedroom of Theo and Jo's Paris apartment where the baby would sleep – 'large branches of white almond blossom against a blue sky'.[9] In Provence, blossoming almond trees in February herald the arrival of spring, being the first of the fruit trees to burst into flower. The Saint-Rémy area was then renowned for its almond trees (fig. 105), so it must have been a magnificent moment when the groves became a mass of delicate white petals with their heady honey-like scent.

Van Gogh probably conceived *Almond Blossom* on 17 February, when a marked rise in the temperature would have encouraged the buds to burst out.[10] At first glance the composition appears quite natural, as if the artist lay on the ground

fig. 103 Birth notice of Vincent Willem van Gogh (son of Theo and Jo), 31 January 1890, envelope and printed card, 9 x 11 cm, Van Gogh Museum, Amsterdam (Vincent van Gogh Foundation)

fig. 104 Vincent Willem van Gogh (son of Theo and Jo) aged three months, April 1890, photograph by Raoul Saisset, Paris, Van Gogh Museum, Amsterdam (Vincent van Gogh Foundation)

fig. 105 Almond trees near Saint-Paul, 1920s–30s, postcard

and gazed up through the gnarled branches – but a closer look reveals that it is an artfully complex arrangement. The branches in the upper right corner and the crossing ones in the lower part of the painting seem to come from three separate trees.

The most likely scenario is that Van Gogh broke off a few branches from the almond tree and took them back to his studio.[11] There his imagination came into play, inspiring him to create this delicate scattering of fresh petals strewn across an azure sky. The composition must have been partly inspired by Japanese prints, which often feature dramatically cropped trees. Spring blossom is also a favourite motif in Japan, as in the work of Hokusai and Utagawa Kunisada (fig. 107).[12]

The new life unfolding all around him would have cheered the artist, but there was another reason which made his spirits soar. On 18 February, while hard at work on *Almond Blossom*, he opened a letter from Theo with news of his first sale of a Provençal painting.[13] *The Red Vineyard*, an Arles landscape which was then in the exhibition of Les Vingt in Brussels, was bought for 400 francs (£16) by Anna Boch, a fellow artist and sister of his friend Eugène Boch. The personal link may have led Van Gogh to feel it was not quite a proper 'commercial' sale, but it still must have provided a welcome boost to his morale.[14] Coming a month after Aurier's article in the *Mercure de France*, Van Gogh was now on the brink of a breakthrough, with a real chance to make a name for himself.

Tragically, just after completing *Almond Blossom* and hearing news of the sale of *The Red Vineyard*, Vincent was struck down again by yet another crisis, while on a visit to Arles. 'Work was going well, the last canvas of the branches in blossom', he later wrote to Theo, 'and the next day done for like a brute'.[15] Without this setback he would have painted more blossoming trees, but by the time he had recovered the season was almost finished. 'Really I have no luck', he admitted ruefully.[16] Although Theo was delighted to receive *Almond Blossom* for their newborn child, the gift must have been tinged with regret, since it was bound up with his brother's latest attack.

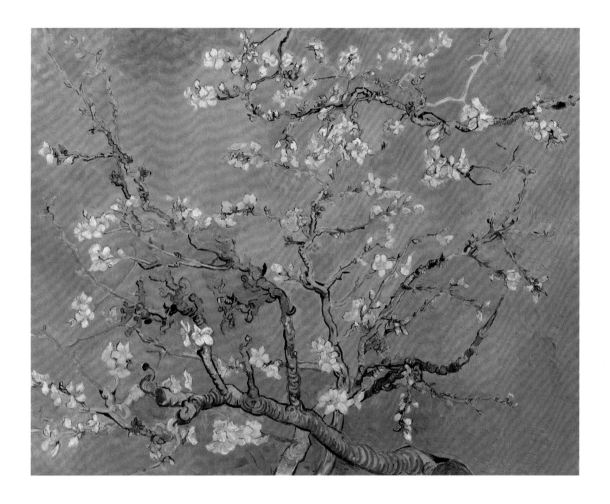

fig. 106 *Almond Blossom*, February 1890, oil on canvas, 74 x 92 cm, Van Gogh Museum, Amsterdam (Vincent van Gogh Foundation) (F671)

Looking back many decades later, Vincent Willem, the artist's nephew, saw likely links between his own birth and the artist's mental traumas. Writing in the 1950s, he pointed out that the ear episode took place when Vincent heard about his brother's engagement. The other crises, he noted, came 'after Theo's marriage, after the announcement that a baby was expected and after his birth'. He added that it must have gone through the artist's mind that he would lose Theo's support, though 'it never came about'.[17] Vincent Willem may have heard this theory from his mother, Jo. It must have been an emotional burden for him to have felt that his own birth might have precipitated his uncle's crises and eventual suicide.

Almond Blossom arrived in a consignment of paintings which Vincent dispatched to Paris in late April 1890.[18] Theo was delighted with the pictures, which included some which were 'very, very beautiful'. Singling out the blossom painting, he observed with apparent understatement that 'you haven't exhausted

fig. 107 Utagawa Kunisada, *A Flower Game in the Garden* (left image of triptych), 1830s, colour woodblock, 38 x 25 cm, Van Gogh Museum, Amsterdam (Vincent van Gogh Foundation)

these subjects'. Although intended to hang in the bedroom, Theo and Jo instead displayed the painting more prominently in their sitting room, above the piano.[19]

This joyful picture remained among the favourites of Jo and then her son Vincent Willem (fig. 104). Jo's grandson, Johan van Gogh, still remembers it from the 1930s, when it hung in the bedroom which he shared with his two brothers in the family home in Laren, a village outside Amsterdam. Recalling their childhood, he says that it was 'a miracle that it was never hit by a flying pillow, or worse'.[20]

Almond Blossom remained with Vincent Willem until 1962, when with the rest of his pictures it was transferred to a foundation and eleven years later this collection formed the core of Amsterdam's newly established Van Gogh Museum. Johan van Gogh, now aged 95, regards this blossom painting as among the artist's 'most important' works in what he still feels is 'our' collection – not in a legal sense, but in terms of the family heritage.[21] Whenever Johan sees *Almond Blossom* he can never forget that this exuberant picture was lovingly painted to hang above his father's crib.

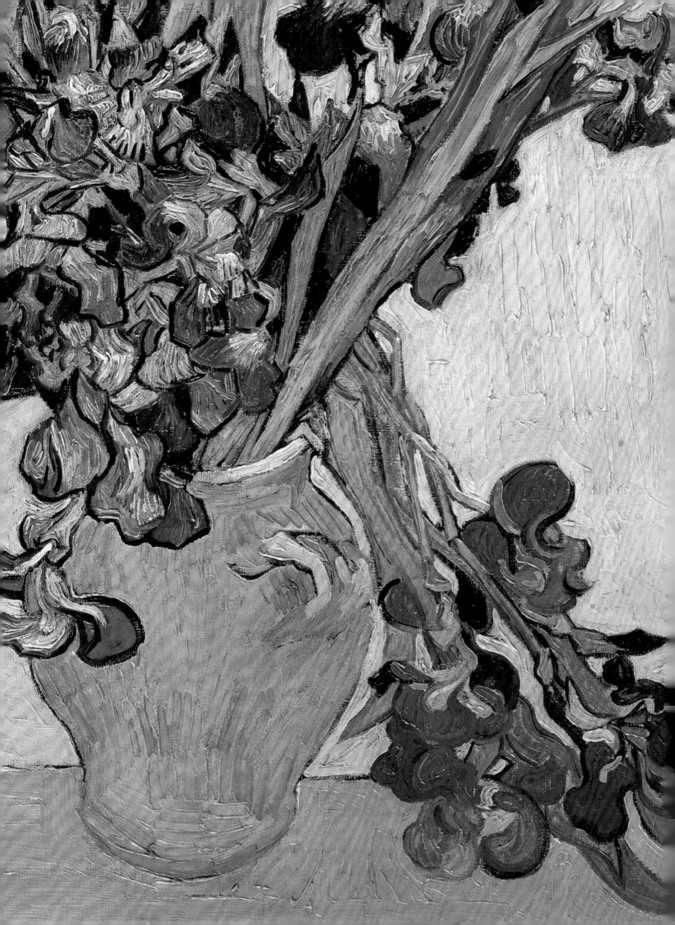

CHAPTER SIXTEEN
ISOLATED

'Ah, if I'd been able to work without this bloody illness! How many things I could have done... But yes – this journey is well and truly finished'[1]

When Aurier published his pathbreaking article on Van Gogh he entitled it *Les Isolés* (The Isolated). He presented the Dutchman as a loner artistically, although the phrase could equally allude to his presence in an asylum so far from Paris. Aurier knew about Van Gogh's mental problems and the fact that he was living at Saint-Paul, although he tactfully avoided mentioning this in print.

In terms of his artistic career, Van Gogh's isolation represented a mixed blessing. Living in Saint-Paul meant that he had virtually no contact with other avant-garde painters in Paris and he lost the stimulation that he had enjoyed during his two years working in the capital. Even in Arles he lived with Gauguin for nine weeks and he was also in contact with several other artists in the locale.[2]

But isolation also brought its benefits. With few other distractions, he was able to channel all his energy into work, at least while he was in reasonable health. Behind the asylum walls, Van Gogh developed his art in a highly personal and idiosyncratic way, almost uninfluenced by market considerations or his peers. This left him free to take bold artistic decisions. Although in Arles Van Gogh had found it difficult to work from his imagination, he was highly successful when he tried it in *Starry Night* (fig. 49). The great regret is that the artist would end up having so little time to develop this side of his art.

Although Van Gogh was cut off from his peers, his work was beginning to become known in progressive circles. Thanks largely to Theo, he began to show his paintings, which were displayed in three significant exhibitions. The first, in September 1889, was organised by the Société des Artistes Indépendants in Paris, a recently formed group of progressive painters. There Van Gogh lent two pictures – *Starry Night over the Rhône*, done in Arles, and *Irises* (fig. 18).[3]

The next show, in Brussels in January 1890, was organised by Les Vingt, an association of 20 radical artists. Their display included six Van Gogh paintings, four from Arles and two from Saint-Paul – *Trees with Ivy in the Garden of the Asylum* (the original version of fig. 20) and *Wheatfield at Sunrise* (fig. 47).

Van Gogh's largest selection was shown in the next exhibition of the Société des Artistes Indépendants in March 1890. On display were no fewer than ten of his pictures, with six from Saint-Paul, including *Wheatfield after a Storm* (fig. 43),

Detail of fig. 108 *Irises in a Vase*, Van Gogh Museum, Amsterdam (Vincent van Gogh Foundation)

Ravine (fig. 59), *Mulberry Tree* (fig. 60), *Road Menders* (fig. 61), *Cypresses* (fig. 72) and *Olive Grove*, plus the two Arles paintings which had just been shown in Brussels.[4] This must have represented a striking display, demonstrating what the artist had achieved in the most trying circumstances.

Although not discussed in the surviving correspondence, Theo at one point wondered whether Vincent might have been able to visit Paris for the inauguration of the 1890 Indépendants show. 'I had hoped that he would be here for the opening', Theo wrote to Wil.[5] Although a lovely thought, travelling around Paris and being surrounded by crowds at the formal opening would have been a terrible shock for someone who had been institutionalised for a year. It is also questionable whether Van Gogh's paintings would have been taken more seriously if the other guests had seen the artist. His mutilated ear and arrival from an insane asylum would have provoked much unkind gossip. Vincent, however, was in the midst of a two-month crisis, so there was absolutely no question of a visit. By the time he was better, the show had closed.

Astonishingly, the president of France, Sadi Carnot, must have seen the Van Goghs. Theo wrote that he had been there when the president came for the opening, adding that Vincent's pictures were 'well placed'.[6] Although it was a very large exhibition, Carnot spent over an hour[7] in its four rooms, which means that the ten Van Goghs must have come within his line of vision. Theo mentioned Carnot's visit slightly casually in his letter to Vincent, which may explain why this episode has been rather overlooked.

Carnot was escorted around the exhibition by the Neo-Impressionist artist Paul Signac, who was one of Van Gogh's most enthusiastic supporters, particularly for his Arles paintings. Signac had met Van Gogh in Paris in 1887 and had visited him in hospital in Arles the following year. Two months before the Paris exhibition he attended the opening of the Brussels show at which two of Van Gogh's *Sunflowers* had been bitterly criticised by an established Belgian artist, Henry De Groux[8]. Signac had come to Van Gogh's rescue, almost challenging De Groux to a duel. In taking Carnot around the Paris exhibition it is likely that Signac would have seized the opportunity to point out Van Gogh's work on the walls. According to a newspaper report, Carnot was struck by the 'disconcerting tonalities' of some of the artists, particularly the Neo-Impressionists, and left after his lengthy visit 'rather amazed'. It is fascinating to think that the president of France can hardly have missed the paintings of Van Gogh, an artist whom we now consider to have been ignored in his time.

* * *

By the winter of 1889–90 Van Gogh was becoming increasingly determined to return to Paris or its surroundings. By the spring he had suffered four crises at Saint-Paul, which might have seemed a reason for staying, but the asylum was not curing him. Institutional life was frustrating and he longed to escape its dulling routines.

fig. 108 *Irises in a Vase*, May 1890, oil on canvas, 93 x 74 cm, Van Gogh Museum, Amsterdam (Vincent van Gogh Foundation) (F678)

Although the surrounding countryside could hardly have been more inspiring, Van Gogh's access to it was often restricted. He also wanted to see his brother – and make the acquaintance of Jo and his godson.

Above all, Van Gogh found that being surrounded by his 'companions in misfortune' lowered his spirits. The patients led a monotonous existence – and he, too, suffered increasingly from ennui. As he told Theo, 'the crowding together of all these lunatics in this old cloister' is dangerous and 'one risks losing all the good sense one might still have retained'. He increasingly felt that he was 'more catching the illness of the others than curing my own.'[9]

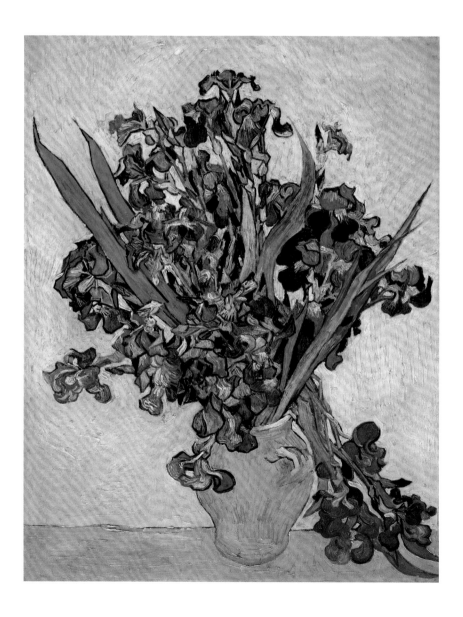

After recovering from his longest attack in late April Van Gogh was more determined than ever to leave, convinced that he had 'delayed too long'. Looking back, he later wrote: 'My last crisis, which was terrible, was due in considerable part to the influence of the other patients, anyway, the prison was crushing me.'[10]

Vincent explained more to Theo in a deeply felt letter: 'The surroundings here are starting to weigh on me more than I could express... I need air, I feel damaged by boredom and grief'. It is difficult 'to sacrifice one's freedom, to stand outside society and to have only one's work'. A year earlier he had felt that the patients let him work undisturbed, but this had changed and 'people here are too curious, idle and ignorant about *painting* for it to be possible for me to practise my profession.'[11]

By this time Theo had come up with what the two brothers felt would be the best solution – a move to the village of Auvers-sur-Oise, 30 kilometres north of Paris, where Dr Paul Gachet had his home. A doctor, amateur artist, collector and friend of many of the Impressionists, he seemed the ideal person to keep an eye on Vincent. Van Gogh could live independently in Auvers, in a modest inn, with a sympathetic doctor close at hand. Auvers, surrounded by delightful countryside, was also only just over an hour from Paris by train, so it would be simple for Vincent to meet Theo and his family.

The final decision to leave Saint-Paul was taken extremely quickly, within days of his recovery. Once it was decided that Van Gogh would move to Auvers he made a final spurt, working as intensively as ever. In the first two weeks of May, just after recovering from his latest crisis, he completed an astonishing eight paintings, half of them flower still lifes.[12] As Vincent explained to Wil, he 'worked like a man in a frenzy, especially on bouquets of flowers.'[13]

One of Van Gogh's first two paintings at Saint-Paul had been *Irises* (fig. 18) and, almost a year to the day, he painted another cluster of the flowers, this time in a pot, rather like his earlier Sunflower still lifes.[14] *Irises in a Vase* (fig. 108) is an exuberant picture, a large bunch of blooms and a handful of dagger-like leaves, with the violet-blue of the flowers set against a complementary yellow background. One stem has just broken and fallen, lying at the side – it both breaks the symmetry and reminds us of the transience of life.

On 13 May Vincent reported to Theo that 'after a last discussion with Mr Peyron I obtained permission to pack my trunk, which I've sent by goods train'. That day he had been taken by carriage to the station to send off his 30-kilogram luggage to Paris. En route he 'saw the countryside again – very fresh after the rain and covered in flowers', thinking wistfully about what he could have achieved with better health. As he wrote, 'how many more things I would have done.'[15]

Three days later – one year and eight days after his arrival – Van Gogh finally left the insane asylum. In the morning of 16 May 1890 Dr Peyron wrote up the medical report, recording that his patient had suffered 'several attacks lasting for between

two weeks and a month', although in the intervals between he was 'perfectly calm and lucid, and passionately devotes himself to painting'. The doctor concluded: 'He is asking to be discharged today, in order to go to live in the north of France, hoping that that climate will suit him better.' He then added the single word, 'cured'.[16]

Van Gogh passed through the gate of the asylum for the last time. He set off for the station by carriage, presumably driven by Poulet, whom he had got to know so well. Dr Peyron may well have accompanied them, since by this time he must have realised quite what an unusual patient he had cared for. After a farewell to the concierge, the carriage passed the Roman monuments, and Van Gogh turned for his last look at the olive groves, set against Les Alpilles. They then descended towards the station, to catch the train at noon.

Poulet probably accompanied Van Gogh on the journey on the narrow-gauge railway to Tarascon, from where they would have had a one-hour wait for the express train to Paris. Vincent took the opportunity to send a telegram to Theo, giving his arrival time. Theo had wanted one of the asylum staff to travel with his brother all the way, but Vincent had refused: 'Is it fair to have me accompanied like a dangerous animal? No thank you, I protest.'[17] He arrived safely in Paris early the following morning, to be greeted by Theo at the Gare de Lyon just before 6 a.m. His year at the asylum was over. A new life at Auvers-sur-Oise beckoned.

<p align="center">*　　*　　*</p>

Van Gogh's stay in Auvers proved to be all too brief. Life seemed to be going well, but on 27 July 1890 he was struck down by another attack while painting in the wheatfields above the village. Along with his easel he had a gun, which he used to shoot himself in the chest. Mortally wounded, Van Gogh staggered back to his inn, where he collapsed.

Vincent had once written from Saint-Paul that 'a painter is too absorbed by what his eyes see and doesn't have enough mastery of the rest of his life'.[18] That was not the whole story. Van Gogh may have blamed himself and his obsession with art, but he obviously suffered from very real physiological and psychological problems. Although painting absorbed virtually all of his energy, without this vocation he would have had much less impetus to live – and it is likely that his life would have come to an end very much sooner.

When looking up at the night sky in Provence Van Gogh had gazed at the stars and contemplated eternity. Just as one might take the train to Tarascon, he felt, so one travelled to the stars when facing death. Illnesses were the celestial means of locomotion, so to die peacefully of old age, he wrote to Theo, would be to go there 'on foot'.[19] Van Gogh's end was even more sudden than cholera or cancer – taking him swiftly to the stars just 36 hours after the shot was fired.

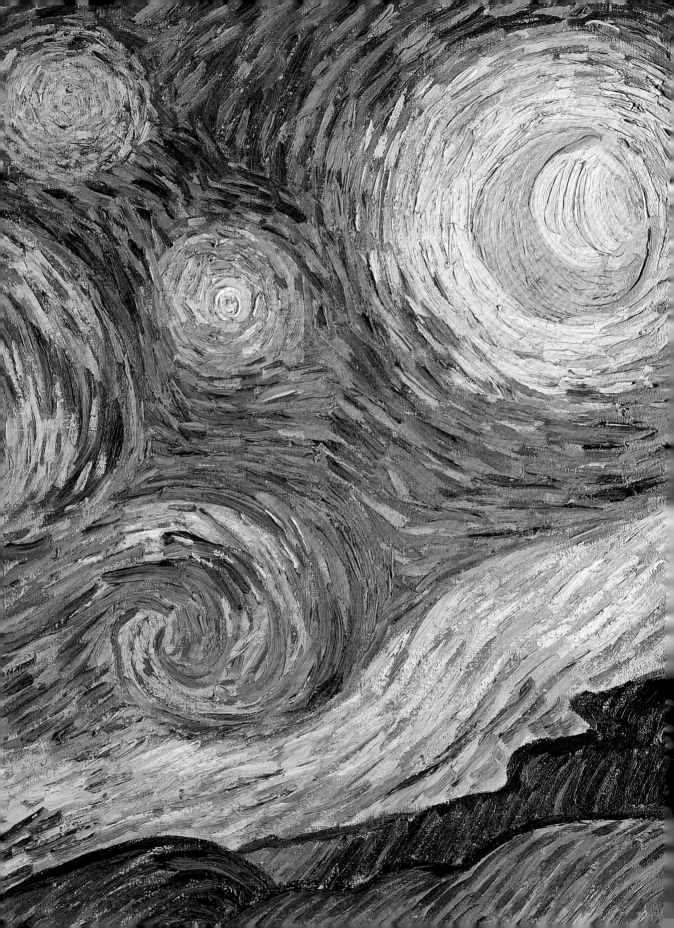

THE ASYLUM
AFTER VAN GOGH

Detail of fig. 49 *Starry Night*, Museum of Modern Art, New York

During the First World War, when Saint-Paul was converted into a detention camp for enemy aliens, it welcomed a most distinguished figure from French Equatorial Africa: Dr Albert Schweitzer. An extraordinary polymath, he was a scholarly theologian, a brilliant organ player and a dedicated specialist in tropical medicine. A year before the outbreak of war, Schweitzer had established a hospital in the remote village of Lambaréné, lying just south of the Equator in present-day Gabon.

Although considering himself French, Schweitzer had been born in Alsace, which was then under German rule. On the outbreak of the First World War, he and his wife Helene were therefore regarded as a potential threat by the French colonial authorities. In September 1917, while still in Lambaréné, they received an order requiring them to return to France, to be imprisoned in an internment camp. The doctor was forced to abandon his hospital and patients. Albert and Helene then set off for a journey of nearly 10,000 kilometres under military guard. After initially being held in a camp in the Pyrenees they were moved to Saint-Paul in March 1918.

At the outbreak of the war in 1914 the numbers of male patients at Saint-Paul had dwindled, leaving only Van Gogh's former companion Revello and two other men, who had been transferred to a hospital. A year later the empty men's block was converted into a camp, which already housed just over 100 internees when the Schweitzers arrived.

fig. 109 Alsace internees in the garden of Saint-Paul (with Albert Schweitzer indicated), April 1918, photograph

fig. 110 Roger Fry, *Spring in Provence*, April 1931, oil on canvas, 80 x 65 cm, Vancouver Art Gallery

Dr Schweitzer was well aware that Van Gogh had once stayed in the block in which he was incarcerated. He later recalled the artist's presence in his autobiography: 'Like us, he had suffered from the cold stone floor when the mistral blew! Like us, he had walked round and round between the high garden walls!'[1] The upper floor of the north wing, where Van Gogh's studio had been located, is visible in the right background of a group photograph in the garden (fig. 109). After four months at Saint-Paul, the Schweitzers were released in an exchange of internees arranged through Switzerland. The camp was closed after the war and Saint-Paul handed back for the patients in 1919.

At Saint-Paul Dr Peyron had run the asylum up until his death in 1895, when he was succeeded by Dr Mathieu Seja, who remained in charge until he too died in post in 1917. Sister Epiphane, who had once cared for Van Gogh, was still there and as mother superior she helped run the asylum right up until her death in 1932. Ownership of the asylum had passed from Dr Mercurin's descendants to the Sisters in 1906. The Sisters continued to serve at Saint-Paul until 2014.

The major managerial change came just after the First World War with the arrival in 1919 of a dynamic, young medical director, Dr Edgar Leroy. Bringing fresh life to the institution, he would soon play a key role in honouring Van Gogh.[2] When he arrived he knew little about the artist, but from the 1920s he began to receive an increasing stream of enquiries asking for information. Dr Leroy, who had an interest in history, therefore

set out to research the artist's stay, using the asylum's archives. Since these documents have remained virtually inaccessible to this day, his publications represent a vital record.

In 1926 Dr Leroy published a series of articles on Van Gogh's asylum stay in *Aesculape*, a monthly journal on medicine and the arts.[3] He then joined forces with Dr Victor Doiteau, a medical specialist in Paris who had been independently studying the artist[4], and together they wrote *La Folie de Vincent van Gogh* – a book which nearly a century later remains essential reading for understanding the artist's medical condition.[5] Dr Leroy continued to write extensively on the subject, right up until the 1950s.[6]

Dr Leroy also took the initiative to establish a small museum dedicated to Van Gogh at Saint-Paul, to cater for the increasing number of visitors. It was set up in 1929 on the ground floor of the east wing, in a room with a window facing the wheatfield. This had not been Van Gogh's actual bedroom, which was on the floor above, but it did give an idea of what it had been like. Saint-Paul had no original artworks, since the Sisters had declined Van Gogh's offer, so instead the museum displayed photographic reproductions of Van Gogh's paintings and drawings done during his stay, provided by de la Faille, the author of the 1928 catalogue raisonné.

The visitors' book for the museum, which was recently acquired by the municipal archive in Saint-Rémy, records over 4,000 names, including many

fig. 111 Paul Signac's
signature in the visitors'
book of the Saint-Paul
museum, April 1933,
Archives Municipales,
Saint-Rémy

fig. 112 Paul Signac,
Les Alpilles, May 1933,
watercolour and black
crayon on paper,
30 x 44 cm, private
collection

distinguished figures who have made the pilgrimage to Saint-Paul.[7] Dr Félix Rey, who had treated Van Gogh in the hospital in Arles, was an honoured guest at the opening. Later visitors included Signac, who came in April 1933 on his pilgrimage to the Van Gogh sites (fig. 111). Then aged 70, Signac painted a watercolour of *Les Alpilles*[8] (fig. 112), his reinterpretation of Van Gogh's painting of *Les Alpilles with a Hut* (fig. 56).

By this time the area around Saint-Paul was attracting a stream of artists, lured by the countryside which had once entranced Van Gogh. Maurice Denis, a leading early Modern painter, visited in 1926 and did several watercolours of the cloister and Roman monuments.[9] André Derain, a slightly later artist, came on several occasions in the 1920s, painting a series of landscapes of the area near Saint-Paul.[10]

A number of English luminaries also came, including the painter, critic and curator Roger Fry. He had given Van Gogh his first major exposure in London at an exhibition in 1910, when he coined the term Post-Impressionist. Fry became a frequent visitor to Saint-Rémy in the 1920s, and in 1931 he provided financial assistance to his local friends Charles

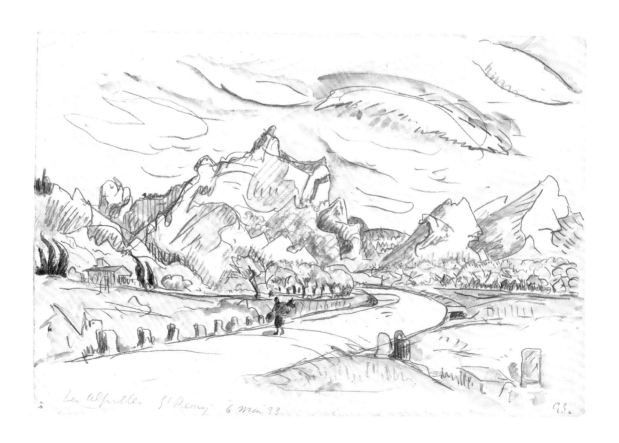

Les Alpilles St Remy 6 mai 33

and Marie Mauron for them to buy Mas d'Angirany, a farmhouse which lies very close to the Roman monuments and the asylum.[11]

Fry was always a very welcome guest at the Maurons. *Spring in Provence* was painted of their garden, showing a stone pillar erected to support a vine, with Mont Gaussier in the distance (fig. 110) – a similar view of Les Alpilles that would have greeted Van Gogh when he stepped outside the asylum. The Maurons were both distinguished writers and Charles went on to publish a series of essays brought together in *Van Gogh: Etudes Psychocritiques*.[12] The English artist Augustus John also became a regular visitor in the late 1930s, after his mistress Dorelia McNeill rented the Mas de Galeron, located very close to Saint-Paul and the Maurons.[13]

Two French artists lived equally close to Saint-Paul and both were dedicated to preserving Van Gogh's legacy. Jean Baltus, a friend of Dr Leroy and his son Robert, was there for most of the interwar years.[14] He zealously compiled memories of Van Gogh and the places where he painted, recording these in his diaries, whilst also making dozens of pictures of the countryside around Saint-Paul (fig. 113). The artist Yves Brayer also lived near the asylum in the late 1940s, painting numerous landscapes.[15] It is astonishing that the relatively small town of Saint-Rémy has produced and attracted so many distinguished artists and writers.

The Second World War also impacted on Saint-Paul, and the remaining female patients were evacuated by the Sisters to their mother house in Ardèche. From 1942 to 1944 the asylum was partially occupied by German troops, who cut down some of the tall pines in the garden for timber. The artist's beloved trees were lost.

In 1951 Dr Leroy helped organise an exhibition of Van Gogh's work in Arles and Saint-Rémy. It was divided into two parts, with half the 100 paintings and drawings shown at the Musée Réattu in Arles and the remainder at the Hôtel de Sade, the former home of the Marquis de Sade in the historic centre of Saint-Rémy (one of the family gave his name to the word sadism).[16] By this time Charles Mauron had become the mayor of Saint-Rémy. Virtually all the loans came from Vincent Willem, the painter's nephew, including 30 works done at Saint-Rémy. The exhibition, which ran for just two weeks, is the only occasion when any Van Goghs have returned to Saint-Rémy.

Vincent Willem, the artist's nephew, came to Saint-Rémy for the first time for the 1951 opening, at the age of 61. It was an emotional experience for him to see the asylum where his uncle had lived for a year. Vincent Willem was introduced to Poulet, then 88, who had accompanied Van Gogh on his painting expeditions. They met surrounded by pictures which Poulet had last seen on the artist's easel more than 60 years earlier. Tears poured down Poulet's face as he recalled taking

the artist on his painting expeditions.[17] The former carriage driver died three years later, in 1954.

The asylum museum had reopened after the war, but the deteriorating condition of the abandoned men's block meant that the rooms had to be closed in the mid-1950s. Dr Leroy remained director of Saint-Paul until his death in 1965, after serving for nearly half a century. The buildings were then modernised in the 1960s and 70s. Although it was vital to provide better accommodation for patients, it is unfortunate that drastic interventions in the men's block destroyed the interior of Van Gogh's time. Fortunately, the facades have been saved. When questioned about this destruction, a Sister responded: 'Monsieur, one cares for the living and not for the dead!'[18]

Dr Jean-Marc Boulon, the current director at Saint-Paul, took over in 1988.[19] Inspired by the Van Gogh legacy, in 1995 he set up Valetudo, an art therapy programme named after the Roman goddess of health, who was celebrated at a spring in nearby Glanum. Valetudo's studio is located in the former monastic refectory of the ancient cloister. Saint-Paul is now a fully modernised psychiatric hospital, with beds for around 120 mentally ill and elderly patients, as well as providing day care. Thanks to the enormous strides that have been made in diagnosis and treatment, the hospital today could hardly be more different from the asylum of Van Gogh's time.

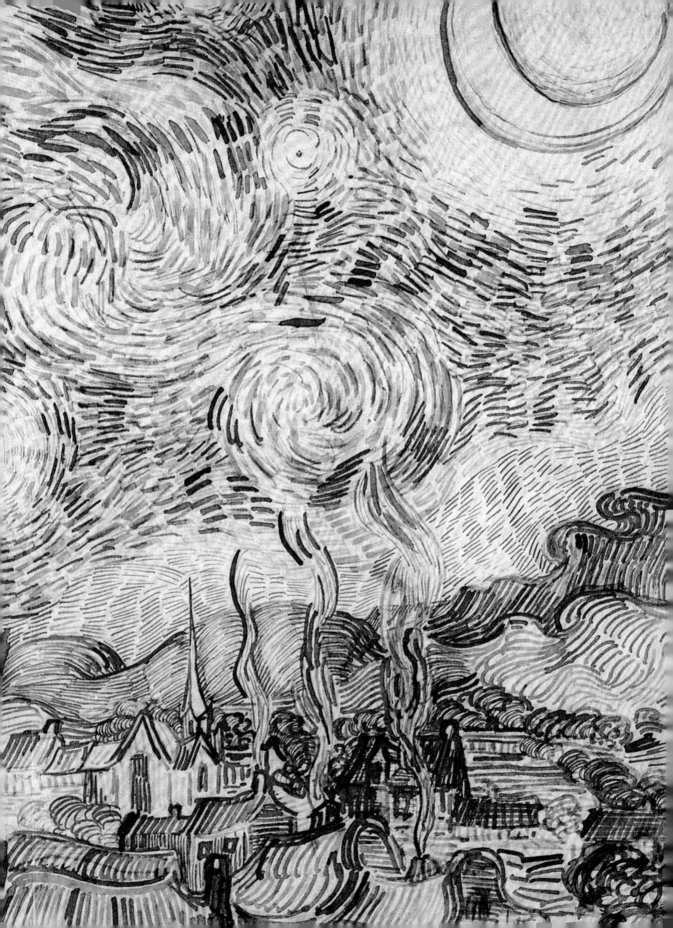

IMPRISONED IN RUSSIA

Towards the end of the Second World War a Russian architecture student serving in the Red Army was amazed to spot what seemed to be a drawing of Van Gogh's *Starry Night* (fig. 114), discarded on the floor in Germany's Karnzow Castle. It was among over 5,000 drawings and prints belonging to the Kunsthalle Bremen which had been hidden in this remote estate lying between Berlin and Hamburg, to protect them from Allied bombing raids. In 1945 Red Army troops, who were occupying the castle, discovered the cache in a bricked-up cellar and began to loot the contents, scattering the works in the melee. What happened to the *Starry Night* drawing and the Bremen collection turned out to be an astonishing story.

Captain Viktor Baldin, the young officer, gathered up hundreds of the more important drawings – to save them. Later packing them into a suitcase, he brought them back to what was then the Soviet Union, where their very existence remained a state secret for decades. The *Starry Night* drawing was therefore recorded in the seminal 1970 Van Gogh catalogue raisonné by de la Faille as 'lost'.[1]

This large pen-and-ink drawing had been done by Van Gogh a few days after he had completed the painting of *Starry Night* (fig. 49) in June 1889. It was among ten or so drawn copies of paintings which Vincent sent to Theo 'so that you may have an idea of what I have on the go'.[2] Although very similar to the painting, in the drawing three houses are topped with plumes of smoke – echoing the cypresses and animating the landscape.

After Theo's death the drawing had passed to Jo, who in 1907 sold it via a dealer to the Bremen-based poet and publisher Alfred von Heymel, who was an important collector. He died during the First World War and bequeathed the Van Gogh to his cousin, Clara Haye. In 1918 she donated the drawing to the Kunsthalle Bremen, which was one of the first German museums to collect modern art. Only rarely exhibited, it was last displayed in 1937 in Paris.

Over half a century later I would become the first outsider to see the drawing of *Starry Night*. In 1990 news had begun to leak out to suggest that some of the Bremen works might have survived and were held in a secret storeroom in the Soviet Union. Then a reporter for *The Observer*, I was intrigued and joined the hunt for the fabled lost collection.[3]

Two years later, on 11 September 1992, I travelled to St Petersburg to meet the newly appointed director of the State Hermitage Museum, Mikhail Piotrovsky (who remains in the post to this day). I thought that if I asked to see a number of drawings, this would probably be refused, so the best tactic would be to request to view just a single one – which would confirm the location of at least some of the Bremen treasures. Without hesitation, I chose *Starry Night*. After putting my case to Piotrovsky in his tapestry-lined office, he eventually agreed.

Decades later I discovered why Piotrovsky had been so helpful to a visiting English reporter. I had contacted him just months after he himself had discovered that this treasure trove had been secretly transferred to his own museum, on the orders of the KGB security agency. He was 'furious' that when he had been the museum's deputy director he had not been informed about the art brought back from Nazi Germany by the victorious Red Army. This cache had recently been hidden in the Hermitage vaults and its existence not even revealed to the museum's senior staff.[4] Piotrovsky believed passionately – and still does – that art should be shared with the world.

The director escorted me into an even grander room on the top floor of the former Czarist palace, the Hall of Twelve Columns, which was then closed to visitors. From there we ascended to a mezzanine level, where he introduced me to his curator of French drawings, Irina Novoselskaya. After much clanging of keys, she produced a portfolio and placed it on a large table. Opening it, she gingerly extracted the drawing of *Starry Night* and displayed it on a stand (fig. 115).

I shall never forget that moment – suddenly coming face to face with a 'lost'

fig. 114 *Starry Night*, June 1889, pen and ink on paper, 47 x 63 cm, formerly Bremen Kunsthalle, present location unknown (F1540)

Van Gogh which had not been exhibited in living memory. It had never been reproduced in colour, which even for a drawing is important in studying the details, so I hardly knew what to expect. Quickly running my eyes over the large work, over 60 centimetres wide, my first feeling was relief that it had survived remarkably well considering its chequered history.

Van Gogh often used inks which have faded badly, but here the brown ink was still relatively fresh, since the drawing had been secreted away and shielded from daylight. It is interesting to compare it with the considerably more faded *Wild Vegetation* (fig. 58), which was drawn at the same time with the same ink. *Wild Vegetation* has been lent for exhibitions 54 times, compared with eight times before the Second World War for the *Starry Night* drawing.[5] The one piece of damage I had not anticipated was a disturbing vertical fold down the centre of the drawing, which had caused a 2-centimetre tear at the very bottom.

I also travelled to Moscow to meet the man who had saved the drawings. In his modest apartment, Baldin, then 72, began to recount his story. On 5 July 1945 his fellow Red Army soldiers had moved a wardrobe, behind which they discovered a sealed-up door, which they broke down. From there, steps led to the basement. Baldin, joining the throng who rushed downstairs, found his comrades scrambling to open the boxes. Thousands of works on paper from the Kunsthalle Bremen began to spill out on the cellar floor. He hastily grabbed whatever he could in order to save them and tried to prevent further looting.

Baldin eventually packed 364 drawings into a modest suitcase. He was then ordered to organise a forced march of Red Army soldiers who had been captured by the Nazis and forced to fight for the Germans. The Red Army regarded them as defectors or traitors, and when later recaptured they were made to walk well over 1,000 kilometres back to the Soviet Union. This terrible journey saw the exhausted men plodding on foot, while Baldin followed behind in a tractor. Beside him on the lumbering vehicle was his precious suitcase, which he hugged close to him every night as he slept.

The fate of the defectors sadly remains unknown, but Baldin and his suitcase arrived safely in Zagorsk, a city north of Moscow (now renamed Sergiev Posad), after weeks on the tractor. Baldin told me how it had felt to open the suitcase lid and spread out his treasured cargo: 'I just couldn't believe what I had'.[6] Along with the Van Gogh were drawings by Dürer, Veronese, Van Dyck, Rembrandt, Tiepolo, Degas and Toulouse-Lautrec. I asked about *Starry Night*, and he told me it was too large to fit into his suitcase. The safest solution had been to neatly fold the paper in half.

Baldin kept the drawings at home for three years, but then decided to hand them over to the Republican Museum of Russian Architecture, where he then worked. Few of the drawings had any architectural significance, but he wanted

fig. 115 Irina Novoselskaya with the drawing of *Starry Night* at the State Hermitage Museum, 1992, photograph by author

them to be cared for by a museum. Baldin rose through the ranks and in 1963 he was appointed its director. He increasingly felt that the drawings ought to be returned to Bremen, but this would have been almost impossible to arrange during the Cold War. Communism began to falter and in May 1991 the KGB secretly ordered that the Bremen drawings should be moved to the Hermitage. In December the Soviet Union was broken up, leading to the creation of the Russian state.

When I met Piotrovsky in September 1992 he revealed plans to exhibit the Bremen drawings. Arranged at great speed, his show opened at the Hermitage on 18 November and early the following year it was presented at a slightly unlikely venue in Moscow, the All-Russia Museum of Decorative, Applied and Folk Art. In the exhibition catalogue, the art historian Professor Alexi Rastorguyev wrote that the Bremen drawings were being 'liberated from illegal storage'.[7] Tatyana Nikitina, then Russia's deputy minister of culture, assured me that 'we have to give them back'.[8] In 2003 it was formally agreed that the Bremen works would be returned.

More than a quarter of a century later this has still not happened. The Soviet Union had suffered enormously during the Second World War and during the 1990s and early 2000s there was growing political pressure against returning 'trophy' artworks to Germany. Then in 2005 a new culture minister in Russia opposed restitution and Piotrovsky was ordered to hand over the Bremen collection to the Ministry of Culture. To this day the Russian government still holds the drawings at a secret location, presumably a storage facility somewhere in Moscow. Van Gogh's drawing of *Starry Night* continues to languish unseen – yet one more victim of the Second World War.

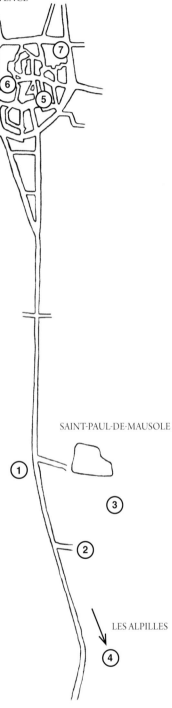

SAINT-RÉMY-DE-PROVENCE

SAINT-PAUL-DE-MAUSOLE

LES ALPILLES

ON THE TRAIL
OF VAN GOGH

Saint-Paul-de-Mausole, formerly an asylum and now a psychiatric hospital, lies one kilometre south of the attractive town of Saint-Rémy-de-Provence. It is a pleasant 20-minute walk from Saint-Rémy's historic centre, past the tourist office and then along Avenue Vincent van Gogh, where a series of panels with reproductions of the artist's paintings are presented along the route. At the end, a short tree-lined road leads to the entrance to Saint-Paul, which is normally open daily.

Visitors enter by the gatehouse, passing along a planted avenue that leads to the monastic chapel, whose ancient interior lies behind an eighteenth-century facade. The adjacent twelfth-century cloister usually offers a peaceful place of contemplation and perhaps a chance to view artworks on display by patients who work at the Valetudo studio.

On the upper floor, above the cloister, is the reconstructed 'Van Gogh's Room'. Although not his actual bedroom, the cell with its iron bed and rush-covered chair evokes the atmosphere of the artist's time. The windows on this upper level provide a panoramic view over the Provençal countryside. Since Van Gogh's time, the olive groves have been much reduced and taller pine trees obscure part of the view, but beyond lie the instantly recognisable hills of Les Alpilles, the backdrop in so many of Van Gogh's paintings.

Beneath the cloister, a door opens into the visitors' garden. The former wheatfield lies to the left, but this is now a private area for patients. Returning via the cloister, on the other side of the church is what in Van Gogh's time was the administrative block and Dr Peyron's home. The rest of the site – including the east and north wings, where Van Gogh had his bedroom and studio – is the psychiatric hospital and is closed to visitors. One can walk around part of the exterior of the hospital to catch occasional glimpses of the buildings.

Within easy walking distance of Saint-Paul lie other fascinating sites. The impressive Roman mausoleum tower and ceremonial arch stand just off the main road from Saint-Rémy (1). Another few minutes up the road is the entrance to Glanum (2), the excavated Roman town with its shrines to ancient gods. The quarries (3) where Van Gogh painted are situated between Glanum and Saint-Paul, but they are slightly difficult to find and should only be viewed from a safe place on the marked public footpath. A wooded valley trail rises up into Les Alpilles (4), which is wonderful walking terrain.

Back in the town of Saint-Rémy, the compact and mainly pedestrianised historic centre is a delight to explore. The main attraction for those on the Van Gogh trail is the Musée Estrine (5), in the street of the same name – an eighteenth-century mansion now elegantly converted into a modern art gallery. Along with rooms of twentieth-century art, a display of wall panels tells the story of Van Gogh's life.[1]

The Musée des Alpilles (6), a very short walk away in Rue Carnot, provides a good insight into the history of the town and its surroundings. Among the collection is a bronze bust of Van Gogh by the Russian-born Parisian sculptor Ossip Zadkine.[2] The church of Saint-Martin, which appears in a modified form in *Starry Night*, is close by.

Strolling through the town's web of narrow alleyways and around its circular boulevard is always a pleasure. It was here, on Boulevard Mirabeau (7), that Van Gogh found his view of *Road Menders* (figs. 61 and 62). The trees and architecture have changed, making it difficult to identify the precise spot.

A short drive south-west from Saint-Rémy lies the medieval hilltop village of Les Baux-de-Provence, now a popular tourist destination with its houses set along a steep alley stretching upwards to the remains of a medieval fortress, with fine views. Further west lies Montmajour, another former monastery, perched up high, which features in many of Van Gogh's drawings and paintings done while he was based in Arles. The city of Arles, where the artist lived for 14 months before coming to Saint-Rémy, lies not far away down in the Rhône valley. For a guide to the Van Gogh sites in Arles, see Martin Bailey, *Studio of the South: Van Gogh in Provence* (Frances Lincoln, 2016), pp. 188–91.

CHRONOLOGY

1889

8 May	Vincent van Gogh arrives at the asylum of Saint-Paul-de-Mausole, just outside Saint-Rémy-de-Provence, coming from Arles (25 kilometres to the south-west) and escorted by Reverend Frédéric Salles. He is a voluntary patient under the asylum director, Dr Théophile Peyron
27 May	Admission of Henri Enrico as a patient
Early June	Allowed to work outside the asylum
18 June	Completes *Starry Night* (fig. 49)
6 July	Hears that his sister-in-law Johanna (Jo) Bonger is pregnant
7 July	First visit to Arles for the day, accompanied, probably by the chief orderly Charles Trabuc. Meets his friends Joseph and Marie Ginoux from the Café de la Gare and his former cleaner Thérèse Balmossière
15 or 16 July	Consignment of paintings sent to Theo
16 or 17 July	Suffers first mental crisis at Saint-Paul
About 21 August	Cor, his youngest brother, leaves Paris to emigrate to South Africa
About 22 August	Recovers, resuming work on 2 September
3 September	Opening of Société des Artistes Indépendants exhibition, Paris (until 4 October), in which Van Gogh has two paintings
6 September	Admission of Joseph Célestin Pontet as a patient

20 September	Consignment of paintings sent to Theo
Late September	Dr Peyron meets Theo in Paris
28 September	Consignment of paintings sent to Theo, including *Starry Night* (fig. 49)
2 November	His mother Anna and sister Willemien (Wil) move from Breda to Leiden
About 16–17 November	Second visit to Arles for two days, when he meets Salles and probably Joseph and Marie Ginoux
6 and 18 December	Consignments of paintings sent to Theo
24 December	Suffers second mental crisis at Saint-Paul
About 31 December	Recovers

1890

2 January	Reverend Salles visits Saint-Paul
3 January	Consignment of paintings sent to Theo
18 January	Opening of Les Vingt exhibition, Brussels (until 23 February), in which Van Gogh has six paintings and two drawings
18 or 19 January	Third visit to Arles, when he meets Joseph and Marie Ginoux
20 or 21 January	Suffers third mental crisis at Saint-Paul
29 or 30 January	Receives the January issue of *Mercure de France* with Albert Aurier's article
By 31 January	Recovers
31 January	Birth of Vincent Willem, the son of Theo and Johanna (Jo)
1 February	Receives news of the birth
18 February	Receives news that *The Red Vineyard* (F495), painted in Arles, has sold for 400 francs – this is the first painting which he is certain to have sold
About 19 February	Starts *Almond Blossom* (fig. 106)
22–23 February	Fourth visit to Arles for two-day visit by himself – suffers his fourth mental crisis during the trip
6 March	Theo receives payment from Anna Boch for *The Red Vineyard*
About 17 March	Temporary short-term respite

19 March	Opening by French president Sadi Carnot of the Société des Artistes Indépendants exhibition, Paris (exhibition runs from 20 March to 27 April), in which Van Gogh has ten paintings
30 March	37th birthday
18 April	First wedding anniversary of Theo and Jo
Late April	Recovers
29 April	Consignment of paintings sent to Theo, including *Almond Blossom* (fig. 106)
1 May	Theo's 33rd birthday
10 May	Birth of Adeline Barral, daughter of Jean Barral, the 'gardener'. She dies on 15 May
16 May	Leaves the asylum
17 May	Arrives in Paris for a three-day visit to Theo and Jo in their apartment at 8 Cité Pigalle
20 May	Moves to the village of Auvers-sur-Oise, 30 kilometres north of Paris, lodging at the Auberge Ravoux
27 July	Shoots himself, in the wheatfields above Auvers
29 July	Death of the artist

ENDNOTES

PREFACE (pp. 8–17)

1 The copy reproduced is at the Van Gogh Museum archive (b4420) (the reverse is inscribed 'Peyron/Rémy', presumably meaning that it dates from when he was director, 1874–96). The only other known copy is at the Musée des Alpilles in Saint-Rémy.
2 The French term in the nineteenth century was an *asile d'aliénes* (insane asylum). I use the terms 'asylum' for Van Gogh's time and 'psychiatric hospital' for recent times.
3 F498 and F499.
4 Interview with Henri Mison, 18 December 1987.
5 On my visit on 18 December 1987, I was accompanied throughout by Henri Mison, the director, who allowed me, as a journalist, to take photographs.
6 Admission register (*Registre des Entrées de 1876 à 1892*) for Saint-Paul, Archives Municipales, Saint-Rémy, 3Q5. I am grateful for the assistance of Rémi Venture and his successor Alexandra Roche-Tramier, as well as the mayor, Hervé Chérubini, for his support for the archive.
7 A comment regarding patient privacy: I have used information which was published by the former asylum director Edgar Leroy in the 1920s or which has now become openly available in the asylum's admission register (3Q5) and other documents in the municipal archive. Identifying the patients makes it possible to research their background and conditions in order to provide a clearer historical context for Van Gogh's stay. All 1889–90 patients would have died by the mid-twentieth century, in most cases much earlier, and none of their children or grandchildren would now still be alive.
8 Letters 800 (5 and 6 September 1889), 822 (c.26 November 1889), 832 (c.23 December 1889) and 836 (4 January 1890). References to letters in the endnotes refer to Jansen, Luijten and Bakker, *Vincent van Gogh – The Letters, The Complete Illustrated and Annotated Edition*, 2009 (www.vangoghletters.org).
9 Letter 772 (9 May 1889), see also 776 (23 May 1889).
10 For further details on Revello and Enrico, see chapter 10.
11 Letter 777 (31 May–6 June 1889).
12 There may also have been a degree of self-censorship. Incoming correspondence for patients was addressed 'c/o Dr Peyron' (see Letters 791, 16 July 1889; 848, 31 January 1890; and 849, 1 February 1890) and presumably outgoing post had to pass through the doctor's office (on one occasion Peyron added a PS on a letter from Van Gogh, Letter 798, c.2 September 1889). See also (Viry), *Dix Lettres d'un Aliéné*, p. 51.
13 Bailey, 2016. An important book on the asylum period is Ronald Pickvance's excellent catalogue of the exhibition at New York's Metropolitan Museum of Art in 1986, but over thirty years later this is inevitably very dated (Pickvance, 1986). The Van Gogh Museum's catalogue of its Saint-Rémy drawings is invaluable (Vellekoop and Zwikker, 2007). A companion volume on the paintings is due to be published in a few years.
14 The evidence is the time in February when this particular tree blossoms, its location and information which originally came from early twentieth-century local residents.
15 I also followed the writings of early Van Gogh specialists who visited Saint-Paul. See Meier-Graefe, 1922; Coquiot, 1923; Piérard, 1924; Perruchot, 1955; Tralbaut, 1969; and Rewald, 1978.
16 The diaries of Baltus (R. and J. Leroy collection) survive for 1924–41. The Saint-Rémy artist should not be confused with the famous Polish-French artist Balthus.
17 Jo Bonger, 'Memoir of Vincent van Gogh' in *The Complete Letters of Vincent van Gogh*, Thames & Hudson, London, 1958, vol. i, p. xlix.
18 Letter 638 (9–10 July 1888).
19 I am extremely grateful to Brendan Owens, public engagement manager at the planetarium (and to Sheryl Twigg, who arranged my visit). For further details, see pp. 81–2.

PROLOGUE: TWO BROTHERS, TWO LIVES (pp. 18–25)

1 Letter 111 (15 April 1877).
2 Theo and Jo met on 10 December and they had decided to become engaged by 21 December. For background, see Jansen and Robert, 1999, pp. 24-7.
3 Theo to Anna, 21 December 1888 (Jansen and Robert, 1999, p. 24).
4 Theo to Jo, 3 and 4 January 1889 (Jansen and Robert, 1999, p. 81).
5 Theo to Jo, 28 February 1889 and Jo to Theo, 10 March 1889 (Jansen and Robert, 1999, pp. 190 and 209).
6 Jo to Mien Bonger, 26 April 1889 (Jansen and Robert, 1999, p. 27).
7 Letters 678 (9–14 September 1888) and 674 (4 September 1888).
8 For further details, see Bailey, 2016, pp. 153–4.
9 Van Gogh Museum specialists have posited borderline personality disorder as a possible diagnosis, but not the most likely (Bakker, Van Tilborgh and Prins, 2016, p. 125). I do not argue that Van Gogh necessarily suffered from borderline personality disorder, but this could explain his deep fear of abandonment. See also Erwin van Meekeren, *Starry Starry Night: Life and Psychiatric History of Vincent van Gogh*, Benecke, Amsterdam, 2003 (conclusion on pp. 140-1) and John Hughes, 'A Reappraisal of the possible Seizures of Vincent van Gogh', *Epilepsy & Behavior*, June 2005, p. 507.
10 For background on French nineteenth-century asylums in English publications see: Robert Castel, *The Regulation of Madness: The Origins of Incarceration in France*, University of California, Berkeley, 1988 and Yannick Ripa, *Women & Madness: The Incarceration of Women in Nineteenth-Century France*, Polity, Cambridge, 1990.
11 Letter 186 (18 November 1881), with the Gheel reference published in Han van Crimpen and Monique Berends-Albert, *De Brieven van Vincent van Gogh*, Uitgeverij, The Hague, 1990, vol. i, p. 437. The town is now known as Geel.
12 Theo to Jo, 16 March 1889 (Jansen and Robert, p. 222).
13 Letter 749 (16 March 1889).
14 Letter 766 (2 May 1889).
15 Henri Dagonet, *Traité des Maladies Mentales*, Baillière, Paris, 1894, table and map at end (1888 figures).
16 Theo was caught up with his marriage arrangements and it was quite a long journey from Paris, which probably explains why he did not visit Saint-Paul. It is more surprising that Vincent did not accompany Salles on 28 April 1889 to see the asylum for himself before making his decision.
17 *Maison de Santé de Saint-Rémy de Provence*, 1866 (see pp. 7–9 for quotes), a revised version of *Etablissement de St-Paul pour le Traitement des Aliénés des deux Sexes*, 1856.
18 Letter 772 (9 May 1889).
19 Salles to Theo, 19 April 1889 (Van Gogh Museum archive, b1050).
20 Theo to Peyron, 24 April 1889 (Tralbaut, 1969, p. 275).
21 Letter 762 (24 April 1889).

CHAPTER ONE: ARRIVAL (pp. 26–33)

1 Letter 772 (9 May 1889).
2 'La France Pays peu connu', *Bibliothèque Universelle et Revue Suisse*, August 1889, p. 319. Sayous tried to visit Saint-Paul, but 'establishments of this sort are not very accessible, the time was badly chosen, and I was not able to enter' (p. 320).
3 Pennell had visited Saint-Rémy and sketched the monuments in September 1888 (Harriet Preston, 'A Provençal Pilgrimage', *Century Magazine*, July 1890, pp. 329–30 and 332 and Joseph and Elizabeth Pennell, *Play in Provence*, Unwin, London, 1892, p. 32).

4 Paul Mariéton, *La Terre Provençale: Journal de Route*, Ollendorff, Paris, 1890, p. 129 (entry for 16 August 1888).

5 The writer Marie Gasquet was apparently given a signed Van Gogh drawing by the unnamed concierge, which she sold during the Second World War (Chantal Guyot-de Lombardon and Magali Jouannaud-Besson, *Marie et Joachim Gasquet*, Académie d'Aix, Aix-en-Provence, 2011, p. 26). Résignier (possibly spelt Réssiguier) is recorded as the concierge in the 1886 and 1891 censuses. Van Gogh gave him a Christmas tip (Letter 829, c.19 December 1889).

6 Among its earlier notable patients was Marie Lafarge, who was convicted in a highly-publicised case of poisoning her husband in 1840. She was held at Saint-Paul in 1851–52.

7 *Maison de Santé de Saint-Rémy de Provence*, 1866, after p. 16.

8 Emile Bernard, *La Plume*, 1 September 1891, pp. 300–1. This short article includes one of the fairly rare descriptions of what Van Gogh was like, written soon after his death.

9 Theo to Peyron, 24 April 1889 (Tralbaut, 1969, p. 275).

10 In addition to the 100 francs a month, Theo also paid for Vincent's extra expenses, most importantly his paints and canvas. Altogether the total came to around 250 francs a month, a similar sum to what Theo had provided for Vincent in Arles or possibly slightly less.

11 An 1874 survey of French asylums recorded that male patients received between 14 and 40 centilitres per day, compared with the 50 centilitres requested for Van Gogh (Augustin Constans, Ludger Lunier and Octave Dumesnil, *Rapport Général sur le Service des Aliénés en 1874*, Nationale, Paris, 1878, p. 217). Vincent himself had requested the extra wine ration (Letter 760, 21 April 1889).

12 Letter 782, c.18 June 1889, see also 787 (6 July 1889). Drinking wine was very widespread in France and 'sobriety' may have referred to spirits.

13 Salles to Theo, 10 May 1889 (Van Gogh Museum archive, b1052).

14 Letter 772 (9 May 1889).

15 Medical register (*Le Grand Registre de l'Asile de Saint-Rémy*) (Bakker, Van Tilborgh and Prins, 2016, pp.156–9). Coquiot may well have got access to this key document (Coquiot, 1923, pp. 226–7). It was first quoted in Hans Evensen, 'Die Geisteskrankheit Vincent van Goghs', *Allgemeine Zeitschrift für Psychiatrie und Psychisch-Gerichtliche Medizin*,

15 February 1926, pp. 150–1. One of the two pages of the register was reproduced shortly afterwards in Doiteau and Leroy, 1926, p. 140 (and later both pages in Doiteau and Leroy, 1928, opposite pp. 84–5). The register (or possibly a photograph of it) was exhibited at Van Gogh exhibitions at the Palais des Musées d'Art Moderne, Paris in 1937 (no. 180) and at the Musée Jacquemart-André, Paris in 1960 (no. 426). A photograph (probably taken in the 1950s) was reproduced in Tralbaut, 1969, pp. 276–7. However, the original medical register does not seem to have been examined by outsiders since 1960.

16 Report by Dr Jules Urpar, chief medical officer of the Arles hospital, 7 May 1889 (medical register, Bakker, Van Tilborgh and Prins, 2016, pp. 156 and 158).

17 Van Gogh told Dr Peyron that 'his mother's sister was epileptic, and that there are several cases in his family' (medical register, Bakker, Van Tilborgh and Prins, 2016, pp. 157 and 159). Van Gogh also reported that Dr Félix Rey in Arles had earlier diagnosed epilepsy (Letter 776, c.23 May 1889, and see also 772, 9 May 1889).

18 Letter 772 (9 May 1889).

CHAPTER TWO: ENCLOSED GARDEN (pp. 34–45)

1 Letter 777 (31 May–6 June 1889).

2 Van Gogh initially called it the garden, although from October onwards he sometimes used the asylum's term, the park.

3 Alphonse (also known as Alfred) Donné, *Change of Air and Scene: A Physician's Hints, with Notes of Excursions for Health Amongst the Watering-places of the Pyrenees, France (Inland and Seaward), Switzerland, Corsica and the Mediterranean*, King, London, 1872, p. 66.

4 Letter 776 (c.23 May 1889).

5 Lilacs is F579.

6 Van Gogh may have known Katsushika Hokusai's print *Iris and a Grasshopper* (1832).

7 Letter 772 (9 May 1889).

8 The two arrivals were Henri Enrico on 27 May 1889 and Joseph Célestin Pontet on 6 September 1889 (admission register, Archives Municipales, Saint-Rémy, 3Q5).

9 Peyron to Theo, 26 May 1889 (Van Gogh Museum archive, b1058).

10 Letter 776 (c.23 May 1889).

11 F609.

12 Letter 825 (8 December 1889).

13 Letter 861 (29 March 1890). The painting was displayed at the Société des Artistes Indépendants, Paris in March 1890. For background on the undergrowth paintings, see Cornelia Homburg and others, *Van Gogh: Into the Undergrowth*, Cincinnati Art Museum, 2017.

14 Göring was photographed inspecting the painting at the Jeu de Paume gallery, Paris in 1940–41.

15 Jo to Octave Maus, 7 February 1891 (Vellekoop and Zwikker, 2007, p. 204).

16 Letter 785 (2 July 1889).

17 The other three are F597, F610 and F749.

18 Vincent owned a reproduction of Hokusai's *Study of Grass* (1845), published in *Le Japon Artistique*, May 1888, image C (Letter 686, 23–24 September 1889). He had earlier hung it in the Yellow House (Letter 768, 3 May 1889).

19 There are two versions, fig. 24 and F659 (November 1889). F659 was once regarded as a possible fake, but is now accepted as authentic (Ella Hendriks and Louis van Tilborgh, 'Van Gogh's "Garden of the Asylum": Genuine or Fake?', *Burlington Magazine*, March 2001, pp. 145–56).

20 Letter 822 (c.26 November 1889).

21 Letter 822 (c.26 November 1889). This description probably refers to F659, which is almost the same composition as fig. 24.

22 Letter 868 (4 May 1890).

CHAPTER THREE: LIFE INSIDE (pp. 46–55)

1 Letter 783 (25 June 1889).

2 Letter 776 (c.23 May 1889).

3 Letter 784 (2 July 1889). The book was *Dicks' Complete Edition of Shakspere's Works* (John Dicks, London, various editions).

4 On one occasion Van Gogh unsuccessfully tried to order a book from a shop in Arles run by Henriette Lamblot (Letter 791, 16 July 1889).

5 Although Van Gogh read widely at the asylum, his letters have fewer literary references than earlier in Arles, suggesting that his reading was slowing down. See Wouter van der Veen, *Van Gogh: A Literary Mind*, Van Gogh Museum, Amsterdam, 2009.

6 Twenty-three letters from Theo survive, although a few may be lost. From 1886 Vincent and Theo normally corresponded in French, rather than Dutch.

7 Letter 628 (c.19 June 1888).

8 The bedroom's location on the upper floor is confirmed by Van Gogh's comment that when ill he had not gone 'downstairs' (Letter 801, 10 September 1889). The room may even have been the end one, furthest from the chapel (Tralbaut, 1959, p. 111).

9 In the east wing the windows had fixed panes at the top. The lower panes opened inwards, with the shutters outside, and beneath the windows the walls were recessed. These details are important in confirming that the bedroom was in the east wing, since the configuration in the north wing was different.

10 Letter 776 (c.23 May 1889).

11 Letter 803 (19 September 1889). Van Gogh may well have painted a few of the garden views from his studio window (such as F651, F731 and F733).

12 In reality, Van Gogh is much more likely to have hung his pictures unframed, since frames may have been difficult to acquire in the asylum and he probably changed the hang regularly, to display his latest paintings and allow them to dry. Although the two 'framed' works are often said to represent drawings, they are very large, with the lower one being almost the width of the window, and are therefore almost certainly paintings.

13 Bakker, Van Tilborgh and Prins, 2016, p. 59. They suggest the ground floor partly because Van Gogh complained of dampness coming up from the building's 'foundations' (Letter 816, c.3 November 1889). However, the studio was then unheated (Letter 825, 8 December 1889), so even an upper-floor room would have been damp in winter.

14 The print (fig. 29) shows four rectangular panes (in height) on the ground floor and three on the upper floor (except for the central window on the upper floor, which also had four panes). This configuration is confirmed by mid-twentieth-century photographs. Van Gogh's garden paintings, in which the windows appear some distance away, do not provide useful evidence. In fig. 23 he omitted the semi-circular tops, whereas he included them in the closer view (fig. 34). He admitted that the picture in fig. 23 was something of a 'simplified' view (Letter 810, c.8 October 1889). When working on fig. 28 the window lay less than two metres away, so there is little reason to question his depiction of the architecture.

15 Sister Epiphane later recalled that Van Gogh had painted in the 'large room to the left of the entrance' (Coquiot, 1923, p. 215), which would have been the common room. However, it seems unlikely that he would have

been permitted or wished to paint with other patients, other than possibly on an occasional basis, and Van Gogh specified that he had been allocated an 'empty' room (Letter 776, c.23 May 1889).

16 Vellekoop and Zwikker, 2007, pp. 249 and 255.

17 For the argument that the three works were done in May-June 1889 for Theo, see Pickvance, 1986, p. 89. But had Vincent sent them to Theo, it seems highly likely that such personal works would have been referred to in the correspondence.

18 Letters 810 (c.8 October 1889) and 815 (c.25 October 1889). *Trees in the Garden of the Asylum* (fig. 25), which probably appears in *Window in the Studio* (fig. 28), may well date from late September or early October (Letter 808, 5 October 1889), which would be compatible with a mid-October dating for the studio scene. *Starry Night* was sent to Theo on 28 September (Letter 806, 28 September 1889), but Van Gogh could well have painted his very sketchy version in the studio interior scene from memory.

19 The view is from the junction with the east wing, facing north.

20 Letter 783 (25 June 1889).

21 Doiteau and Leroy, 1928, p. 63. The plan of Saint-Paul by Joseph Girard, 1857, copied by Marcel Guesnot, 12 September 1959 (Archives Municipales, Saint-Rémy, 3Q7), confirms that the common room lay just to the north of the vestibule. The fireplace in the sketch is somewhat similar to that in a 1950s photograph taken at the asylum in an unidentified room (Vellekoop and Zwikker, 2007, p. 410).

22 Christie's, 7 February 2012. The painting is due to be sold again at Christie's, 15 May 2018.

CHAPTER FOUR: ALIENISTS (pp. 56–67)

1 Letter 841 (20 January 1890).

2 Jean-Baptiste Descuret, *La Médecine des Passions ou les Passions*, Béchet, Paris, 1841, p. 180.

3 Eugène de Tamisier, *Saint-Rémy et la Vallée des Baux*, Aubanel, Avignon, 1875, p. 40.

4 Bénédict-Henry Révoil, 'La Maison de Fous', *Le Dessus du Panier*, Sartorius, Paris, 1862, p. 131. Saint-Paul is not named, but the asylum is placed in the Midi (South) (p. 128) and Dr Mercurin is named (p. 129).

5 André Thévenot, 'Adieux à la Provence', *Méridionales, Poésies Intimes*, Garcin, Arles, 1835, p. 258.

6 Louis Mercurin's daughter Catherine married Pierre-Aimé de Chabrand, with ownership later passing to their descendants. In Van Gogh's time the asylum was owned by Aubert de la Castille. Under the medical directorship of Dr Pierre-Egiste Lisle in 1868-70 there had been problems between Saint-Paul and the municipality (Lisle was the author of *Du Traitement de la Congestion Cérébrale et de la Folie*, Savy, Paris, 1871). Dr Emile Bourgarel then served until the arrival of Peyron. For further background on the asylum, see Jean Delrieux's unpublished paper 'L'Establissement de Saint-Paul à Saint-Rémy-de-Provence', Escolo dis Aupiho, 7 April 1988 (available at Bibliothèque Joseph-Roumanille, Saint-Remy).

7 Report of Inspecteur Général des Asiles (Augustin Constans) to Préfet of Arles, 12 August 1874 (Archives Municipales, Saint-Rémy, 3Q6). The published national survey on asylums was Augustin Constans, Ludger Lunier and Octave Dumesnil, *Rapport Général sur le Service des Aliénés en 1874*, Nationale, Paris, 1878.

8 Leroy, 1926, p. 140 and Doiteau and Leroy, 1928, p. 53.

9 Théophile Peyron, *Etude sur la Démence Paralytique*, Cristin, Montpellier, 1859.

10 Viry was at Saint-Paul from 23 May 1879 to 17 June 1880 (admission register, Archives Municipales, Saint-Rémy, 3Q5).

11 (Viry), *Dix Lettres d'un Aliéné*, 1884, pp. viii and 46 (the only known copy is at the Bibliothèque Nationale de France, Paris). See also Viry's earlier anonymous pamphlet, Ouvrier Typographe (Viry), *Affaire Monastério: Lettre Audit Carlos*, Nouvelle, Lyon, 1884.

12 Letter 777 (31 May–6 June 1889).

13 For 'kind', see Letters 797 (22 August 1889), 798 (c.2 September 1889), 801 (10 September 1889), 808 (5 October 1889), 863 (29 April 1890) and 865 (c.1 May 1890). For 'Père', see Letter 806 (28 September 1889) and unsent letter RM20 (24 May 1890).

14 Peyron's monthly reporting letters to Theo may have survived until 1913, but most now seem lost (Jo Bonger, 'Memoir of Vincent van Gogh' in *The Complete Letters of Vincent van Gogh*, Thames & Hudson, London, 1958, vol. i, p. xlix). A few letters do survive in the Van Gogh Museum archive (29 April, 26 May, 9 June and 2 September 1889 and 29 January, 24 February and 1 April 1890), see also Hulsker, 1971, pp. 24 and 39-44. Some letters from Theo to Peyron may still be in the archive of Saint-Paul (24 April, 23 May and c.8 December 1889). Peyron's visit to Paris was in late September 1889 (Letters 806, 28 September 1889 and 807, 4 October 1889).

15 Letter 777 (31 May–6 June 1889). The identification of the man in the painting as Dr Peyron was made in Coquiot, 1923, p. 220 and Doiteau and Leroy, 1928, opposite p. 60.

16 Viry described Dr Peyron as 'half Silenus, half Falstaff' (*Dix Lettres d'un Aliéné*, 1884, p. 28).

17 Letter 816 (c.3 November 1889) and Doiteau and Leroy, 1928, p. 77.

18 Joseph Peyron to Henri Vanel, 26 July 1926 (copy of transcribed version of the original at unknown location). See also Doiteau and Leroy, 1928, pp. 53–4 and Victor Doiteau and Edgar Leroy, 'Van Gogh et le Portrait du Dr Rey', *Aesculape*, February 1939, p. 42.

19 Henri Vanel's father was also called Henri, and he too was a clockmaker. See Doiteau and Leroy, 1926, p. 186 and Tralbaut, 1969, p. 292.

20 Joseph Peyron to Henri Vanel, 26 July 1926 (copy of transcribed version of the original at unknown location). See Tralbaut, 1969, p. 292 and Perruchot, 1955, p. 346. On Vanel, see Henri Longdon, 'Contribution à la Connaissance de Mirèio', *Revue d'Histoire Littéraire de la France*, January 1954, p. 86. Marie Gasquet was née Girard.

21 Théodore Duret, *Vincent van Gogh*, Bernheim-Jeune, Paris, 1916, p. 78. Gasquet is also said to have owned an unidentified Van Gogh drawing given to her by the concierge of Saint-Paul (Chantal Guyot-de Lombardon and Magali Jouannaud Besson, *Marie et Joachim Gasquet*, Académie d'Aix, Aix-en-Provence, 2011, p. 26).

22 Letter 776 (c.23 May 1889).

23 Letter 800 (5 and 6 September 1889).

24 Letter 801 (10 September 1889).

25 Letters 804 (19 September 1889) and 801 (10 September 1889). A recent novel has been written based on an imaginary life of Jeanne Trabuc: Susan Fletcher, *Let Me Tell You About a Man I Knew*, Virago, London, 2016.

26 The surviving version of the portrait of Jeanne was bought by Otto Krebs of Holzdorf in 1927, but it was seized by the Red Army in Germany in 1945 and secretly taken back to the Soviet Union. The painting surfaced at the Hermitage in 1995, where it remains (Albert Kostenevich, *Hidden Treasures Revealed*, State Hermitage Museum, St Petersburg, 1995, pp. 232–5).

27 Letter 800 (5 and 6 September 1889). For the location, see Bonnet, 1992, pp. 86–7. In 1940 the house became the residence of the writer Léon Daudet (until his death in 1942), the son of the famed novelist Alphonse Daudet.

28 Letter 801 (10 September 1889).

29 The photograph is in the collection of the Musée Estrine, Saint-Rémy (my thanks to Philippe Latourelle for his assistance). The seated man on the left is Frédéric George, who became a talented photographer, and the standing men are Frédéric's brothers Joseph (left) and Louis (right). For background on the George family, who lived close to Saint-Paul, see *Saint-Rémy en 1900: Photographies de Frédéric George*, Musée des Alpilles, Saint-Rémy, 1988 and Marcel Bonnet, *Saint-Rémy-de-Provence: Chronique photographique de Frédéric George*, Equinoxe, Marguerittes, 1992.

30 Letter 836 (4 January 1890). Van Gogh used the word *garçon* (boy or lad). The only other asylum employee in their twenties in the 1891 census was Joseph Recoulin, then a 26-year-old orderly, but as Van Gogh knew Poulet well and was accompanied by him on painting excursions, Poulet is much more likely to have been the sitter.

31 Tralbaut, 1969, p. 288. On one occasion according to Poulet, Van Gogh kicked him from behind (de Beucken, 1938, p. 133), but there is little other evidence that the artist was violent. For Poulet's memories, see also de Beucken, 1938, pp. 109–11, 120–22, 133–4 and 157; Piérard, 1946, p. 187; Jean-Denis Longuet, *Dauphiné Libéré Dimanche*, 5 April 1953, p. 4; and Rewald, 1978, p. 357. See also entries in the diary of Jean Baltus (R. and J. Leroy collection), 25 December 1931, 21 December 1934 and 22 September 1936.

32 The painting was recorded as *le jardinier* (gardener) when it was first exhibited in 1908 (Druet, Paris). It was then reproduced in Julius Meier-Graefe, *Vincent van Gogh*, Piper, Munich, 1910, p. 44 as *Schnitter im Feld* (Reaper in Field).

33 The handwritten note is in a file at the Musée Estrine in Saint-Rémy, in a large collection of research notes on Van Gogh by an unidentified local researcher in around the 1980s who appears to have been well informed and meticulous. The note reads: *Louis Poulet, rapportant un propos de son grand-père, François Poulet, qui fut garde-malade à St-Paul, dit que ce serait là le portrait de Jean Barral (1861–1942)* (Louis Poulet, according to his grandfather, François Poulet, who was an orderly at Saint-Paul, said that it was the portrait of Jean Barral, 1861–1942). Analysing all the evidence, it is highly likely that the portrait does indeed depict Barral. The

birth year given for Jean Barral in the note is correct (he was born on 21 January 1861 in Eyragues); he was a *cultivateur* (farmer) when he married on 28 December 1887 in Saint-Rémy; he would have been aged 28 when the portrait was painted; and his daughter Adeline was born in the town (Rue Blancard) on 10 May 1890, when he was *un journalier* (day-labourer).

34 Jean Barral married Marie Brun in Saint-Rémy on 28 December 1887.

35 Théodore Duret, *Vincent van Gogh*, Bernheim-Jeune, Paris, 1916. p. 78. Duret records that the parents of the *jardinier* (gardener) had their portraits painted, although he does not name him.

36 Letter 808 (5 October 1889). The 2009 edition of the letters includes a reproduction of the portrait, which might date from around the 1840s (judging by the women's clothing and appearance).

37 The chapel had a painting of *The Conversion of Paul* by an unknown artist (probably seventeenth century), which remains there, although now in poor condition.

38 Eugène de Tamisier, *Saint-Rémy et la Vallée des Baux*, Aubanel, Avignon, 1875, p. 19.

39 They came from either Vaisseau (Eugène de Tamisier, *Saint-Rémy et la Vallée des Baux*, Aubanel, Avignon, 1875, p. 40) or nearby Aubenas (Leroy, 1926, p. 182), both in Ardèche.

40 Photograph reproduced in Jacob-Baart de la Faille, *L'Epoque Française de Van Gogh*, Bernheim-Jeune, Paris, 1927, p. 56.

41 Letters 801 (10 September 1889) and 807 (4 October 1889).

42 Leroy, 1926, p. 182 and Doiteau and Leroy, 1928, p. 53

43 Rewald, 1978, p. 357. For other published memories by Sister Epiphane, see Coquiot, 1923, pp. 213–6; Leroy, 1926, pp. 182 and 186; Doiteau and Leroy, 1928, p. 53; Piérard, 1946, p. 186; Leprohon, 1964, p. 343; and Leprohon, 1972, pp. 261 and 265–6. See also Coquiot's notebook of his 1922 visit to Provence (Van Gogh Museum archive, b3348).

CHAPTER FIVE: WHEATFIELD (pp. 68–75)

1 Letter 776 (c.23 May 1889).

2 Letter 777 (31 May–6 June 1889).

3 Letter 785 (2 July 1889). Vincent had learned of Jo's pregnancy just a few days later (Letter 786, 5 July 1889). For background on Van Gogh's wheatfields see Herzogenrath and Hansen, 2002; Dorothee Hansen, Lawrence Nichols and Judy Sund, *Van Gogh: Fields*, Toledo Museum of Art, 2003; and Dorothy Kosinski, *Van Gogh's Sheaves of Wheat*, Dallas Museum of Art, 2006.

4 Letter 805 (c.20 September 1889).

5 Van Gogh's bedroom window faced almost directly east, but the depicted wheatfield views were more towards the southeast. A few of the drawings and paintings of the wheatfield appear to depict views from lower down, suggesting that he would have been standing in the field, but most were as seen from his room.

6 For example, Van Gogh depicts farmhouses in different positions in the background of the wheatfield paintings (Teio Meedendorp, 'Van Gogh's Topography' in Standring and Van Tilborgh, 2012, pp. 110–3).

7 On 15 May 1889 43 mm of rain fell at Saint-Rémy, compared with a total of 25 mm in the second half of the month and only 2 mm in the whole of June (Eleuthère Mascart, *Annales du Bureau Central Météorologique de France, Année 1889*, Gauthier-Villars, Paris, 1891, pp. 110 and 132). Van Gogh worked on the painting on 9 June (Letter 779, 9 June 1889).

8 Letter 779 (9 June 1889). The field was not quite rectangular, and the walls at the far left corner met at about 110 degrees, which results in what appears to be a slightly unusual perspectives in the wheatfield paintings.

9 Letter 800 (5 and 6 September 1889).

10 Letter 800 (5 and 6 September 1889).

11 Letter 800 (5 and 6 September 1889). The original painting, from June 1889, is F617 and the smaller repetition is F619.

12 Letter 790 (14–15 July 1889).

13 Letter 790 (14–15 July 1889).

14 Donald Olson, *Celestial Sleuth*, Springer, New York, 2014, p. 57.

15 Eleuthère Mascart, *Annales du Bureau Central Météorologique de France, Année 1889*, Gauthier-Villars, Paris, 1891, p. 220 and Letter 816 (c.3 November 1889).

16 Letter 827 (9–10 December 1889).

17 It was shown in Les Vingt, Brussels in January 1890 and the Société des Artistes Indépendants, Paris in March 1890.

18 In the past some specialists have dated *Green Wheatfield* to May 1889, but the present consensus is that it is May 1890.

19 Letter 811 (c.21 October 1889).

CHAPTER SIX: THE STARS (pp. 76–85)

1 Letter 777 (31 May–6 June 1889).

2 Letter 782 (c.18 June 1889).

3 Letters 594 (9 April 1888) and 628 (1 June 1888).

4 F474.

5 Letter 678 (9 and c.14 September 1888).

6 Letter 777 (31 May–6 June 1889). Daubigny and Rousseau both painted numerous night skies. Van Gogh may also have had in mind other artistic sources of inspiration. Theo had bought Jean-Charles Cazin's *Starry Night* (mid-1880s) for his gallery in September 1887, while Vincent was living in Paris (Cazin's small dots for stars, however, are quite unlike those of Van Gogh); the Cazin was sold at Sotheby's, 15 October 1976. Millet, whom Van Gogh greatly admired, had painted *Starry Night* (completed in 1865), which Van Gogh might possibly have known (Yale University Art Gallery, New Haven). Van Gogh also probably knew the nocturnes of James Whistler.

7 *Starry Night* is not mentioned in Van Gogh's letter of 16 June in which he lists the paintings he has just completed (Letter 780, 16 June 1889) and it was finished two days later (Letter 782, c.18 June 1889). For background on the painting, see Lauren Soth, 'Van Gogh's Agony', *Art Bulletin*, June 1986, pp. 301–13; Heugten, Pissarro and Stolwijk, 2008; and Thomson, 2008.

8 Letter 779 (9 June 1889).

9 Letter 776 (c.23 May 1889).

10 Letter 782 (c.18 June 1889).

11 Yonghui Zhao and others, 'An Investigation of Multispectral Imaging for the Mapping of Pigments in Paintings' in David Stork and Jim Coddington, *Computer Image Analysis in the Study of Art*, Society for Imaging Science and Technology, San José, 2008, pp. 7–8 of the paper on *Starry Night*.

12 Bailey, 2016, pp. 103–5.

13 Letter 596 (c.12 April 1888). On completing *Starry Night*, Vincent told Theo that he thought it would be 'comparable in sentiment' to paintings by Gauguin and Bernard, both of whom worked more from their imagination (Letter 782, c.18 June 1889).

14 Coquiot's notebook of his 1922 visit to Provence (Van Gogh Museum archive, b3348).

15 Letter 805 (c.20 September 1889). Gauguin's written advice came three months after Van Gogh's *Starry Night*, but he had probably said something similar when they were working together in Arles.

16 Alphonse Daudet, *Tartarin sur les Alpes*, Marpon & Flammarion, Paris, 1886, p. 34. Van Gogh himself described the limestone of Les Alpilles as 'grey or blue' (Letter 772, 9 May 1889).

17 Van Heugten, Pissarro and Stolwijk, 2008, p. 84.

18 Letter 676, 8 September 1888. This was in response to a lost letter from Theo which mentioned *The Great Wave*, which was part of Hokusai's series of 'Thirty Six Views of Mount Fuji'. Two weeks later Theo sent a group of Japanese prints to Vincent in Arles and it is just possible that it included *The Great Wave* (Letter 685, 21 September 1888). Gauguin probably discussed Hokusai and *The Great Wave* with Van Gogh in the Yellow House later in the autumn. Gauguin's painting of *La Vague* (The Wave), done in August–October 1888, was almost certainly inspired by the print. In January 1889 Gauguin pinned a group of his Hokusai prints in the studio of Emile Schuffenecker in Paris (Jean de Rotonchamp, *Paul Gauguin*, Crès, Paris, 1925, p. 77). *The Great Wave* would become popular among avant-garde European artists in the 1890s and the Van Gogh brothers were among its early admirers (Claude Monet and Henri Rivière also owned copies).

19 I am very grateful to Brendan Owens, of the Peter Harrison Planetarium at the Royal Observatory at Greenwich, who set up a presentation in the planetarium and has provided very helpful advice. For other astronomical perspectives, see: Albert Boime, 'Van Gogh's Starry Night: A History of Matter and a Matter of History', *Arts Magazine*, December 1984, pp. 86–103; Boime, 'Van Gogh's Starry, Starry Night' in *Revelation of Modernism*, University of Missouri, 2008, pp. 1–51; Charles Whitney, 'The Skies of Vincent van Gogh', *Art History*, September 1986, pp. 351–62; and 'Vincent van Gogh and Starry Skies over France' in Donald Olson, *Celestial Sleuth*, Springer, New York, 2014, pp. 46–7 and 61–2.

20 Letter 619 (c.3–4 June 1888).

21 A compilation with the group of poems 'From Noon to Starry Night' is Ernest Rhys (ed), *Leaves of Grass: The Poems of Walt Whitman*, Scott, London, 1886, pp. 291–300 (the reference to 'starry nights' is in the poem 'Thou Orb Aloft Full-Dazzling', pp. 291–2). For Van Gogh's interest in Whitman, see: Lewis Layman, 'Echoes of Walt Whitman's "Bare-Bosom'd Night"', *American Notes and Queries*, March–April 1984, pp. 105–9; Hope Werness, 'Whitman and Van Gogh', *Walt Whitman Quarterly Review*, spring 1985, pp. 35–41;

and Jean Schwind, 'Van Gogh's "Starry Night" and Whitman', *Walt Whitman Quarterly Review*, summer 1985, pp. 1–15.

22 Letter 670 (c.26 August 1888).

23 Letters 119 (4–5 June 1877), 120 (12 June 1877) and 131 (18 September 1877). The poem 'Under the Stars' (1875) was published in *Good Words*, January 1877, p. 49 and reprinted in Dinah Mulock Craik, *Thirty Years: Being Poems, New and Old*, Macmillan, Edinburgh, 1881, pp. 307-8.

24 Letter 638 (9–10 July 1888). Gauguin had lived in Rouen in 1884.

25 Letters 782 (c.18 June 1889) and 805 (c.20 September 1889). *Starry Night* is unsigned.

26 Letters 813 (22 October 1889) and 822 (c.26 November 1889).

27 *L'Echo de Paris*, 31 March 1891. Mirbeau knew Theo and Jo, but he might also have seen *Starry Night* at the shop of Tanguy, whom he also knew and who then stored much of the Van Gogh collection. The painting is listed in the late 1890 inventory compiled by Jo's brother, Andries Bonger, and it was therefore probably sent to Jo in the Netherlands in April 1891. It is no. 181 in this inventory, as *Les astres* with *Indép* (Société des Artistes Indépendants) added by another hand. This additional word is incorrect, as the picture exhibited at the Indépendants in September 1889 was in the inventory as no. 121, *Rhône le soir (Nuit étoilée)* (F474).

28 The novel was first published in parts in *L'Echo de Paris* (September 1892–May 93). Reprinted as *Dans le Ciel*, L'Echoppe, Tusson, 1989 and translated into English by Ann Sterzinger, *In the Sky*, Nine-Banded Books, Charleston, Virginia, 2015 (p.103 for the cited phrases). Mirbeau's enthusiasm for Van Gogh can be gauged by the fact that he bought *Irises* (fig. 18) in 1892 and *Wheatfield with Cypresses* (fig. 71) in around 1901.

29 *Starry Night* was exhibited at Bernheim-Jeune, Paris, 1901 (no. 65); Stedelijk Museum, Amsterdam, 1905 (no. 199); Oldenzeel, Rotterdam, 1906 (no. 47); Kunstkring, Rotterdam, 1910 (no. 35); Boymans Museum, Rotterdam, 1927 (no. 33); and Museum of Modern Art, New York, 1937 (unpublished in the catalogue).

30 See Leclercq to Jo, c.1900, 28 December 1900, 15 March 1901 and 5 April 1901 (Van Gogh Museum archive, b5738, b4131, b4138 and b4141).

31 Chris Stolwijk and Han Veenenbos, *The Account Book of Theo van Gogh and Jo van Gogh-Bonger*, Van Gogh Museum, Amsterdam, 2002, p. 181 (see also pp. 48, 51 and 125) and Feilchenfeldt, 2013, pp. 21–2. Leclercq died in October 1901. The dealer handling the 1906 sale was Rotterdam-based Oldenzeel. See Oldenzeel to Jo, 19 February and 7 and 13 March 1906 (Van Gogh Museum archive, b5438, b5439 and b5440).

32 Dirk Hannema, *Flitsen uit mijn Leven als Verzamelaar en Museumdirecteur*, Donker, Rotterdam, 1973. p. 56.

33 The painting was offered via The Hague dealer Van Wisselingh (*De Groene Amsterdammer*, 3 July 1936 and Museum of Modern Art file).

34 Kelvin de Veth, 'Starry Starry Night: 120 jaar De Sterrennacht', thesis, University of Tilburg, 2009, p. 16.

35 I am grateful for information from Lynn Rother, the museum's senior provenance specialist. *Portrait of Victor Choquet in an Armchair* (1877) is now at the Columbus Museum of Art; *Fruit and Wine* (c.1890) at the Pola Museum of Art, Kanagawa; and *May Belfort in Pink* (1895) at the Cleveland Museum of Art. The exchange is confirmed in a letter from Paul Rosenberg to Alfred Barr, 17 June 1941. Rosenberg wrote that he had paid $35,500, including a commission to de la Faille, Rosenberg to Barr, 4 June 1941 (correspondence kindly supplied by Marianne Rosenberg).

36 Letters 782 (c.18 June 1889), 805 (c.20 September 1889), 806 (28 September 1889) and 813 (22 October 1889). The titles given in this paragraph are translated from the original French.

37 Van Gogh exhibited his earlier Arles painting of stars above the Rhône (F474) as *Nuit Étoilée* (Starry Night) at the Société des Artistes Indépendants, Paris in September 1889. The similar (and changing) titles of the Arles and Saint-Paul paintings have caused some confusion in the Van Gogh literature on the early history of both works.

38 In 1972 it inspired Don McLean's song 'Vincent', with its opening line 'Starry, Starry Night'.

CHAPTER SEVEN: BEYOND THE WALLS (pp. 86–97)

1 Letter 787 (6 July 1889).

2 Letter 777 (31 May–6 June 1889).

3 Peyron to Theo, 9 June 1889 (Van Gogh Museum Archive, b1060).

4 *Maison de Santé de Saint-Rémy-de-Provence*, 1866, p. 5. This image was reused in a poster (fig. 1).

5 Balmossière is named in Murphy, 2016, pp. 94–5.

6 Letter 797 (22 August 1889). The book is Edouard Rod, *Le Sens de la Vie*, Perrin, Paris, 1889, p. 223.

7 Letter 890 (23 June 1890). In exchange Boch gave Vincent and Theo a coal-mining scene, *The Agrappe Mine in Frameries, Borinage* (1888–90, Van Gogh Museum, Amsterdam). This brought back memories of Van Gogh's stay as a missionary in the Borinage in 1879–80.

8 Letter 797 (22 August 1889). The attack occurred on 16 or 17 July 1889 and Van Gogh had recovered by 22 August. The Noé quarry, around 100 metres south of Saint-Paul, is also known as the Salade quarry.

9 Letter 805 (c.20 September 1889). Van Gogh painted another quarry scene in October 1889 (F635).

10 Letter 809 (c.8 October 1889).

11 Meta Chavannes and Louis van Tilborgh, 'A missing Van Gogh unveiled', *Burlington Magazine*, August 2007, p. 548.

12 Van Gogh later painted another version in his studio in December 1889 (F661).

13 Letter 859 (c.20 March 1890).

14 Ambroise Vollard, *Recollections of a Picture Dealer*, Dover, New York, 1978, p. 174 (Vollard describes the painting as 'a landscape in a mauve tonality'). The two *Sunflowers*, which Gauguin had been given in 1887, were F375 and F376.

15 Meta Chavannes and Louis van Tilborgh, 'A missing Van Gogh unveiled', *Burlington Magazine*, August 2007, pp. 546–50.

16 Letters 824 (7 December 1889) and 827 (9–10 December 1889). A mulberry tree is also probably depicted in the drawing F1501.

17 The painting Pissarro gave in return has not been identified (Chris Stolwijk and Han Veenenbos, *The Account Book of Theo van Gogh and Jo van Gogh-Bonger*, Van Gogh Museum, Amsterdam, 2002, pp. 24 and 199).

18 Letter 806 (28 September 1889).

19 He worked outside the asylum for part of the time when he was in reasonable health: early June to mid-July and mid-September to late December 1889 and for short periods in early 1890.

20 He once painted a vineyard (probably F726) 'a few hours away' (Letter 811, c.21 October 1889), which would have involved a walk of at least 10 kilometres each way.

21 He apparently visited Arles by himself in February 1890, and may well have been unaccompanied on his visits in November 1889 and January 1890.

22 The total population for the larger census area of Saint-Rémy and its surroundings was 5,757 in 1886.

23 References in his correspondence to local shopping are sparse. He bought 'linen clothing' (Letter 808, 5 October 1889) and a suit (Letter 854, 12 February 1890), but it is unclear whether he purchased these in Saint-Rémy or from visiting salesmen at the asylum.

24 Letter 779 (9 June 1889) is about his first visit and there are several references to his paintings of *Road Menders* (figs. 61 and 62). There are other scattered references to 'Saint-Rémy', but these refer to the asylum or its surroundings, rather than the town.

25 Letter 779 (9 June 1889). No doubt his mutilated ear and the fact that he was accompanied by an asylum employee will have worried those who encountered him in town.

26 Edmond and Jules de Goncourt, *Journal des Goncourt*, Charpentier, Paris, 1894, vol. vii, p. 72 (entry for 28 September 1885).

27 Letter 824 (7 December 1889). Van Gogh also depicted roadworks in his Arles painting of *The Yellow House* (F464). Van Gogh and the Goncourts both describe the trees as plane trees, although some were being replaced with elms (Rudolf Bakker, 'Portfolio/Gallische Brieven (3)', *Maatstaf*, April 1990, pp. 33–48).

28 Tralbaut, 1969, p. 294. The accompanying 1950s photograph is said to depict the same trees, although this is unlikely because they do not appear to have grown sufficiently thicker in the intervening 60 years. This suggests that the old trees were cut down soon after Van Gogh's stay and replaced. Van Gogh's view is from the town side (with the wide pavement), facing houses on the outer part of the boulevard.

29 Van Gogh is known to have painted the scene in December 1889. The pavement work on the Boulevard de l'Est is recorded in a document dated 1 February 1890 and payment was authorised on 22 June 1890 (Archives Municipales, Saint-Rémy, 1O10 and 1D21). This time difference between Van Gogh's original painting and the municipal records is curious, but it is possible that the paperwork was dealt with after the work had been completed.

30 This material, known as *torchon*, may also have been utilised for clothing or upholstery. Van Gogh made use of it for another landscape (F721). See Eliza Rathbone

and others, 2013, pp.141–53; Vellekoop and others, 2013, pp. 309 and 328; and Leanne Tonkin and Marcia Steele, 'Striving towards Originality and Authenticity?', *ICON News*, January 2016, pp. 14–7.

31 Letter 834 (3 January 1890).
32 Letter 838 (8 January 1890).
33 Letter 801 (10 September 1889).

CHAPTER EIGHT: OLIVE GROVES (pp. 98–105)

1 Letter 763 (28 April 1889).
2 Letter 805 (c.20 September 1889).
3 *Starry Night* came to the Museum of Modern Art in 1941 and *Olive Trees with Les Alpilles* in 1998.
4 Letter 805 (c.20 September 1889).
5 Letter 806 (28 September 1889).
6 These are figs. 37, 63, 67 and 69 plus F586, F587, F654, F656, F708, F709, F710, F714 and F715. Although unrecorded in the Van Gogh literature, a local farmer, François Ripert, later recalled the artist painting in the local olive groves (diary of Jean Baltus [R. and J. Leroy collection], 28 November 1934 and 5 February 1939). Saint-Rémy's olive groves were devastated by an extremely severe frost in 1956, so very few ancient trees remain.
7 Press release, Nelson-Atkins Museum of Art, 6 November 2017.
8 On this painting, see Joan Greer, 'A Modern Gethsemane: Vincent van Gogh's *Olive Grove*', *Van Gogh Museum Journal*, 2001, pp. 106–17.
9 The first two versions are F654 and F656.
10 Letters 841 (20 January 1890) and 840 (c.17 January 1890). Van Gogh's small drawing has not survived.
11 Letter 820 (c.19 November 1889). Gauguin's painting is *Christ in the Garden of Olives*, 1889 (Norton Simon Museum, Pasadena). Bernard's is *Christ in the Garden of Olives*, 1889 (private collection, known only from a black-and-white photograph).
12 Letter 823 (26 November 1889).
13 Letter 685 (21 September 1888).
14 Unsent letter RM21 (25 May 1890).

CHAPTER NINE: CYPRESSES (pp. 106–113)

1 Letter 783 (25 June 1889).
2 Letter 783 (25 June 1889). Van Gogh was probably remembering the obelisk (actually Roman) which he had frequently seen in Arles, in Place de la République.

3 See Amédée Pichot, 'Le Cyprès de Saint-Rémy', *Arlésiennes*, Hachette, Paris, 1860, pp. 67–72.
4 Letters 850 (1 February 1890) and 783 (25 June 1889).
5 Van Gogh made three versions: the original (fig. 71) and two replicas (F615 and a smaller one for his mother and Wil, F743). See John Leighton, Anthony Reeve, Ashok Roy and Raymond White, 'Vincent van Gogh's *A Cornfield, with Cypresses*', *National Gallery Technical Bulletin*, 1987, pp. 42–59 and Susan Alyson Stein and Asher Miller (eds.), *The Annenberg Collection*, Metropolitan Museum of Art, New York, 2009, pp. 206–11.
6 Letter 823 (26 November 1889). Although Van Gogh wrote about sales to 'England', Reid was Scottish, so Van Gogh presumably meant 'British'. He had earlier described the colours in fig. 73 as like 'a multicoloured Scottish plaid', which is further evidence of the Reid link (Letter 784, 2 July 1889). Van Gogh later returned to the idea of selling his work in 'Scotland' (Letter 854, 12 February 1890).
7 Letter 836 (4 January 1890).
8 Letter 864 (29 April 1890).
9 'Les Isolés: Vincent van Gogh', *Mercure de France*, January 1890, p. 24. A shortened version of Aurier's article was published in the Belgian journal *L'Art Moderne*, 19 January 1890, pp. 20–2.
10 Letters 853 (9–10 February 1890) and 867 (3 May 1890). Van Gogh painted another version of *Cypresses with Two Women* in February 1890 (F621).
11 Unsent letter RM23 (c.17 June 1890). There are thirteen paintings which feature prominent cypresses: figs. 25, 49, 70, 71, 72, 73 and 74 and F621, F623, F704, F717, F731 and F743 (smaller cypresses feature in several other pictures).

CHAPTER TEN: FELLOW TRAVELLERS (pp. 114–121)

1 Letter 776 (c.23 May 1889).
2 Letter 772 (9 May 1889).
3 (Viry), *Dix Lettres d'un Aliéné*, p. 51.
4 Letters 776 (c.23 May 1889) and 832 (c.23 December 1889).
5 Letters 776 (c.23 May 1889) and 801 (10 September 1889).
6 Letter 776 (c.23 May 1889).
7 Ouvrier Typographe (Viry), *Affaire Monastério: Lettre Audit Carlos*, Nouvelle, Lyon, 1884, p. 3.

8 A lack of models was one of Van Gogh's constant refrains at Saint-Paul. See Letters 782 (c.18 June 1889), 798 (c.2 September 1889), 805 (c.20 September 1889), 812 (c.21 October 1889), 820 (c.19 November 1889) and 822 (c.26 November 1889).

9 Letters 811 (c.21 October 1889) and 867 (3 May 1890).

10 The portrait was first shown in an exhibition on German Expressionism (Marseille, 1965), and then in shows on mental health (Haarlem and Gouda, 1983–84), art and madness (Vienna, 1997), contemporary art (Amsterdam, 2003) and one entitled insanity (Amsterdam, 2016). The man in the portrait looks as if he might be in his fifties, which would fit Paulin Sicard (50), Louis Bizalion (52) and Etienne Duffaud (55).

11 Photocopy of the daily register of patient and staff numbers at Saint-Paul for May 1889 (Van Gogh Museum, documentation file). Doiteau and Leroy (1928, p. 56) gave the number of male patients as *une dizaine* (around ten), but the actual number was nearly double.

12 The medical register (*Le Grand Registre de l'Asile de Saint-Rémy*) has always remained inaccessible and only the Van Gogh entry was photographed and reproduced: Doiteau and Leroy, 1928, opposite pp. 84–5; Tralbaut, 1969, pp. 276–7; and Bakker, Van Tilborgh and Prins, 2016, pp. 158–9 (in this latter publication the black-and-white photograph has been artificially coloured). Leroy, 1926 and Doiteau and Leroy, 1928 report the medical conditions of many of the patients (in very similar terms in the two sources) from the medical register, but do not name the patients. The admission register, at the Archives Municipales of Saint-Rémy (3Q5), records names and dates of admission, but not medical conditions. The 1886 and 1891 census registers (1F10 and 1F11) exclude asylum patients, but patients are enumerated in the detailed 1891 census household returns (1F24). Names are sometimes spelt slightly differently in various documents, but the most likely variant is used in this book. For a comment on patient privacy, see note 7 on page 192.

13 Leroy, 1926, p. 156 and Doiteau and Leroy, 1928, p. 60, giving his age as 23. The admission register (3Q5) names Revello (he turned 23 on 29 or 30 July 1889, soon after Van Gogh's arrival). Further information on Revello is given in correspondence in the Archives Municipales, Saint-Rémy (3Q4).

14 Letter 776 (c.23 May 1889).

15 Leroy, 1926, p. 158 and Doiteau and Leroy, 1928, p. 63, where Raineri's age (26) and condition (but not name) is recorded. The admission register (3Q5) gives his date of admission (3 February 1889), age (26) and previous residence (Nimes).

16 Leroy, 1926, pp. 156–7 and Doiteau and Leroy, 1928, p. 61. The identity of the lawyer has not been established. Eugène Pierre Figuières, *un avoué* (a type of lawyer), had been admitted to Saint-Paul in 1883, but he seems to have died in Aix-en-Provence on 17 August 1886, aged 52, so it was not him. There was presumably a second lawyer who was present when Van Gogh arrived, unless Leroy made an error over the profession of the patient who suffered from hallucinations.

17 Letter 776 (c.23 May 1889).

18 Report by Dr Albert Delon, 7 February 1889 and by Peyron, 9 and 25 May 1889 (Bakker, Van Tilborgh and Prins, 2016, pp.141–3 and 156–9).

19 Leroy, 1926, p. 157; Doiteau and Leroy, 1928, p. 61. Because of the coincidence, one might wonder whether Doiteau and Leroy had confused the two cases, but Van Gogh's comments confirm that the unnamed man did indeed suffer from similar symptoms.

20 De Beucken, 1938, pp. 107–8, see also Perruchot, 1955, p. 313.

21 There were also three other elderly patients who are listed in the 1891 census, but are not listed in the admission registers for 1855–76 and 1876–92 (3Q5), so they were presumably either admitted before 1855 or for some reason were not recorded in the registers. These are: Jean Biscolly (aged 76 in 1889), Jean Carrassan (62) and Paulin Sicard (50). Van Gogh (aged 35 when admitted) mentioned that some of the patients were 'considerably older' than himself (Letter 865, c.1 May 1890). These three men were probably there during Van Gogh's time. This would leave five more men unnamed among the 18 who were there when then the artist arrived.

22 Leroy, 1926, pp. 157–8 and Doiteau and Leroy, 1928, pp. 62–3. See also the conditions listed in Coquiot, 1923, pp. 226-7 (Coquiot's information may well have come from Leroy, Sister Epiphane or directly from the medical register on his 1922 visit).

23 Enrico's age is unclear. It is given as 40 in the admission register (3Q5). Although Leroy does not name him, he gives the age of the patient admitted on 27 May as 27, but he may have confused the age with the date

(Leroy, 1926, pp. 157–8 and Doiteau and Leroy, 1928, p. 62).

24 Leroy, 1926, pp. 157–8 and Doiteau and Leroy, 1928, p. 62.

25 Letter 777 (31 May–June 1889).

26 They also came from Marseilles and were of similar ages. Thérèse Louise was admitted for a short period in 1862 and readmitted in 1868 and again in 1872, leaving in 1873. Jacques Eugène was admitted for a few months in 1875 and again in 1890, just after Van Gogh's departure.

27 For instance, he had a row and broke off relations with his friend Anthon van Rappard in 1885.

28 Letter 836 (4 January 1890).

CHAPTER ELEVEN: CRISES (pp. 122–129)

1 Letter 801 (10 September 1889).

2 Van Gogh usually used the word *crise* (crisis) for these incidents or sometimes *attaque* (attack). Peyron used the term *accès*, which can be translated as either crisis or attack.

3 Theo to Jo, 14 February 1889 (Jansen and Robert, 1999, pp. 161–2).

4 Letters 779 (9 June 1889) and 743 (28 January 1889).

5 Report by Dr Albert Delon, 7 February 1889 (Bakker, Van Tilborgh and Prins, 2016, pp.141–3).

6 Medical register, Saint-Paul (Bakker, Van Tilborgh and Prins, 2016, pp.156–9).

7 For background on how the condition was regarded at the time, see: Ernest Compérat, *Des Hallucinations de la Vue et de l'Ouïe*, Parent, Paris, 1872; Gabriel Descourtis, *Des Hallucinations de l'Ouïe*, Masson, Paris, 1889; Jules Séglas, *Pathogénie et Physiologie Pathologique de l'Hallucination de l'Ouïe*, Crépin-Leblond, Nancy, 1896; and René Legay, *Essai sur les Rapports de l'Organe Auditif avec les Hallucinations de l'Ouïe*, Steinheil, Paris, 1898.

8 Mutilating or cutting off of the ear is an extremely unusual occurrence, but one case has recently been recorded in the medical literature. An 18-year-old male, with schizophrenia, was suffering from 'command hallucinations which ordered him to cut-off his ears' (M.K. Goutham, Rajeshwari Aroor, Vadish Bhat and Marina Saldanha, 'Van Gogh Syndrome: A rare case of bilateral ear mutilation, *Indian Journal of Otology*, 1 June 2011, cited in Bakker, Van Tilborgh and Prins, 2016, pp. 39–40).

9 Cited in Jo to Mien Bonger, 9 August 1889 (Van Gogh Museum archive, b4292).

10 Letter 797 (22 August 1889).

11 De Beucken, 1938, p. 134. De Beucken writes that Van Gogh was sent to a room for the *gâteux* (senile), although it was much more likely to have been one for the *agités* (agitated). The rooms for both categories, which were adjacent, were on the ground floor of the east wing, whereas Van Gogh's own bedroom was on the upper floor, at the far end. See plan of Saint-Paul by Joseph Girard, 1857, copied by Marcel Guesnot, 12 September 1959 (Archives Municipales, Saint-Rémy, 3Q7).

12 Tralbaut, 1969, p. 274 and Tralbaut, 1958, p. 110. The photograph may have been commissioned, rather than taken, by Tralbaut.

13 Letter 812 (c.21 October 1889), see also 794 (4 August 1889).

14 Letter 797 (22 August 1889).

15 Letters 801 (10 September 1889) and 797 (22 August 1889).

16 Letter 800 (5 and 6 September 1889). Van Gogh painted a different version of this scene later in the autumn (F706).

17 Peyron to Theo, c.2 September 1889 (Van Gogh Museum archive, b650), which is a postscript to Letter 798 (c.2 September 1889).

18 Letter 810 (c.8 October 1889).

19 As Van Gogh's three other trips to Arles were all at weekends, it is most likely that this visit was on 16–17 November.

20 For the identification of Gabrielle Berlatier, see Murphy, 2016, pp. 217–28 and Martin Bailey, 'The Mysteries of Arles', *Apollo*, December 2016, pp. 84–8.

21 Letters 632 (26 June 1888) and 683 (18 September 1888).

22 Letter 833 (31 December 1889–1 January 1890). Van Gogh had predicted this attack, fearing that 'the crisis returns towards Christmas' (Letter 800, 5 and 6 September 1889, see also 805, c.20 September 1889).

23 Letter 835 (3 January 1890), although 838 (8 January 1890) suggests that Dr Peyron may have initially overreacted.

24 Letter 836 (4 January 1890). The still life was apparently sold for 200 francs by Lucie Laserges, a daughter of Salles, at some point after her father's death in 1897 (Benno Stokvis, 'Vincent van Gogh à Arles', *Gand Artistique*, January 1929, p. 6). This painting is now lost.

25 Peyron to Theo, 29 January 1890 (Van Gogh Museum archive, b1061). The visit to Arles was on 18 or 19 January 1890 and the attack began two days later, on 20 or 21 January.

26 Letter 850 (1 February 1890).

27 Peyron to Theo, 24 February 1890 (Van Gogh Museum archive, b1062).

28 Peyron to Theo, 24 February 1890 (Van Gogh Museum archive, b1062). The first breakdown occurred one week after his July 1889 visit to Arles, the second on the anniversary of the ear incident in Arles, the third two days after his January 1890 visit to Arles and the fourth in February 1890 while in Arles.

29 Letter 857 (c.17 March 1890).

30 Peyron to Theo, 1 April 1890 (Van Gogh Museum archive, b1063).

31 Letters 860 (29 March 1890) and 863 (29 April 1890). It is interesting that Theo never visited Saint-Paul.

32 Peyron's note in medical register, 16 May 1890 (Bakker, Van Tilborgh and Prins, 2016, p. 157). Peyron referred to *garçon* (boy). There were then only two male employees under 30 – Poulet (26) and Joseph Recoulin (25), a junior orderly.

33 Sister Epiphane reported an attempt to eat paint (Piérard, 1946, p. 186). Poulet said that Van Gogh had tried to swallow paint and turpentine (De Beucken, 1938, pp. 133–4) or three tubes of paint (Tralbaut, 1969, p. 290). A similar incident had taken place in Arles, with Signac writing that in February 1889 Van Gogh had 'wanted to drink a litre of turpentine' (Coquiot, 1923, p. 194).

34 Salles to Theo, 7 February 1889 (Van Gogh Museum archive, b1046). This fear of poisoning must have made it very difficult for asylum staff to have fed Van Gogh during these crises.

35 Report by Dr Albert Delon, 7 February 1889 (Bakker, Van Tilborgh and Prins, 2016, pp.141–3).

36 Letter 812 (c.21 October 1889), see also 807 (4 October 1889).

37 Bakker, Van Tilborgh and Prins, 2016, p. 123.

38 Letter 743 (28 January 1889). Leroy believed it likely that Van Gogh was also given potassium bromide at Saint-Paul (Doiteau and Leroy, 1928, p. 64).

39 Letter 782 (c.18 June 1889), see also 776 (c.23 May 1889).

40 Letter 801 (10 September 1889).

41 There is an extensive literature on Van Gogh's condition. Two important, but dated, books are Humberto Nagera, *Vincent van Gogh: A Psychological Study*, Allen & Unwin, London 1967 and Albert Lubin, *Stranger on the Earth: A Psychological Biography of Vincent van Gogh*, Holt, New York, 1972. The best recent summary is Bakker, Van Tilborgh and Prins, 2016. A symposium on Van Gogh's illness at the Van Gogh Museum brought together leading specialists on 14–15 September 2016, although it did not reach definitive conclusions. A report on the symposium is due to be published later in 2018.

42 Bakker, Van Tilborgh and Prins, 2016, pp. 121–8.

CHAPTER TWELVE: MIRROR IMAGES (pp. 130–137)

1 Letter 800 (5 and 6 September 1889).

2 Letter 800 (5 and 6 September 1889). Later Van Gogh described this self-portrait as having been done 'when I was ill' (Letter 805, c.20 September 1889), but he must have meant immediately after recovering. He started it at about the same time that he worked on *Field with Ploughman* (fig. 79).

3 The other self-portrait with a bandaged ear is F529.

4 Letter 800 (5 and 6 September 1889).

5 Letter 815 (c.25 October 1889).

6 Letter 760 (21 April 1889).

7 Letter 805 (c.20 September 1889).

8 Letter 800 (5 and 6 September 1889).

9 Letter 877 (3 June 1890), see also 879 (5 June 1890).

10 Letter 811 (c.21 October 1889).

11 Letter 650 (29 July 1888). Van Gogh wrote that he no longer looked like the 'mad painter', but more like 'the very placid abbot' in the 1872 picture by Emile Wauters of *The Painter Hugo van der Goes in the Red Cloister* (Musées Royaux des Beaux-Arts, Brussels).

12 For an analysis of the bedroom paintings, see Gloria Groom (ed.), *Van Gogh's Bedrooms*, Art Institute of Chicago, 2016.

13 At Vincent's request, Theo had sent the original of *The Bedroom* (F482) to Saint-Paul in June 1889, so that Vincent could copy it. As well as the smaller replica (fig. 84), he also made a full-size version of it in September (F484).

14 Letter 812 (c.21 October 1889). The paintings for Anna and Wil, which also included *Women picking Olives* (fig. 69), were sent to Theo in Paris on 6 December.

15 Letter 804 (19 September 1889).

CHAPTER THIRTEEN: TRANSFORMING INTO COLOUR (pp. 138–153)

1 Letter 839 (c.13 January 1890).
2 Along with the 28 paintings after prints by other artists, he also made four surviving paintings after a drawing by Gauguin and one painting after a print or drawing by himself.
3 Letter 805 (c.20 September 1889). For background on Van Gogh's copying, see Homburg, 1996.
4 Recollections of Anton Kerssemakers in *The Complete Letters of Vincent van Gogh*, Thames & Hudson, 1958, vol. ii, p. 447. There was a piano at Saint-Paul for the female patients, but apparently not in the men's block (*Etablissement de St. Paul pour le Traitement des Aliénées des Deux Sexes*, 1856).
5 Letter 839 (c.13 January 1890).
6 Letter 801 (10 September 1889).
7 Van Gogh's smaller version is F757. Delacroix's original painting (1850), which is half the dimensions of Van Gogh's larger version, is now at the Nasjonalgalleriet, Oslo. The print and Van Gogh's subsequent picture show the reversed image of the original Delacroix.
8 Letter 804 (19 September 1889).
9 Letters 804 (19 September 1889) and 801 (10 September 1889).
10 Van Gogh copied five religious works at Saint-Paul: two of the *Pietà* (fig. 86 and F757) and the *Good Samaritan* (F633), after Delacroix; the *Raising of Lazarus* (F677), after Rembrandt; and the *Angel Raphael* (F624), after a Rembrandt follower.
11 In 1973 F757 was donated to the Vatican by the Archdiocese of New York.
12 See Louis van Tilborgh, *Van Gogh & Millet*, Van Gogh Museum, Amsterdam, 1988 and *Millet/Van Gogh*, Musée d'Orsay, Paris, 1998.
13 Letters 37 (6 July 1875) and 816 (c.3 November 1889).
14 Millet had made pastels which were then turned into prints. The prints were published in *L'Illustration* (*Noon* on 26 July 1873, p. 168).
15 Letters 816 (c.3 November 1889) and 839 (c.13 January 1890). The four paintings are *Morning* (F684), *Noon* (fig. 90), *End of the Day* (F649) and *Evening* (F647).
16 The first, smaller painted version is F689. Van Gogh's 1880 drawn copy is lost, although an 1881 version done in Etten survives (F830).
17 *De Katholieke Illustratie*, 1872–73, p. 357.
18 *The Night Café*, 1888 (Pushkin State Museum of Fine

Arts, Moscow).
19 Letter 801 (10 September 1889). Van Gogh had in mind Beecher Stowe's *Uncle Tom's Cabin* (1852) and Dickens's *Christmas Books* (1845), both of which he re-read.
20 Along with fig. 96, the surviving versions are F541, F542 (given to Gauguin) and F543.
21 Unsent letter RM23 (c.17 June 1890).
22 Letter 884 (c.13 June 1890) and unsent letter RM23 (c.17 June 1890).
23 Vincent had asked Theo to send him some of his early figure drawings to Saint-Paul (Letter 863, 29 April 1890). Theo presumably included either the 1882 drawing (F997) or the resulting lithograph (F1662).
24 Cited in a letter from Theo to Anna and Wil, 15 April 1890 (Van Gogh Museum archive, b928), see also Theo to Mien Bonger, 27 April 1890 (b4305).
25 Letters 810 (c.8 October 1889) and 839 (c.13 January 1890).
26 Van Gogh's *Reaper with a Scythe* sold at Christie's, 27 June 2017. Millet's *The Angelus* (1859, now Musée d'Orsay, Paris) sold in January 1890 for 800,000 francs. The modern record price of £2 million for a Millet is for *Summer, the Gleaners*, Sotheby's, 1 November 1995.

CHAPTER FOURTEEN: MEMORIES OF THE NORTH (pp. 154–159)

1 Letter 863 (29 April 1890).
2 Letter 864 (29 April 1890). Curiously, on the same day he wrote to Theo about 'not having been able to work for two months' (Letter 863, 29 April 1890), but he may have meant that he had not worked *properly*.
3 Letter 741 (22 January 1889).
4 On one occasion he was just well enough to write to Theo in the middle of the two-month crisis (Letter 857, c.17 March 1890).
5 Letter 863 (29 April 1890), see also 864 (29 April 1890).
6 Letter 841 (20 January 1890).
7 These pictures may well date from late March to mid-April, since he does not mention them in the one letter sent in the middle of his two-month crisis (Letter 857, c.17 March 1890).
8 Van Gogh also made another version of this scene (F673).
9 Letter 864 (29 April 1890).
10 Although the painting is sometimes entitled 'The

Weeders', a snow-covered field would not be weeded and Van Gogh himself describes the scene as 'women lifting turnips' (Letter 864, 29 April 1890). In 1885 he had also painted a landscape, now lost, of women harvesting turnips in the snow (Letter 529, c.19 August 1885). At Saint-Paul Van Gogh had witnessed an impressive snowfall from his window at the end of December (Letter 833, 31 December 1889–1 January 1890).

11 Vellekoop and Zwikker, 2007, p. 292.

CHAPTER FIFTEEN: ALMOND BLOSSOM
(pp. 160–165)

1 Letter 857 (c.17 March 1890).

2 Letter 786 (5 July 1889).

3 Letter 787 (6 July 1889). This letter was addressed jointly to Theo and Jo, and Vincent also sent one letter to Jo (Letter 846, 31 January 1890). Interestingly, all his other correspondence from Saint-Paul was addressed solely to Theo, rather than to Theo and Jo.

4 Theo had written on 16 June 1889 (Letter 781), but he did not write again until 16 July (Letter 792). The 16 July letter probably arrived just after Vincent's crisis, so he did not read it until he recovered a few weeks later.

5 Peyron to Theo, 29 January 1890 (Van Gogh Museum archive, b1061). The letter probably arrived in Paris on 30 January, but it could have been the following day, the day of the birth.

6 Letter 845 (29 January 1890).

7 The birth notice (b1493) and the photograph (b4670) are in the Van Gogh Museum archive.

8 Letter 850 (1 February 1890).

9 Letter 855 (19 February 1890). Although Vincent told his mother that he had begun the picture 'right away' (presumably after receiving news of the birth, which he heard about on 1 February), he said to Will that it had been done just a 'few days' before writing (Letter 856, 19 February 1890). Interestingly, Van Gogh did not sign the painting or add a written dedication.

10 *Bulletin Annuel de la Commission de Météorologie du Département des Bouches-du-Rhône 1890*, Barlatier & Barthelet, Marseille, 1891, p. 50. On 17 February the weather became milder after a long cold spell, after which it got warmer. Van Gogh wrote that 'in the last few days we've had rather miserable weather here, but today it was a real spring day' (Letter 855, 19 February 1890).

11 This is what Van Gogh had done on a very much smaller scale exactly a year earlier in Arles. At the very end of February 1888 he cut a twig from a blossoming almond tree and took it back to his hotel room to paint (F392 and F393, Letter 582, c.2 March 1888).

12 Van Gogh owned the Kunisada print and may well have known Hokusai's print *Weeping Cherry and Bullfinch* (Small Flowers), 1834.

13 Theo's letter probably arrived on 18 February 1890. On 19 February Vincent wrote that Theo had informed him 'yesterday', which presumably meant that was when the letter was received, rather than written (Letter 855, 19 February 1890). *The Red Vineyard* is F495.

14 Theo's letter of c.17 February with news of the sale and Vincent's possible immediate response do not survive, but Vincent's later reaction seems surprisingly low key. Vincent told his mother about the sale, but commented that the price 'isn't much' (Letter 855, 19 February 1890). The price was actually quite substantial, and represented the fees for four months at the asylum. It was also more than for some paintings sold by Gauguin (in 1890 Theo sold two Gauguins for 200 and 300 francs, see Letter 897, 5 July 1890). Inexplicably, three months after the sale of *The Red Vineyard* Vincent apparently forgot which painting had been sold (Letter 875, 25 May 1890). Anna Boch was a cousin of Octave Maus, the organiser of the Brussels exhibition, and Van Gogh may have felt that as the buyer was also the sister of his friend Eugène Boch the purchase might have been partly a friendly gesture – or he may have had ambivalent feelings about success.

15 Letter 857 (c.17 March 1890). The attack occurred on 22 February 1890.

16 Letter 863 (29 April 1890). In Arles he had done 15 paintings of blossoming orchards in March–April 1888 (Bailey, 2016, pp. 29–33).

17 Vincent Willem van Gogh, 'Some Additional Notes' in *The Complete Letters of Vincent van Gogh*, Thames & Hudson, London, 1958, vol. i, p. lviii.

18 Letter 863 (29 April 1890). Vincent later suggested that he had 'brought back' *Almond Blossom* when he returned to Paris on 17 May (Letter 879, 5 June 1890), but it had actually been sent a few days before his departure, since Theo had acknowledged its arrival (Letter 867, 3 May 1890).

19 Letters 867 (3 May 1890) and 879 (5 June 1890).

20 Johan van Gogh, 'The History of the Collection', Evert

van Uitert and Michael Hoyle, *The Rijksmuseum Vincent van Gogh*, Meulenhoff, Amsterdam, 1987, p. 4.

21 Email with Johan van Gogh's comments, 25 July 2017.

CHAPTER SIXTEEN: ISOLATED (pp. 166–171)

1 Letter 865 (c.1 May 1890)

2 Although Van Gogh had some correspondence with artists while at Saint-Paul, this was fairly limited, judging from the surviving letters. Five letters from Gauguin survive (Letters 817, 828, 840, 844 and 859), two to Bernard (809 and 822) and one to the Australian artist John Russell (849).

3 *Starry Night over the Rhône* is F474.

4 *Olive Grove* is F586. The two Arles paintings were F517 and F454 (or possibly F456).

5 Theo to Wil, 14 March 1890 (Van Gogh Museum archive, b927).

6 Letter 858 (19 March 1890). Carnot's visit was on 19 March 1890.

7 *Le Petit Journal*, 20 March 1890.

8 The *Sunflowers* were F454 and F456. See Bailey, 2013, p. 105.

9 Letters 833 (31 January–1 February 1890) and 883 (11 June 1890).

10 Letter 868 (4 May 1890) and unsent letter RM20 (24 May 1890).

11 Letters 868 (4 May 1890) and 865 (c.1 May 1890).

12 The flower still lifes are fig. 108, F680, F681 and F682. He also completed two garden scenes (F672 and F676), a wheatfield (fig. 48) and an imaginative landscape (fig. 74, and possibly also F704).

13 Letter 879 (5 June 1890).

14 The Arles Sunflowers are F453, F454, F455, F456, F457, F458 and F459. See Bailey, 2013.

15 Letter 872 (13 May 1890).

16 Medical register (Bakker, Van Tilborgh and Prins, 2016, pp.156–9). Peyron wrote that the longest crisis lasted one month, but he may have regarded the mid-February to late April attack as two separate ones, with a brief respite in between. Although Peyron referred to the Provençal climate as a reason for Van Gogh's departure, there is little reference to this in Van Gogh's letters (other than complaints about the mistral).

17 Letter 868 (4 May 1890).

18 Letter 833 (31 December 1889–1 January 1890).

19 Letter 638 (9–10 July 1888).

POSTSCRIPT I: THE ASYLUM AFTER VAN GOGH (pp. 172–179)

1 Albert Schweitzer, *My Life and Thought*, Allen & Unwin, London, 1954, p. 205. See also Gérard Vial, 'Albert Schweitzer et ses Compagnons d'infortune', *Saint-Rémy-de-Provence: Son Histoire*, 2014, pp. 358–61 and Gérard Claude, 'Les Détenus de Saint-Paul', *Provence Historique*, 2009, no. 236, pp. 193–220.

2 See the essay by his son, Robert Leroy, 'Docteur Edgar Leroy', *Saint-Rémy-de-Provence: Son Histoire*, 2014, pp. 402–4.

3 Leroy, 1926.

4 Doiteau's first work was 'La Folie de Vincent van Gogh', *Le Progrès Médical*, Supplement Illustré, January and March 1926, pp. 1–8 and 17–20.

5 Leroy, 1926 and Doiteau and Leroy, 1928, see also Doiteau and Leroy, 1936.

6 Leroy's most important publications are listed in the Select Bibliography, but because of his access to the Saint-Paul archive it is worth recording his other numerous relevant writings: 'La Folie de Van Gogh', *La Picardie Médicale*, July 1928, pp. 247–53; 'L'Art et la Folie de Vincent van Gogh', *Journal des Praticiens*, 21 July 1928, pp. 1558–63; 'La Folie de Van Gogh', *Cahiers de Pratique Médico-Chirurgicale*, 15 November 1928, pp. 3–11; 'Saint Paul de Mausole', *Mémoires de l'Institut Historique de Provence*, 1929, pp. 107–21; 'La Provence à travers les Lettres de Vincent van Gogh', *La Revue des Pay d'Oc*, June 1932, pp. 329–45; 'Vincent van Gogh: Son Séjour en Provence', *Revue du Médical-Auto-Club de Marseille*, February 1934, pp. 43–7, March 1934, pp. 65–7 and April 1934, pp. 89–93; 'Les Origines de l'Asile Saint-Paul-de-Mausole', *L'Hygiène Mentale*, September 1938, pp. 121–33; 'A Saint-Paul de Mausole, Quelques Hôtes Célèbres au cours du XIXme Siècle', *La Revue d'Arles*, June 1941, pp. 125–30; 'Vincent van Gogh au Pays d'Arles', *La Revue d'Arles*, October 1942, pp. 261–2; 'Van Gogh à l'Asile' in François-Joachim Beer, *Du Demon de Van Gogh*, ADIA, Nice, 1945, pp. 73–85; 'Vincent van Gogh au Coeur de la Provence' in exhibition catalogue, *Vincent van Gogh en Provence*, Musée Réattu, Arles and Hôtel de Sade, Saint-Rémy, 1951, unpaginated; 'Vincent van Gogh et la Provence', c.1953 (unpublished typescript, copy at Van Gogh Museum library); and 'Le Couvent des Observantins de Saint-Paul-de-Mausole', *Etudes Franciscains*, June 1954, pp. 71–96 and December 1955, pp. 205–21.

7 The museum's Livre d'Or was acquired in 2016 (Archives Muncipales, Saint-Rémy, 2R4). There are two visitors' books (with 222 and 73 pages), covering the period 1929–52.

8 Sold at Sotheby's, 22 June 2012.

9 The sketchbook page with the watercolour of the cloister is owned by the Musée d'Orsay, Paris. See Maurice Denis, *Journal*, La Colombe, Paris, 1959, vol. iii, p. 58 (entry for 28 September–21 October 1926).

10 Michel Kellermann, *André Derain: Catalogue Raisonné de l'Oeuvre Peint*, Schmit, Paris, 1999, vol. ii (Saint-Rémy works include no. 511).

11 It is possible that Mas d'Angirany is depicted in Van Gogh's *Two Huts amid Olive Trees and Cypresses* (F623).

12 Mauron, 1976.

13 Other English artists inspired by the Saint-Paul area included the sculptor Barbara Hepworth and her partner, the painter Ben Nicholson, who visited in 1933 and in later years.

14 See *Jean Baltus, Peintre des Alpilles 1880–1946*, Musée des Alpilles, Saint-Rémy, 2016.

15 See *Yves Brayer: Catalogue Raisonné*, Bibliothèque des Arts, Paris, vols. i and ii, 2000 and 2008.

16 *Vincent van Gogh en Provence*, Musée Réattu, Arles and Hôtel de Sade, Saint-Rémy, 10 May to 3 June (closure originally scheduled for 27 May) 1951.

17 *Le Provençal*, 10 June 1954.

18 Jacques Soubielle, 'Pardon, Monsieur Van Gogh', *Touring*, December 1975, p. 19.

19 For Dr Boulon's informed account of Van Gogh's stay at Saint-Paul, see Boulon, 2003 and rev. ed. 2005.

POSTSCRIPT II: IMPRISONED IN RUSSIA (pp. 180–185)

1 De la Faille, 1970, p. 532 (F1540).

2 Letter 784 (2 July 1889).

3 *The Observer*, 5 August 1990. For background on Baldin see Rainer Schossig, *Viktor Baldin: Der Mann mit dem Koffer*, Hachmann, Bremen, 2005.

4 Geraldine Norman, *Dynastic Rule: Mikhail Piotrovsky & the Hermitage*, Unicorn, London, 2016, p. 163.

5 For exhibitions of *Wild Vegetation*, see Vellekoop and Zwikker, 207, p. 244. The drawing of *Starry Night* was shown in exhibitions at Vollard, Paris, 1896; Stedelijk Museum, Amsterdam, 1905; Cassirer, Berlin, 1914; Gestner, Hannover, 1919; Wacker, Berlin, Vienna and Hannover, 1927–28; and Palais des Musées d'Art Moderne, Paris, 1937. It was also presumably occasionally displayed at the Kunsthalle Bremen.

6 Interview, 8 September 1992.

7 *West European Drawing of XVI–XX Centuries: Kunsthalle Collection in Bremen Catalogue*, Kultura, Moscow, 1992, p. 10.

8 Interview, 9 September 1992, published in *The Observer*, 20 September 1992.

ON THE TRAIL OF VAN GOGH (pp. 186–187)

1 Philippe Latourelle, 'Le Musée Estrine, Un Musée de France à Saint-Rémy', *Saint-Rémy-de-Provence: Son Histoire*, 2014, pp. 498–500.

2 The museum's version was cast in 1992. Zadkine had in 1966 provided a bust for Saint-Paul, which was originally displayed in the avenue between the entrance and the chapel; it was stolen in 1989 and recovered in 2009.

SELECT BIBLIOGRAPHY

Martin Bailey, *The Sunflowers are Mine: The Story of Van Gogh's Masterpiece*, Frances Lincoln, London, 2013

Martin Bailey, *Studio of the South: Van Gogh in Provence*, Frances Lincoln, London, 2016

Martin Bailey, 'The Mysteries of Arles', *Apollo*, December 2016, pp. 84-8

Nienke Bakker, Louis van Tilborgh and Laura Prins, *On the Verge of Insanity: Van Gogh and his Illness*, Van Gogh Museum, Amsterdam, 2016

Guy Barruol and Nerte Dautier (eds.), *Les Alpilles: Encyclopédie d'une Montagne Provençale*, Alpes de Lumière, Forcalquier, 2009

Jos ten Berge, Teio Meedendorp, Aukje Vergeest and Robert Verhoogt, *The Paintings of Vincent van Gogh in the Collection of the Kröller-Müller Museum*, Kröller-Müller Museum, Otterlo, 2003

Jean de Beucken, *Un Portrait de Vincent van Gogh*, Balancier, Liège, 1938

Carel Blotkamp and others, *Vincent van Gogh: Between Earth and Heaven, the Landscapes*, Kunstmuseum Basel, 2009

Marcel Bonnet, *St-Rémy-de-Provence: Le Temps Retrouvé*, Equinoxe, Marguerittes, 1989

Marcel Bonnet, *Saint-Rémy-de-Provence: Chronique Photographique de Frédéric George (1868–1933)*, Equinoxe, Marguerittes, 1992

Jean-Marc Boulon, *Vincent van Gogh*, Saint-Paul-de-Mausole, Saint-Rémy, 2003 and rev. ed. 2005

Nicholas Burliuk (ed), *Color and Rhyme*, New York, nos. 20–1 and 22 (Van Gogh issues), 1950–51

Jean-Paul Clébert and Pierre Richard, *La Provence de van Gogh*, Edisud, Aix-en-Provence, rev. ed., 1989

Gustave Coquiot, *Vincent van Gogh*, Ollendorff, Paris, 1923

Victor Doiteau and Edgar Leroy, *La Folie de Vincent van Gogh*, Aesculape, Paris, 1928

Victor Doiteau and Edgar Leroy, *Van Gogh et le Drame de l'Oreille coupée*, Aesculape, Paris, 1936

Douglas Druick and Peter Kort Zegers, *Van Gogh and Gauguin: The Studio of the South*, Art Institute of Chicago, 2001

Ann Dumas and others, *The Real Van Gogh: The Artist and his Letters*, Royal Academy of Arts, London, 2010

Pierre Dupuy, *Saint-Rémy-de-Provence*, Equinoxe, Saint-Rémy, 2017

Etablissement de St-Paul pour le Traitement des Aliénés des deux Sexes, Clément, Avignon, 1856 (rev. ed. *Maison de Santé de Saint-Rémy de Provence*, Masson, Paris, 1866)

Jacob-Baart de la Faille, *The Works of Vincent van Gogh: His Paintings and Drawings*, Meulenhoff, Amsterdam, 1970

Walter Feilchenfeldt, *Vincent van Gogh: The Years in France, Complete Paintings 1886–1890*, Wilson, London, 2013

Martin Gayford, *The Yellow House: Van Gogh, Gauguin and nine turbulent weeks in Arles*, Fig Tree, London, 2006

Judith Geskó, *Van Gogh in Budapest*, Museum of Fine Arts, Budapest, 2006

Jennifer Helvey, *Irises: Vincent van Gogh in the Garden*, J. Paul Getty Museum, Los Angeles, 2009

Wulf Herzogenrath and Dorothee Hansen, *Van Gogh: Fields*, Kunsthalle Bremen, 2002

Sjraar van Heugten, Joachim Pissarro and Chris Stolwijk, *Van Gogh and the Colors of the Night*, Museum of Modern Art, New York, 2008

Sjraar van Heugten, *Van Gogh and the Seasons*, National Gallery of Victoria, Melbourne, 2017

Cornelia Homburg, *The Copy turns Original: Vincent van Gogh and a new Approach to traditional Art History*, Benjamins, Amsterdam, 1996

Cornelia Homburg, *Vincent van Gogh and the Painters of the Petit Boulevard*, Saint Louis Art Museum, 2001

Cornelia Homburg, *Vincent van Gogh: Timeless Country – Modern City*, Skira, Milan, 2010

Cornelia Homburg (ed.), *Van Gogh Up Close*, National Gallery of Canada, Ottawa, 2012

Jan Hulsker, 'Vincent's Stay in the Hospitals at Arles and St-Rémy', *Vincent* (journal), Spring 1971, pp. 24–44

Jan Hulsker, *The New Complete Van Gogh: Paintings, Drawings, Sketches*, Meulenhoff, Amsterdam, rev. ed. 1996

Colta Ives, Susan Alyson Stein, Sjraar van Heugten and Marije Vellekoop, *Vincent van Gogh: The Drawings*, Metropolitan Museum of Art, New York, 2005

Leo Jansen and Jan Robert (eds.), *Brief Happiness: The correspondence of Theo van Gogh and Jo Bonger*, Van Gogh Museum, Amsterdam, 1999

Leo Jansen, Hans Luijten, Nienke Bakker, *Vincent van Gogh – The Letters: The Complete Illustrated and Annotated Edition*, Thames & Hudson, London, 2009 (www.vangoghletters.org)

Voijtěch Jirat-Wasiutyński, 'Vincent van Gogh's Paintings of Olive Trees and Cypresses from St-Rémy', *Art Bulletin*, December 1993, pp. 647–70

Richard Kendall, Sjraar van Heugten and Chris Stolwijk, *Van Gogh and Nature*, Clark Art Institute, Williamstown, Mass., 2015

Tsukasa Kodera, Cornelia Homburg and Yukihiro Sato (eds.), *Van Gogh & Japan*, Seigensha, Kyoto, 2017

Stefan Koldehoff, *Van Gogh: Mythos und Wirklichkeit*, Dumont, Cologne, 2003

Pierre Leprohon, *Tel fut Van Gogh*, Sud, Paris, 1964 (rev. ed. *Vincent van Gogh*, Bonne, Paris, 1972)

Edgar Leroy, see also under Doiteau

Edgar Leroy, 'Le Séjour de Vincent van Gogh à l'Asile de Saint-Rémy-de-Provence', *Aesculape*, May, June and July 1926, pp. 137–43, 154–8 and 180–6

Edgar Leroy, *Saint-Paul-de-Mausole à Saint-Rémy-de-Provence*, Syndicat d'Initiative, Saint-Rémy, 1948

Edgar Leroy, 'Quelques Paysages de Saint-Rémy-de-Provence dans l'Oeuvre de Vincent van Gogh', *Aesculape*, July 1957, pp. 3–21

Charles Mauron, *Van Gogh: Etudes Psychocritiques*, Corti, Paris, 1976

Julius Meier-Graefe, *Vincent van Gogh: A Biographical Study*, Medici, London, 1922, 2 vols

Edwin Mullins, *Van Gogh: The Asylum Year*, Unicorn, London, 2015

Bernadette Murphy, *Van Gogh's Ear: The True Story*, Chatto & Windus, London, 2016

Steven Naifeh and Gregory White Smith, *Van Gogh: The Life*, Profile, London, 2011

Patrick Ollivier-Elliott, *Les Alpilles, Montagnette et Terres Adjacentes*, Edisud, Saint-Rémy, 2015

Ladislas Paulet, *Saint-Rémy-de-Provence: Son Histoire, Nationale, Commmunale, Religieuse*, Roumanille, Avignon, 1906

Henri Perruchot, *La Vie de Van Gogh*, Hachette, Paris, 1955

Ronald Pickvance, *Van Gogh in Arles*, Metropolitan Museum of Art, New York, 1984

Ronald Pickvance, *Van Gogh in Saint-Rémy and Auvers*, Metropolitan Museum of Art, New York, 1986

Louis Piérard, *La Vie Tragique de Vincent van Gogh*, Crès, Paris, 1924 (rev. ed. Correa, Paris, 1946; English edition *The Tragic Life of Vincent van Gogh*, Castle, London, 1925)

Eliza Rathbone and others, *Van Gogh Repetitions*, Phillips Collection, Washington, DC, 2013

John Rewald, 'Van Gogh en Provence', *L'Amour de L'Art*, October 1936, pp. 289–98

John Rewald, 'Van Gogh vs. Nature: Did Vincent or the Camera Lie?', *Artnews*, 1 April 1942

John Rewald, *Post-Impressionism: From Van Gogh to Gauguin*, Museum of Modern Art, New York, rev. ed.1978

Pierre Richard, *Van Gogh à Saint-Rémy*, Centre d'Art Présence Van Gogh, Saint-Rémy, 1990

Henri Rolland, *Saint-Rémy de Provence*, Générale, Bergerac, 1934

Mark Roskill, *Van Gogh, Gauguin and the Impressionist Circle*, Thames & Hudson, London, 1970

Klaus Albrecht Schröder and others (ed.), *Van Gogh: Heartfelt Lines*, Albertina, Vienna, 2008

Saint-Rémy-de-Provence: Son Histoire, Société d'Histoire et d'Archéologie de Saint-Rémy-de-Provence, 2014

Timothy Standring and Louis van Tilborgh, *Becoming Van Gogh*, Denver Art Museum, 2012

Susan Alyson Stein, *Van Gogh: A Retrospective*, Park Lane, New York, 1986

Richard Thomson, *Vincent van Gogh: The Starry Night* (for the exhibition Van Gogh and the Colors of the Night), Museum of Modern Art, New York, 2008

Marc Tralbaut, *Van Gogh: A Pictorial Biography*, Thames & Hudson, London, 1959

Marc Tralbaut, *Vincent van Gogh*, Viking, New York, 1969

Marije Vellekoop and Roelie Zwikker, *Vincent van Gogh Drawings: Arles, Saint-Rémy & Auvers-sur-Oise 1888–1890*, vol. iv, Van Gogh Museum, Amsterdam, 2007

Marije Vellekoop, Muriel Geldof, Ella Hendriks, Leo Jansen and Alberto de Tagle, *Van Gogh's Studio Practice*, Van Gogh Museum, Amsterdam, 2013

(Edouard Viry) Ouvrier Typographe, *Dix Lettres d'un Aliéné*, Nouvelle, Lyon, 1884

INDEX

Page numbers in *italics* refer to illustrations. Endnotes are indexed selectively, with an 'n' number for the note.

PICTURE CREDITS

akg-images: 38, 39, 41, 46, 49, 51, 56, 58, 60, 64, 68, 70, 102, 114, 117, 118

Alamy Stock Photo: 136 (Paul Fearn)

Association Les Amis de Jean Baltus (amisjeanbaltus.free.fr), photograph by Daniel Cyr Lemaire: 179 (Private collection)

Martin Bailey 11, 12, 13, 15, 176, 185

Barnes Foundation, Philadelphia: 157

Bridgeman Images: Cover, 8, 76, 79, 172 (Museum of Modern Art, New York), 18, 23 (Samuel Courtauld Trust, The Courtauld Gallery, London), 21 (Van Gogh Museum, Amsterdam), 29 R (Musée des Beaux-Arts, Marseille), 32 Van Gogh Museum, Amsterdam (Vincent van Gogh Foundation), 34, 44 (De Agostini Picture Library), 36 (J. Paul Getty Museum, Los Angeles), 42 (Museum Folkwang, Essen), 43 (Private collection), 61 (State Hermitage Museum, St Petersburg), 71 (Van Gogh Museum, Amsterdam), 73, 122 (Philadelphia Museum of Art, Pennsylvania, The Henry P. McIlhenny Collection in Memory of Frances P. McIlhenny), 74 (Private collection), 75 (Private collection / Photo Lefèvre Fine Art Ltd., London), 86, 97 (The Phillips Collection, Washington, DC, Acquired 1949), 89 (Kunsthalle Bremen), 95 (Norton Simon Museum, Pasadena), 96 (Cleveland Museum of Art, Gift of the Hanna Fund), 98, 100 (Museum of Modern Art, New York), 101 (Rijksmuseum Kröller-Müller, Otterlo / De Agostini Picture Library), 103 (Van Gogh Museum, Amsterdam), 104 (Minneapolis Institute of Art, The William Hood Dunwoody Fund), 108 (Národní Galerie, Prague), 112 (Rijksmuseum Kröller-Müller, Otterlo), 113 (Rijksmuseum Kröller-Müller, Otterlo), 127 (Private collection, Photo Christie's Images), 130, 133 (Musée d'Orsay, Paris), 132 (National Gallery of Art, Washington, DC), 135 (Private collection), 138, 145 (Musée d'Orsay, Paris), 141 (Van Gogh Museum, Amsterdam), 143 (Private collection, Photo Christie's Images), 147 (Private collection), 149 (Pushkin State Museum of Fine Arts, Moscow), 151 (Galleria Nazionale d'Arte Moderna, Rome / De Agostini Picture Library / A. Dagli Orti), 153 (Rijksmuseum Kröller-Müller, Otterlo), 160, 164 (Van Gogh Museum, Amsterdam), 166, 169 (Van Gogh Museum, Amsterdam)

Fine Arts Museums of San Francisco: 150 (Memorial gift from Dr. T. Edward and Tullah Hanley, Bradford, Pennsylvania, 69.30.78 / Image Courtesy the Fine Arts Museums of San Francisco)

Foundation E.G. Bührle Collection, Zurich: 158, 154

Collection Kröller-Müller Museum, Otterlo: 37, 75

The Mesdag Collection, The Hague: 142

Metropolitan Museum of Art, New York: 52 (Bequest of Abby Aldrich Rockefeller, 1948), 105 R (The Walter H. and Leonore Annenberg Collection, Gift of Walter H. and Leonore Annenberg, 1995, Bequest of Walter H. Annenberg, 2002), 106, 109 (Metropolitan Museum of Art, New York, Purchase, The Annenberg Foundation Gift, 1993), 111

Image courtesy of Nevill Keating Pictures (with thanks to the Royal Academy, London): 62

Paul Rosenberg Archives (III.3), Museum of Modern Art Archives, New York: 84

Rijksmuseum, Amsterdam: 82

Scala Archives: 26, 55, 90 (The Solomon R. Guggenheim Foundation, Thannhauser Collection, Gift Justin K. Thannhauser, 1978 / Art Resource, New York), 93 (Museum of Fine Arts, Boston, Bequest of Keith McLeod. Acc.n.: 52.1524. All rights reserved), 137

Photo Sotheby's: 177 (Private collection)

Vancouver Art Gallery: 175

Van Gogh Museum, Amsterdam (Vincent van Gogh Foundation): 10, 20 L + R, 40, 48, 54, 80, 91, 92, 116, 124, 140, 144, 146, 148, 156, 159, 162 top L, bottom L + R, 165

ACKNOWLEDGEMENTS

My deepest thanks go to Onelia Cardettini, my friend in Provence, who helped on every step of the journey. She provided crucial assistance for the archival research in Saint-Rémy – deciphering difficult handwriting, spotting key facts and suggesting important links. An excellent polyglot, she also helped translate and explain many of the subtleties of the French and Provençal languages. I am extremely grateful for her assistance, and for patiently responding to a constant stream of queries. Her dedication to our project has added greatly to this book.

I am deeply indebted to the Archives Muncipales in Saint-Rémy, particularly to the archivist Rémi Venture and his successor Alexandra Roche-Tramier. I am also grateful to the town's mayor, Hervé Chérubini, for his support for the archive. My visits to the open areas of Saint-Paul-de-Mausole and the publications of its director, Dr Jean-Marc Boulon, proved essential.

I would also like to give special thanks to the three editors of the magnificent 2009 edition of Van Gogh's letters – Leo Jansen, Hans Luijten and Nienke Bakker. This represents a wonderful resource for anyone researching Van Gogh. I am extremely grateful to my other colleagues, past and present, at the Van Gogh Museum in Amsterdam – particularly Isolde Cael, Fleur Roos Rosa de Carvalho, Maite van Dijk, Ella Hendriks, Monique Hageman, Anita Homan, Axel Rüger, Chris Stolwijk, Sjraar van Heugten, Fieke Pabst, Teio Meedendorp, Louis van Tilborgh, Lucinda Timmermans, Marije Vellekoop and Anita Vriend. It is always a privilege to work in the museum's library. I am also grateful to the staff of the London Library. My Amsterdam friend Jaap Woldendorp assisted greatly with Dutch translations and research questions.

Others who have kindly assisted in various ways include Oliver Brayer, David Brooks, Isabelle Cahn, Victor Doiteau Jr, Walter Feilchenfeldt, Martin Gayford, Lukas Gloor, Johan van Gogh, Jantine van Gogh, Josien van Gogh, Willem van Gogh, Gloria Groom, Christoph Grunenberg, Dorothee Hansen, Cornelia Homburg, Stefan Koldehoff, Philippe Latourelle, Marieke Lenferink, Jacqueline Leroy, Alice Mauron, Claude Mauron, Diederik Mooij, Richard

Munden, Bernadette Murphy, Gérard Nicollet, Geraldine Norman, Virginie Olier, Brendan Owens, Mikhail Piotrovsky, Aileen Ribeiro, Chris Riopelle, France de La Rocque, Marianne Rosenberg, Lynn Rother, Mary Schafer, Frances Spalding, Susan Stein and Piet Voskuil.

It has been a great experience working with Nicki Davis, my editor at Frances Lincoln, which this year became part of White Lion Publishing. She skilfully edited my two previous books, *The Sunflowers are Mine: The Story of Van Gogh's Masterpiece* (2013) and *Studio of the South: Van Gogh in Provence* (2016). Nicki created the elegant design for this latest book, assisted by Maria Bourke. I am very grateful to Laura Nicolson, the picture researcher, who tracked down the images, some from obscure sources. My thanks to Melody Odusanya, who organised the publicity.

As always, I am deeply grateful to Alison, my wife – for her companionship in exploring Saint-Rémy and for her editorial skills.

* * *